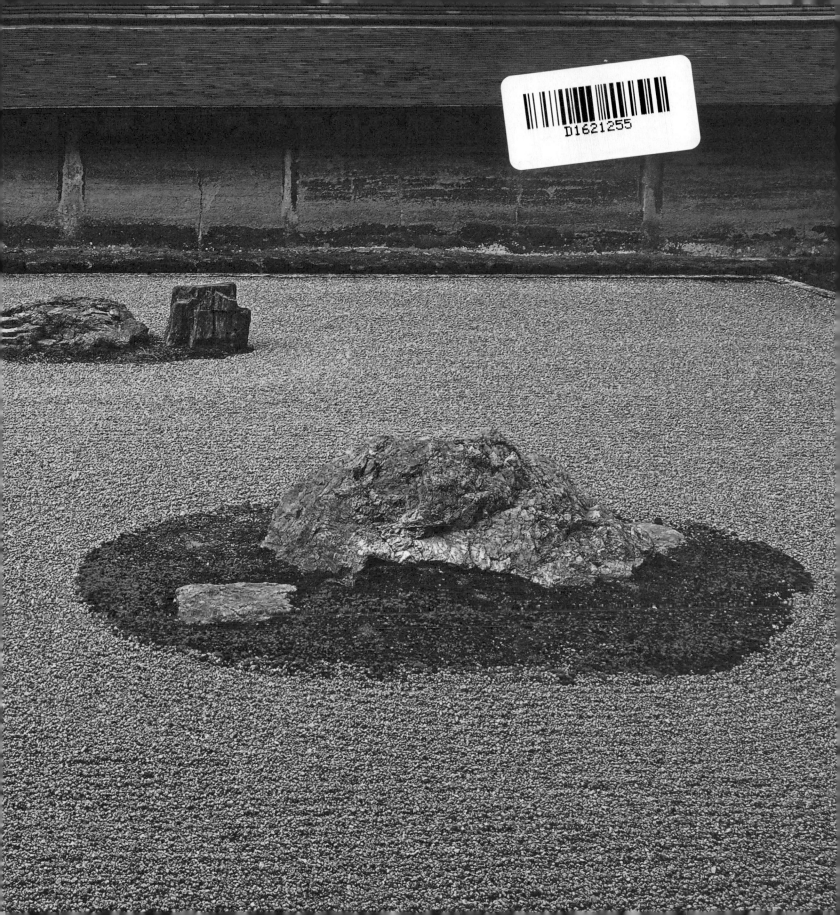

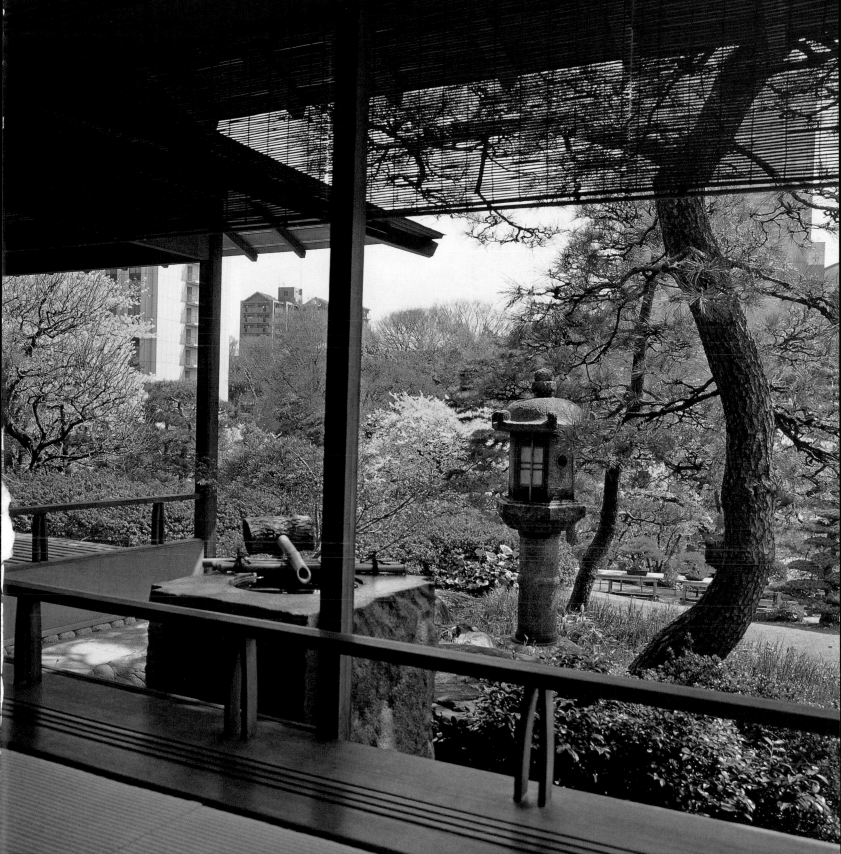

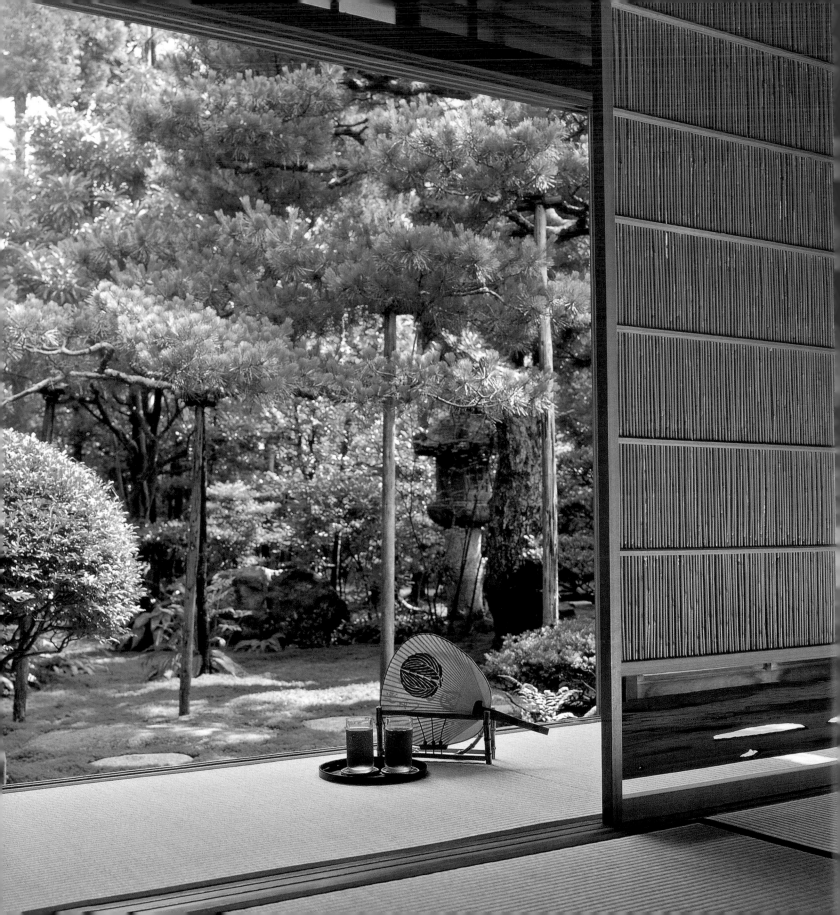

JAPANESE gardens

Tranquility

Simplicity

Harmony

Geeta K. Mehta and Kimie Tada

Photography by Noboru Murata

TUTTLE Publishing

Tokyo | Rutland, Vermont | Singapore

Published by Tuttle Publishing, an imprint of Periplus Editions (HK) Ltd.

www.tuttlepublishing.com

Text copyright © 2008 Periplus Editions (HK) Ltd.
Photos copyright © Noboru Murata
Project Coordinator: Kaoru Murata

Library of Congress Cataloging-in-Publication Data

Mehta, Geeta K.
 Japanese gardens : tranquility, simplicity, harmony / Geeta K. Mehta
and Kimie Tada ; photography by Noboru Murata. -- 1st ed.
 207 p. : col. ill. ; 25 cm.
 ISBN 978-4-8053-0942-1 (hardcover)
 1. Gardens, Japanese. I. Tada, Kimie. II. Title.
 SB458.M44 2008
 712.0952--dc22
 2008027111
ISBN 978-4-8053-0942-1

Distributed by:
North America, Latin America and Europe
Tuttle Publishing
364 Innovation Drive
North Clarendon, VT 05759-9436 U.S.A.
Tel: 1 (802) 773-8930; Fax: 1 (802) 773-6993
info@tuttlepublishing.com
www.tuttlepublishing.com

Japan
Tuttle Publishing
Yaekari Building, 3rd Floor
5-4-12 Osaki; Shinagawa-ku; Tokyo 141 0032
Tel: (81) 3 5437-0171; Fax: (81) 3 5437-0755
sales@tuttle.co.jp
www.tuttle.co.jp

Asia Pacific
Berkeley Books Pte Ltd
61 Tai Seng Avenue
#02-12, Singapore 534167
Tel: (65) 6280-1330; Fax: (65) 6280 6290
inquiries@periplus.com.sg
www.periplus.com

Printed in Hong Kong

20 19 18 17 16 8 7 6 1607EP

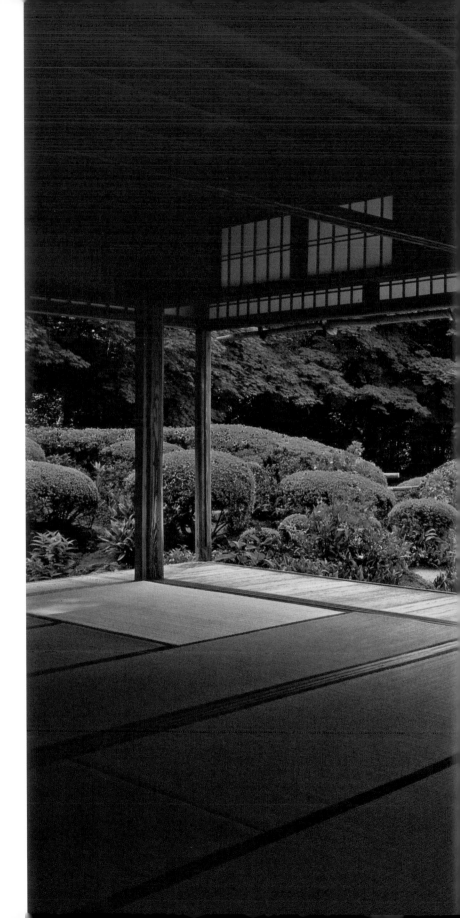

PREVIOUS PAGE An *engawa* porch at the Ishikawa International Salon
unites the interior of the house with the garden.

RIGHT This view at Shisen-do includes raked sand in the foreground,
clipped azaleas in the mid-ground, and large trees in the background.

NEXT PAGE Elements often found near the pond in a Japanese garden
include a *yukimi-doro* lantern, iris flowers, and a half moon bridge.

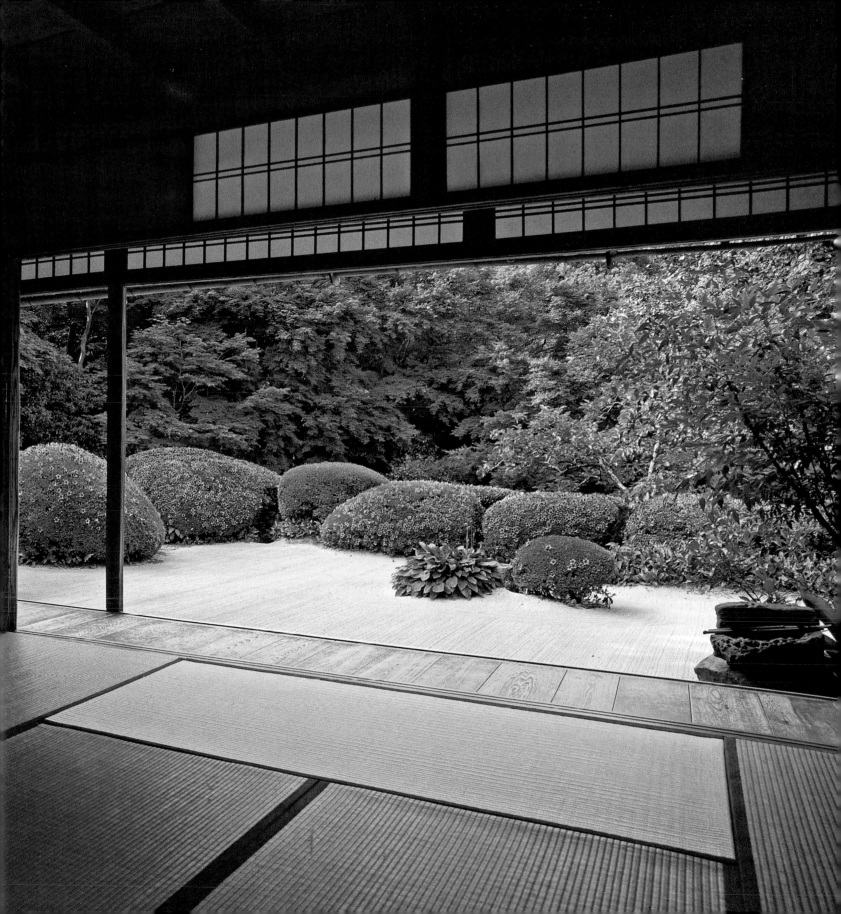

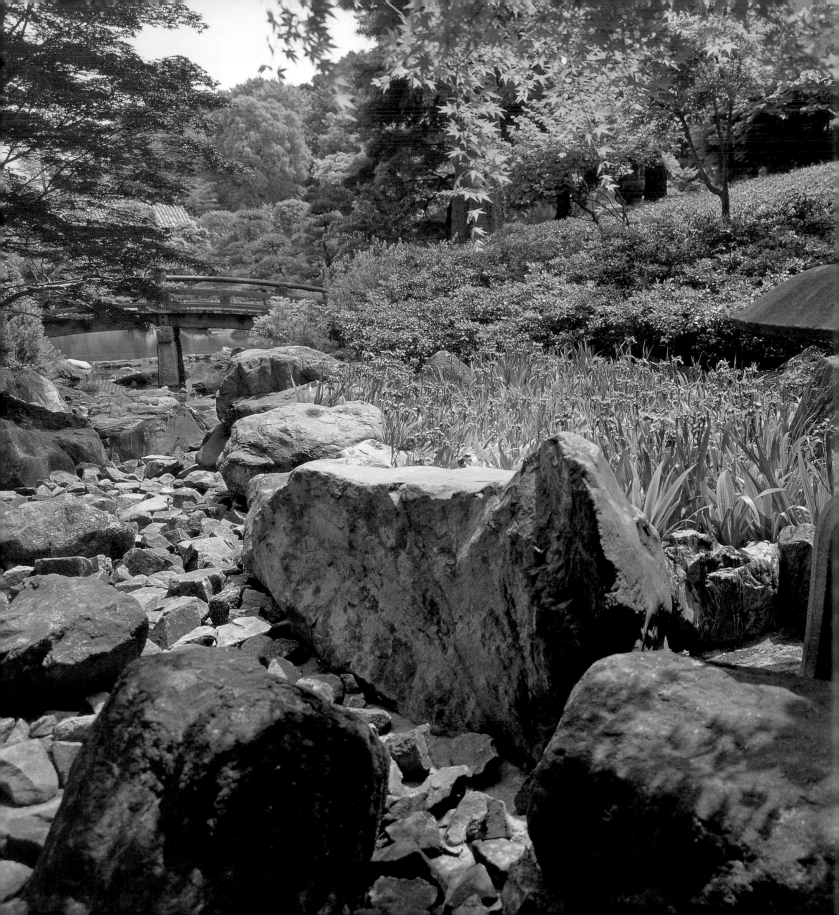

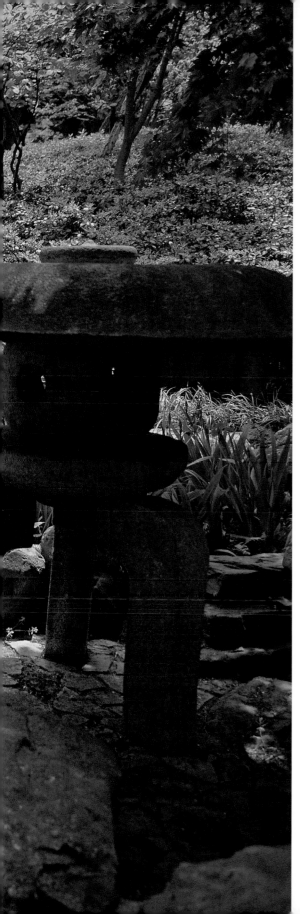

contents

Gentle Acts of Nature, Time and Man

Between dreamtime and time,
Beyond time and thought, the fresh of the morning,
A morning of the afternoon, a morning of the evening,
A morning of life, a sparkling dewdrop,
A garden of the soul, a garden in the soul,
A garden

Gentle acts of nature, time and me
Woven in beauty, a soul nurtured
A hoe, a shear, a seed, held for now
In my transparent hands, then simply let go
From me the past, to me the future
A garden

—Geeta K. Mehta

A characteristic feature of Japanese gardens is their close relationship to architecture. Each element is designed keeping the others in mind. Simply sliding away walls made of *shoji* doors can combine the interior and exterior spaces. Views of the garden are a major consideration in situating the buildings on the site.

At their best, gardens are reminders of our own divinity. A beautiful garden resonates into the depths of our soul, fresh as the early morning any time we care to be fully present in it. Once it is internalized, you can return to such a garden many times, and be surrounded with a fresh, nurturing energy. How does one create and care for such a garden? This is the central question that the best Japanese gardeners have been persistent in asking and answering.

The authors of this book embarked on a beautiful journey to understand the Japanese garden. We looked at enchanting gardens where the efforts of man, nature and time complement each other, and we saw many more gardens of exquisite beauty than fit into this book. Many of these have evolved well beyond their original concept, so that the designers would scarcely recognize them now. A good example is the "moss garden" of Saiho-ji in Kyoto, where moss was not even a part of the original design, but has grown over hundreds of years, and now defines the garden.

While human ingenuity and geometric perfection inform most other garden traditions, Japanese gardens are different. Most gardens around the world are hierarchical, arranged around a building—which is often the main reason for the garden's existence. In Japan, it is the other way around. In the best Japanese gardens, tea huts and other buildings are tucked to one side of the garden so as to be as unobtrusive as possible. It is said that aristocrats of the Heian period located their gardens on a site first, and then constructed villas in the space left over.

Japanese gardens are very different from Chinese gardens, to which they nevertheless owe a large debt. Things Chinese were

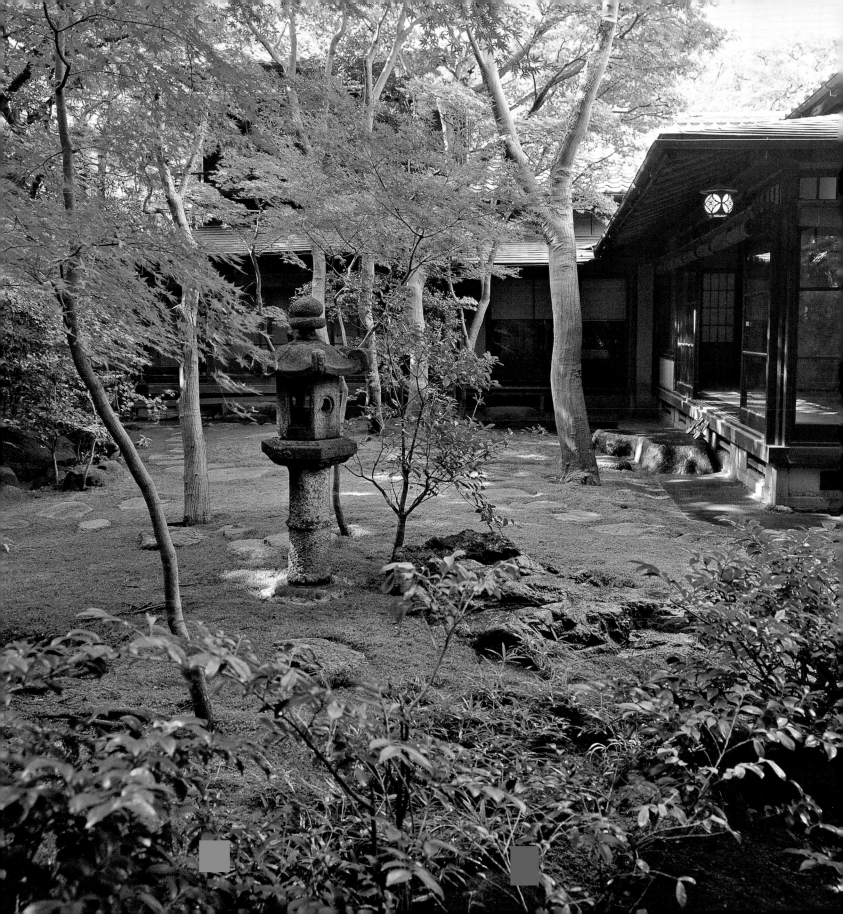

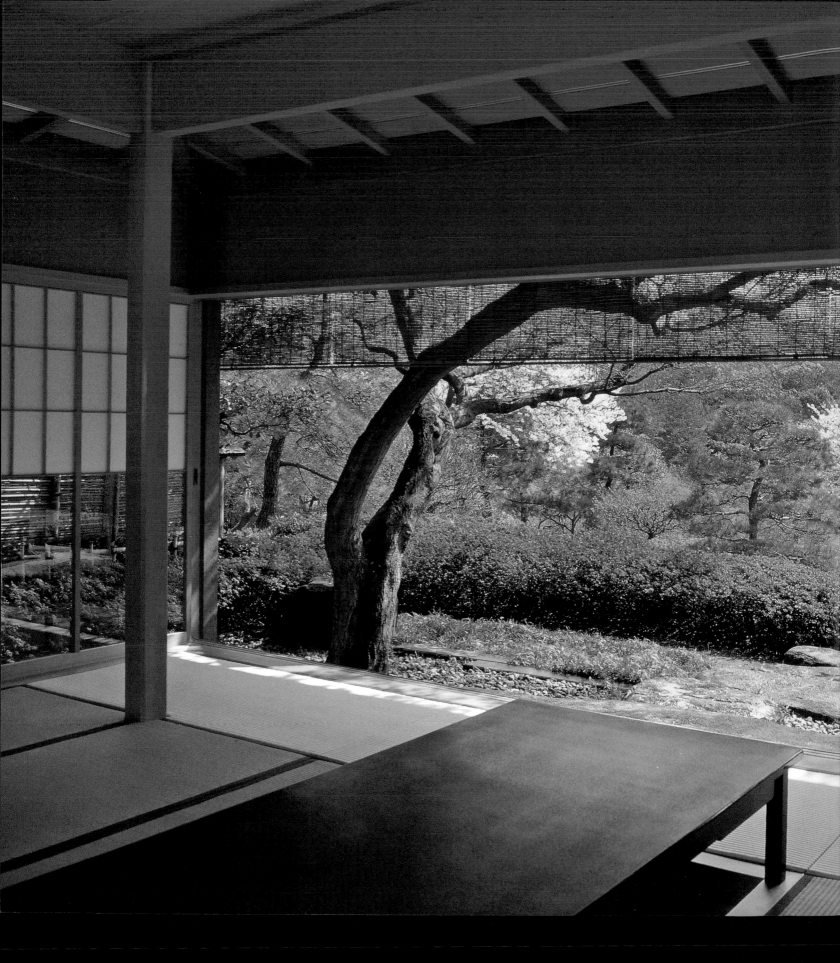

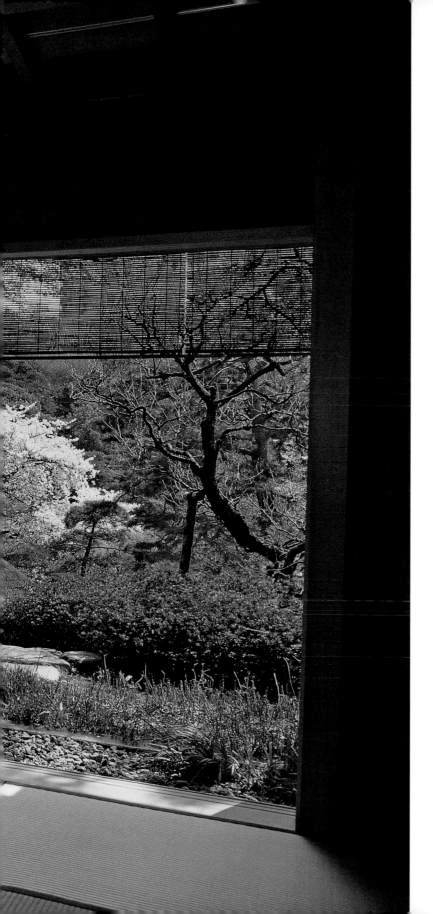

revered in Japan prior to the Meiji period. Yet while some coveted plant materials used in Japanese gardens today may be traced back to China, the essence of the Japanese garden harks back to Japan's pre-Buddhist roots where nature was deeply understood and held sacred. Every stone was believed to have a soul then, and the best gardeners then as now sought to understand and set each stone to express its soul. Trees are pruned back to their essence, and the leaves of autumn are prized. Plants that articulate the beauty of seasonal changes are carefully selected and situated to highlight the rhythms of nature.

Japanese gardens may be classified broadly into two groups: those meant to be experienced by entering and walking in them, and "visual gardens" meant to be experienced mainly with the eyes and the mind. The former category includes stroll gardens, Pure Land Jodo gardens, and tea gardens. Visual gardens were designed for contemplation and meditation and include the *karesansui* or dry-mountain-water gardens, and *naka niwa* interior courtyard gardens. Visual gardens are usually viewed from one side only, from inside a *shin*-style room, and are composed like three-dimensional paintings depicting an ideal landscape or a complex philosophical concept. One of the best examples of this is the abbot's rock garden at Ryoan-ji temple (page 54).

A Brief History of the Japanese Garden

The earliest Japanese gardens, known as *niwa*, were sacred natural objects or places such as trees, mountains or rocks with unusual or extraordinary shapes. Mountains and rocks that rose straight up from the plains were thought to possess sacred qualities or ominous power. Groupings of natural rocks were frequently worshipped as *iwasaka* or *iwakura*, places where gods or sacred spirits descended or lived. White sand or rope ties were often used to demarcate such areas.

Shinto, the native pre-Buddhist religion of Japan, focused on nature and ancestor worship. From these early developments, with

The entire *shoji* wall has been slid away to unite this formal room with the garden outside, alive with the glory of spring. The delicate bamboo *sudare* screens shade the room from excessive sun.

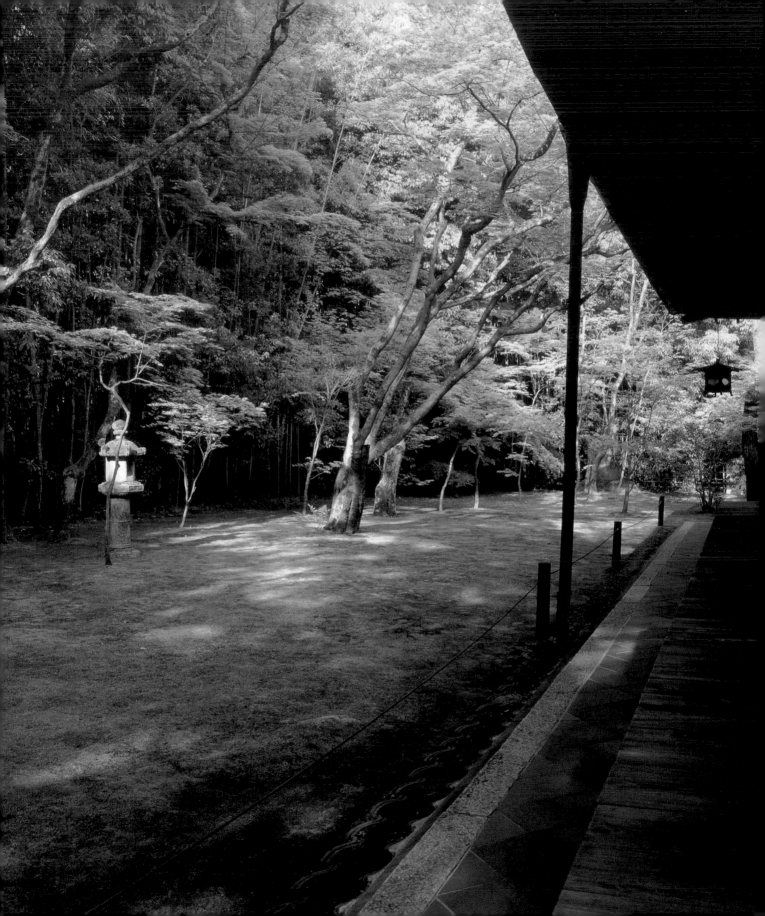

added influences from Korea and China, the Japanese developed the religious and aristocratic gardens of the Yamato period in the sixth century A.D. Japanese texts from this period mention these early gardens although no examples remain. Archeological records at Nara suggest that such gardens had a pond with one or more islands in the middle. Some scholars believe that these gardens represented seascapes interspersed with islands that early migrants may have seen on arriving at the Yamato plains by boat. It is possible that women designed these early pre-Buddhist gardens. Shinto priestesses and shamans in early Japan are likely to have played a key role in the establishment of such sacred places. The role of women in garden design, as well as in Japan in general, appears to have declined with the arrival of Buddhism in the Asuka period (second half of the sixth century) and Nara period (710–794).

Known gardens from the Asuka and Nara periods express Buddhist and Taoist visions of the sacred world. Emissaries who brought Buddhism to Japan added continental elements such as bridges to the repertoire of Japanese designers. During the Heian period (794–1192) aristocratic mansions with gardens in the *shinden-zukuri* style modeled after Chinese gardens became popular. In this style, a garden was created on the south side of a villa and included a water channel or *yarimizu* that flowed into a pond at the center of the garden.

Gardens were constructed on a larger scale during the late Heian period, imitating more variegated landscapes with artificial hills, ponds and streams. A small hill in a pond was likened to Shumisen, the abode of Buddhist deities in India. Formal receptions called "water poetry ceremonies" or *kyokusui no utage* were introduced, where courtiers composed poetry and floated cups of rice wine to each other along a stream winding through the garden. In a game popular at that time, a guest had to drink rice wine as a penalty if he could not finish composing a poem before the sake-filled cup reached him. Garden streams were linked to other water features such as waterfalls and large ponds for boating. Areas in between buildings were filled with sand, which aided drainage control.

Besides entertainment, these gardens were used for contemplative strolling, chanting Buddhist sutra texts, and as

places of initiation into the spiritual life. In this respect, Heian gardens are the forerunners of the stroll gardens of today. The best sources for information about these gardens are the texts of this time, such as the first Japanese novel, *The Tale of Genji*. Pure Land or Jodo Buddhism in the late Heian period referred to the Buddhist "Western Paradise" where ultimate unification with the Buddha occurred in heavenly eternity. Pure Land temple and aristocratic house gardens were thus created in the image of the Western Paradise. The villas in these gardens consisted of one-room living spaces connected to each other by open pavilions, and the entire arrangement was surrounded by a garden. The stream flowing through a Pure Land garden symbolically separated this earth and the afterlife. Islands and bridges were symbolic of the stages of life in passing from the world of earthly pleasures to that of eternal faith. The ponds were often constructed in the shape of 心, the character for heart or *kokoro*.

Gardens in the later Heian period usually included an Amitabha Buddha hall and a pond. Byodo-in in the town of Uji near Kyoto, Jyoruri in Kyoto and Motsu-ji in Hiraizumi in Iwate Prefecture are examples of this advanced style. Taoist and Onmyodo (animistic) beliefs influenced the aristocratic social life of this period, so gardens followed the theme of *shijinsō*, the ideal composition according to Taoism where directional gods are located in appropriate places to invoke good luck. This system held that hills or mountains should be in the north, rivers should be in the east, ponds in the south, and roads in the west.

The oldest Japanese garden design manual, Toshitsuna Tachibana's *Sakuteiki* ("The Art of Setting Stones"), was published during the late Heian period. This book documents construction methods used in Shinden gardens and mentions techniques for the allotment of land, arrangement of stones and artificial waterfalls, drainage and plantings. It is a compilation of rules that were codified so that designers with less well-developed sensibilities could create a successful garden. The purpose of the ideal garden, according to this treatise, is to evoke nature in its

Japanese gardens do not rely on bright flowers or exotic plants for their beauty, focusing instead on the simplicity of trees, shrubs and moss.

primal form. Stones must be carefully chosen and arranged, since their composition will influence whether they bring good or bad luck. It was apparently partly due to such beliefs that symmetry was avoided. The *Sakuteiki* suggests that "water should flow east, then south, and finally to the west." Its rules about setting rocks include suggestions that "there should be more horizontal than vertical stones in a composition; and a stone that appears to be running away should be accompanied by chasing stones; and the leaning stone should be accompanied by supporting stones."

A radically different concept of garden design emerged during the subsequent Kamakura (1185–1333) and Nanbokucho (1333–1392) periods. Zen temples or monasteries gradually moved away from towns and up to the mountains. Priestly garden designers called *ishi-tate-so* or "rock-setting priests" created retreats for Buddhist meditation by arranging rocks in the forest. One of the most famous of these was Soseki Muso (1275–1351) who designed many gardens using sand, gravel and stones, with a reduced emphasis on natural vegetation.

The Muromachi period (1392–1466) is often called the "Golden Age" of Japanese gardens. Trends begun by Soseki Muso and others blossomed into *karesansui* gardens. These often depicted miniaturized landscapes of mountains, currents of running water, and riverbeds of sand and rocks. The *karesansui* gardens had meanings inspired by profound Zen concepts or Chinese brush paintings. Ideals such as "the strength to swim against the current" were depicted in specific rock formations. Other gardens were designed to "startle" the mind into a more spiritual state—acting like *koan* or cosmological riddles such as the famous "sound of one hand clapping" that were meant to trigger a higher consciousness. The sight of raked sand or rock compositions amidst abundant greenery in Kyoto is as mind-bending as an oasis in a desert.

By the middle Muromachi period, *ishi-tate-so* Zen gardener priests were creating gardens for the elite samurai warrior class in return for financial support for their temples. Artisans of the lower class, called *senzui kawaramono* ("mountain, water and riverbank men"), constructed gardens under the supervision of Zen monks. Examples of these dry-landscape gardens include Ryoan-ji (page 54) and Daisen-in in Kyoto. The great creative leap in minimalism, understatement and simplicity in the Japanese arts during this

period came from the convergence of two powerful forces: Zen Buddhism and Bushido (the "way of the warrior"). *Yasegaman no bunka*, or the "way of frugality," was another factor relevant to people who had to deal with a lack of material things and an often meager supply of food. Bushido teachings made the lack of possessions a poetic and heroic virtue by popularizing the concept that the very small and simple can represent the very large and great, and that the possession of worldly things is unnecessary. The powerful warrior class as well as wealthy merchants in this period embraced these principles and emerged as patrons of the Zen arts including Noh theater, tea ceremony and garden design.

During the Warring States period (1467–1573), two new garden types were added to the repertoire of garden designers. One sort popularized by warlords made use of rocks of unique shapes or vivid colors, and exotic plants such as cycads. The other type was tea ceremony gardens popularized by tea masters Shuko Murata, Sen no Rikyu and others. These gardens were embodiments of the philosophy of tea emphasizing simplicity, understatement, harmony, refinement, and control over one's ego. All these concepts are expressed in the term *wabi sabi*. The study of tea in Japan includes not only tea making but calligraphy, flower arrangement, architecture and garden design. Tea gardens have a *roji* or "dewy path" made of stepping stones leading up to the tea hut, stone lanterns for mood lighting, stone washbasins for visitors to purify themselves, and fences that enclose and separate the world of tea from the outer mundane world. The journey into a tea arbor along the stone *roji* path is akin to an initiation rite into the world of tea. Inside the tea garden, the hut and other garden elements emphasize rusticity and seek to merge with their natural surroundings.

In the Edo (Tokyo) period, garden designs from earlier periods continued to be practiced, and a synthesis of these hitherto different styles took place. Daimyos (hereditary lords) and warrior landlords constructed large *chisen* hybrid gardens. Enshu Kobori is

Stone lanterns are wrapped in straw to protect them from the freezing weather in Kanazawa. This is done so skillfully that such wrapped lanterns have become symbolic of Kanazawa gardens.

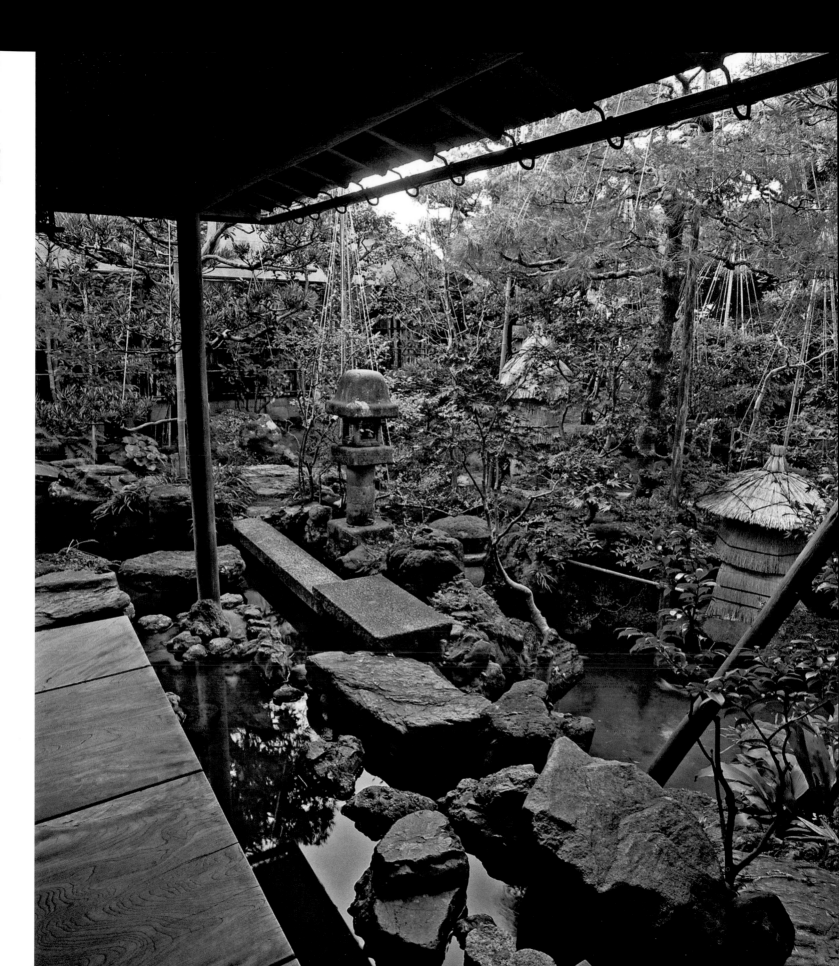

the best known designer of this period, and was responsible for one of the most famous examples of this genre, the Katsūra Rikyu garden for an imperial prince. Warlords created large "stroll gardens" inside their castles and mansions which usually had a pond or artificial hill at the center with a winding path around it so that visitors could walk from one scenic spot to another, experiencing constantly shifting scenery and viewing inspiring symbols. *Chisen* stroll gardens were also designed to be admired from inside the house. Examples of this style include Happo-en in Tokyo (page 168) and Koraku-en in Okayama. Unfortunately, many superb gardens belonging to the daimyos were destroyed during the battles leading up to the Meiji Restoration and soon afterwards.

The Edo period resulted in 250 years of uninterrupted peace. Businesses prospered, resulting in the emergence of wealthy merchants who constructed gardens within the more limited spaces in their townhouses. Tiny gardens inside long, narrow *machiya* merchant homes are called *naka niwa* or *tsubo niwa*. Such gardens were meant to be viewed from a porch or from inside the house. Openings around such gardens were sized and located to provide tantalizing glimpses of the gardens and to suggest interior spaces larger than they actually were. Since merchants were considered lower in social class than samurai, wealthy merchants were eager to express their refinement through the design of gardens and through patronage of the arts.

During the Meiji period, garden design veered sharply away from Japanese traditions under the government's policy of "uncompromising Westernization." Former daimyos lost their estates as the government implemented land reform. While some gardens were converted into public parks, others were repurchased and rebuilt by daimyos who had become powerful businessmen and politicians. A well-known garden aficionado of this period was the soldier/politician Aritomo Yamagata, who twice served as the prime minister of Japan. Professional garden designers of that time include the seventh-generation Jihei Ogawa, also known as Ueji. Ogawa is credited with modernizing traditions at gardens such as the International House of Japan in Tokyo (page 200).

Parks open to the public without discrimination exemplified the revolutionary new ideal of a classless society in Meiji-era Japan. The government at this time sought to modernize (read

"Westernize") Tokyo along the lines of the great capitals of the world, and invited British architect Josiah Conder and others to design Western-style buildings and gardens, as well as train Japanese architects in Western techniques and aesthetics. The German firm of Hermann Ende and Wilhelm Bochman was particularly prolific, and proposed a neo-Baroque plan of radial streets and public parks ringed by ministerial buildings for the area south and east of the Imperial Palace in Tokyo. Hibiya Park was the result of the many changes and compromises to these plans, and it became a major tourist attraction as people flocked to see this first Western-style park. Grassy lawns, rose gardens, flowerbeds, ponds with swans, and promenades for families to stroll in were novel attractions of the time. Planting techniques from England, Germany and France were studied and modified to suit Japanese conditions. These gardens were promoted as a symbol of Japan's modernity compared to the old gardens of the feudal Japan. A similar philosophy infused the gardens and parks of the pre- and postwar periods, when ambitious public works were undertaken. Yoyogi Park and Komazawa Park in Tokyo, built for the 1964 Olympics, are good examples of this effort. However, the sensibilities of the traditional garden continued to show through in the works of sculptors like Isamu Noguchi and compositions of the ikebana master Teshigahara. Mirei Shigemori is another star designer of this period, who flouted traditional rules while creating bold, modern designs and reinterpretations of traditional principles.

During the postwar Showa period, Japan was gripped by a frenzy of nation-building. Modernist methods of landscaping by looking at scale models from above became widespread, and the traditional concern for user experience and human scale were disregarded. Buildings were set on concrete platforms, and the traditional Japanese art of creating gardens around them gave way to vast concrete plazas around tall buildings. The landscape of Makuhari Messe, the new business center in Chiba, is a good example of this national phenomenon that is only now being recognized for its environmental damage. The many treeless plazas designed by Kenzo Tange Associates are another example. One can only imagine what the landscaping in these places would be like if traditional Japanese garden sensibilities had been applied instead.

Symbolism and Abstraction in Japanese Gardens

Since the time of the *Sakuteiki*, the ancient garden treatise, a good Japanese garden is said to have six attributes: seclusion, antiquity, spaciousness, human ingenuity, water, and scenic views. Other important concepts have been added to this list over time. While the skill to make the garden soulful must be inculcated over time, concepts that make the Japanese garden special are discussed in the paragraphs below.

Besides the many elements from Onmyodo, Buddhism and Taoism touched on above, there are other aspects of the Japanese garden that can deepen the experience of the visitor. For example, certain plants are imbued with meanings. Pines and evergreens indicate permanence or longevity, while bamboos symbolize truth and vigor. Although Zen priests in the Muromachi period spurned the "superstitious" beliefs expressed in the *Sakuteiki*, their gardens retain many abstract values related to the phenomena of nature or mind discussed in the *Sakuteiki* over a millennium earlier. For example, water has always been a symbol of purification. Whereas in pre-Zen gardens it may have symbolized the dragon god, in Zen gardens it symbolizes the cooling effect of rain in summer. White sand symbolizes the ocean while stones symbolize islands. Stone lanterns, and particularly the "hour jewel" atop lanterns, are a symbol of enlightenment. However looking for symbols in Japanese gardens is not always necessary and may even be counter-productive. Gardens like Ryoan-ji (page 54) were designed to free the mind from thought, though the temptation to associate meanings to this garden seems irresistible, and interpretations of it certainly abound.

No concept in Japanese design is more expressive and harder to explain than *wabi sabi*. This aesthetic and philosophical idea seeks to express the inherent beauty of things that are imperfect and impermanent. It derives from Buddhist teachings about the contemplation of imperfection, constant change due to passage of time, and the impermanence of all things. Words used to describe *wabi sabi* include simplicity, minimalism, understatement, rusticity and loneliness. Appreciation of the passage of time and of the impermanence of things is reflected in the choice of garden materials that are imperfect, old or worn out, and compositions that seek to recall the lonely depths of remote forests. Ornamen-

tation is avoided, and the essence of nature highlighted. Human vulnerability, fragility of existence, and the soft but inexorable passage of time are expressed through the deliberate use of old and worn materials. Taikan Yokoyama, the famous Japanese artist known for his views of Mount Fuji, commented that the Japanese worship imperfection. Driven by Zen ideals that seek to look beyond temporary physical perfection, Japanese gardens seek a "perfect imperfection" by, for example, raking a perfect geometric pattern and then sprinkling a few dead leaves over it. The spirit of *wabi sabi* is found equally in a large tea garden or a small garden in a tray.

The views in a Japanese garden are often conceived in terms of foreground, mid-ground and background. The background views often consist of a *shakkei*, or "borrowed scenery," that is outside the garden itself. Distant mountains, forests, plains, or sea visible from the garden are taken into account while laying out the garden. The mid-ground is designed to provide a sense of continuity between the distant background and the plants or objects in the immediate foreground, so as to make the *shakkei* an integral part of the garden, and greatly enhance the perception of space within it.

There may be places in the garden where the designer would like the visitor to pause and admire a particular view or an object with fresh eyes. This is achieved by placing a particularly uneven or large stone at that place in the garden path, so that the guest is most likely to look down before looking up again with fresh eyes at the object or view presented.

Japanese gardeners also use reduction in scale as a scenic technique. Stroll gardens often recreate and miniaturize natural views or scenic places of interest such as sacred mountains, rivers, or ponds. Reduction in scale is adopted in Zen gardens through the use of abstract symbols. Small mounds may represent large mountains, and wave patterns in the sand express miniaturized seas. Tea gardens, *naka niwa* interior gardens and bonsai are miniaturized and idealized versions of nature. Miniaturization is particularly useful in the limited spaces in urban gardens.

Seclusion and space are luxuries in Japan, and the best architecture and gardens strive to achieve them. Japanese gardens use the principle of "hide and seek" to create intimate spaces. Gardens are designed so that the visitors do not see all the com-

ponents of a garden at once. A building or a view may be high-lighted and revealed and then again hidden from view only to re-appear later, creating a sense of mystery and discovery referred to as *yugen* in Japanese.

Since natural landscapes are never symmetrical, Japanese gardens follow this rule in their representation of nature. Rare natural things such as Mount Fuji that are nearly symmetrical were worshipped as sacred objects in Shintoism, but symmetrical compositions were otherwise avoided in favor of asymmetrical designs with a dynamic balance. Symmetrical balance is considered too easy and static. This aspect of Japanese design sets it apart from nearly all other aesthetic traditions in the world, including Western and Chinese.

Heightened sensitivity to seasonal change is another important element of Japanese gardens, flower arrangements, tea ceremony and cooking. The colors and moods of the seasons are celebrated with enthusiasm. Kiyomori Taira, a powerful warlord from the Heian period, established a palace for each season: a flowery palace for spring, a watery palace for summer, a palace for moon viewing in fall, and a palace for snow viewing in winter. Chinese geomancy also promoted an emphasis on seasonality in gardens. According to *Shijinsō* theory, seasons relate to the four directions. Spring is to the east, summer to south, autumn to the west, winter to the north. Different plants thus represent these seasons in a garden.

The ideal for a Japanese gardener, architect, artist or craftsman of the past was to be as invisible in their creations as possible, and to create something that looked like it had always been there. This goal was accomplished by understanding materials deeply, and using them in a way that a person's hand would be least obvious. Once planted, gardens were meticulously maintained to imitate casual, natural growth. Good gardeners seek to get guidance from a stone as to where it wishes to be placed, while builders pray to the land in a ceremony called Jichinsai before starting construction. This is a ceremony of gently seeking permission from the land to build upon it, rather than the groundbreaking ceremony observed elsewhere. The ideal of the past was not to control nature, but coexist with it, with an understanding that nature will outlast the hand that shapes it.

Japanese gardens and buildings are designed to complement

each other. A uniquely Japanese space called *engawa* borders rooms facing a garden, and provides a transitional space that can be opened to the inside or outside, and made into a part of the garden depending upon the seasons. In summer, storm shutters and sliding screens are pushed away, and the *engawa* becomes a pleasant place to sit and enjoy the garden. Sliding away a few screens removes the barrier between inside and outside. The garden may come right into the tea hut, as shown in the example of Seison-kaku (page 176). When snow shutters are removed from the wide eaves of Mimou House (page 74) in summer, the garden, the *engawa* and the interior flow into each other and the sounds of birds chirping permeate every corner.

How do you pour eternity into a teacup? How do you evoke the feeling of uninterrupted deep forests and shaded valleys in the narrow confines of a warrior residence or an urban Zen temple? This was the real problem in historically crowded Japan, and the solutions to this constitute the real genius of Japanese garden design. Japan is a condensed country. Three-quarters of Japan is mountains, so the people have historically lived in the other one-quarter that is relatively easy to cultivate and build on, often in very close proximity to each other. This proximity has deeply influenced the society, arts, architecture and garden design in Japan. In their quest to bring the beauty of the outdoors to the more heavily-populated urban areas, Japanese gardeners studied and mimicked nature in great detail. This was not analytical study, but an empathetic journey to the essence of an old tree, a stone, or a bamboo fence.

Putting all that has been said above aside, we hope that the readers of this book will go into their next garden with a mind empty of thought. It is important to see what the garden is at any given moment, rather that what and why it was and what it can be. In the words of Dogen (1200–1253), "there are those who, attracted by grass, flowers, mountains and waters, flow into the Buddha Way."

It is customary to water *roji* stone paths, rock gardens and shrubs as a sign of welcome just before the arrival of guests. Some stones change their color when wet, and are selected for use in gardens for this reason.

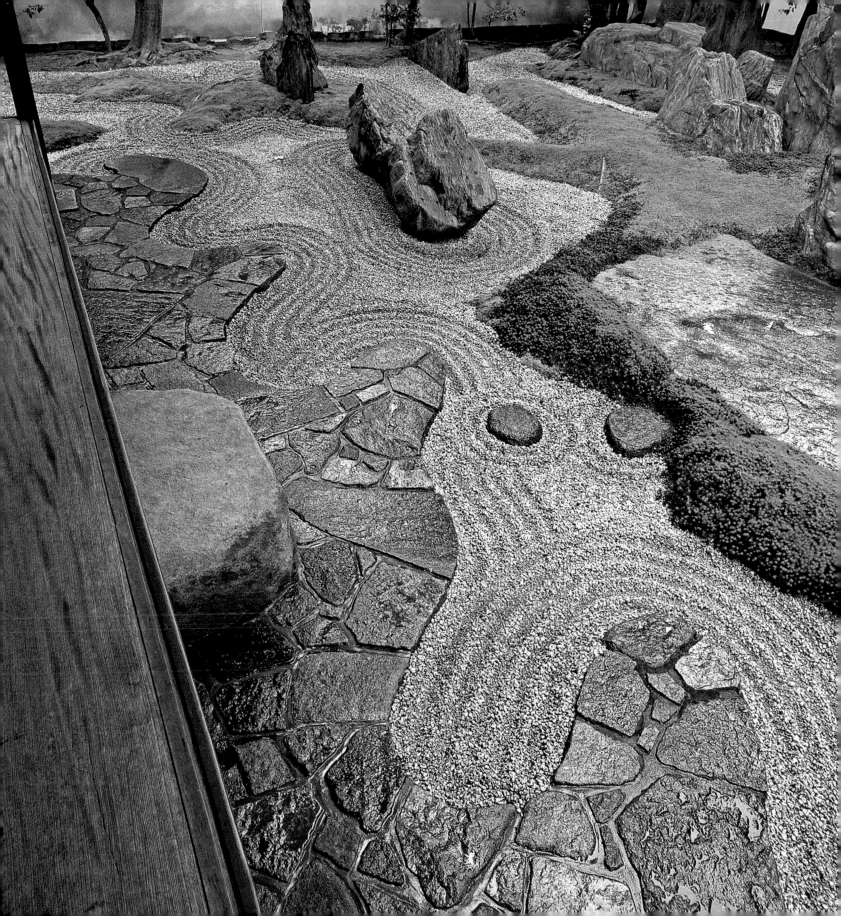

temple gardens

The sight of a gently curving tiled roof against a pine tree is a symbol of the beauty of Japan. In spite of the frenzy of real estate building and rebuilding, such sights still abound, and Japanese cities are dotted with Buddhist temples and Shinto shrines both large and small. Most of these have gardens, since the idea of nature worship has been an integral part of Japan's religious traditions.

The temples' garden designs have had defining influence on secular garden designs in the past, and that continues today. Several important concepts in Japanese gardens were perfected in temple gardens featured here, such as *karesansui* dry landscape gardens in Ryoan-ji, the trendsetting use of stones in Shinju-an, and innovative use of lanterns in Koto-in. Although many of these gardens have been reduced in size, they continue to provide a poignant way to understand how cutting edge modernity and age-old traditions live side by side in Japan.

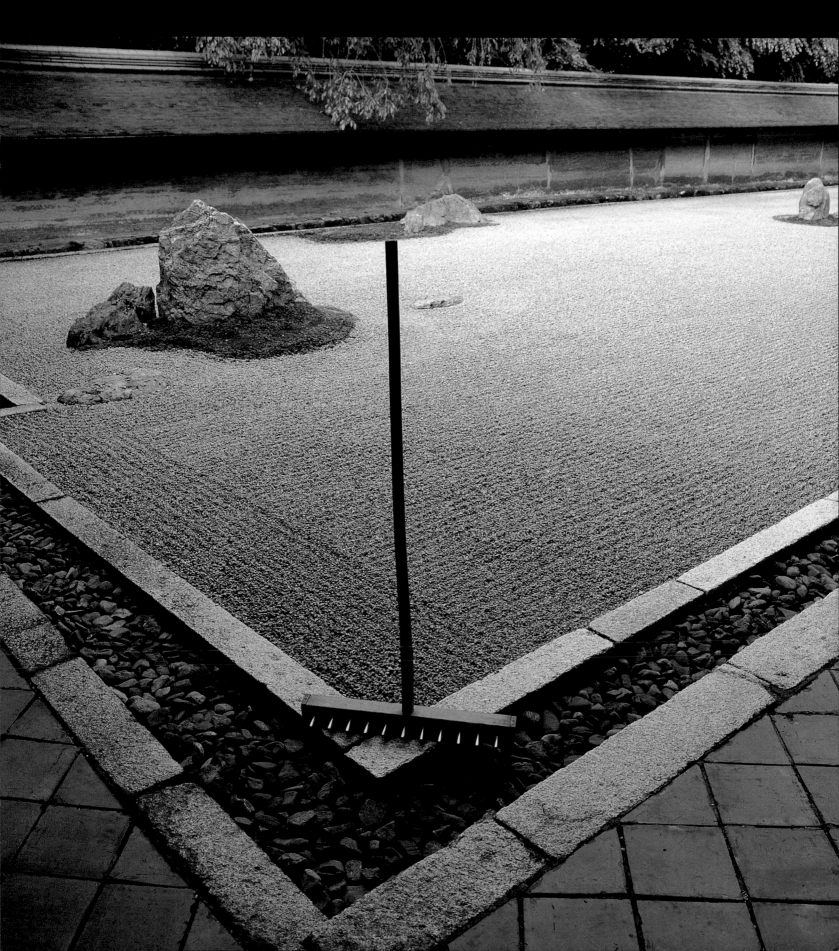

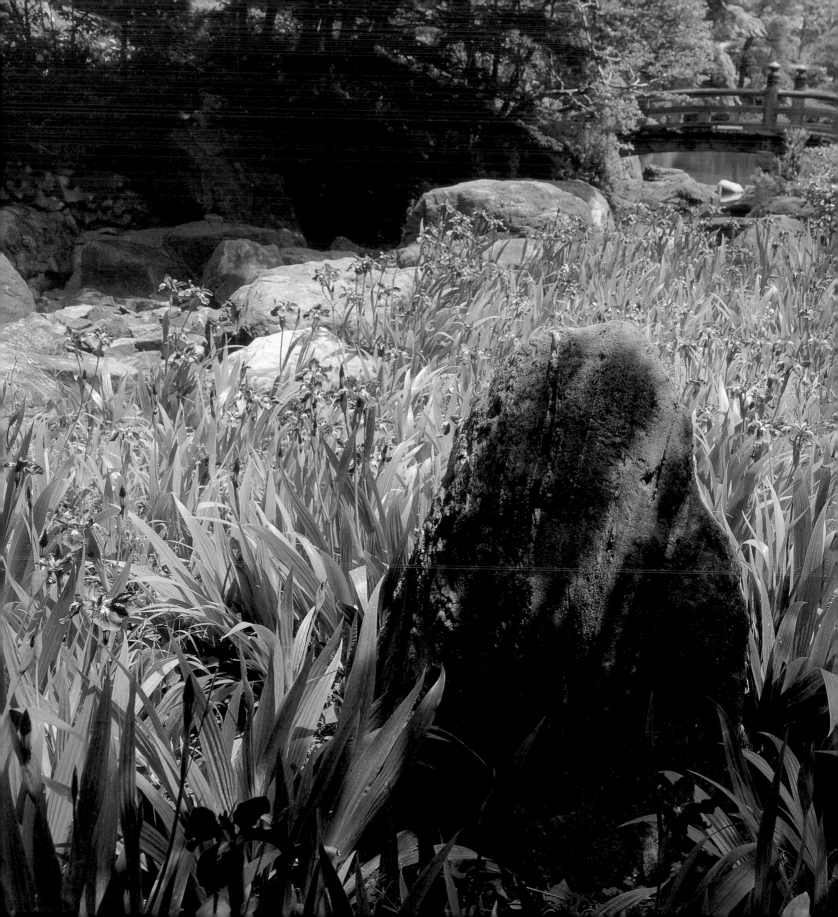

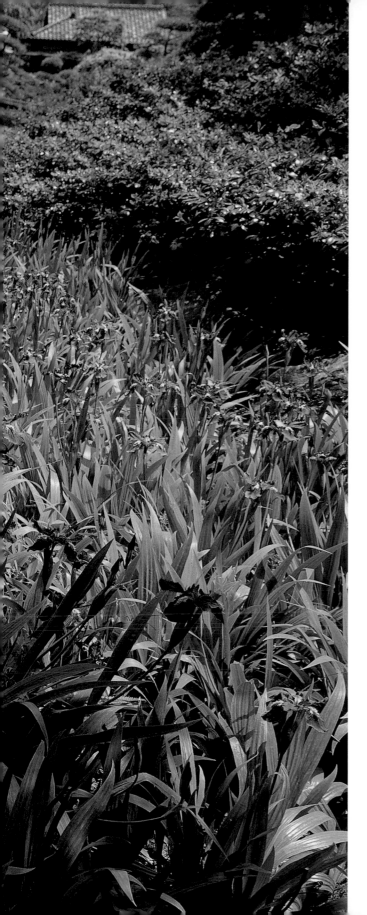

Ikegami Honmon-ji
Tokyo

Nichiren was one of the most influential and controversial Buddhist monks during the Kamakura period, and inspired the founding of several Lotus Sutra sects that are active to this day. He died at the home of a wealthy disciple named Munenaka Ikegami on October 13, 1282. Munenaka commemorated the master's death by donating 69,384 *tsubo* (about 231,000 square meters) of land located west of Tokyo, to match the number of letters in the Lotus Sutra text. It is on this land that the temple and garden of Ikegami Honmon-ji and the headquarters of the Nichiren sect stand today.

The temple complex has several buildings including the main gate, the main temple, a five storied pagoda, and a sutra repository. The garden called Syoto-in lies behind the main temple. This garden is said to have been designed by Enshu Kobori (1579–1647), a powerful feudal lord of the Edo period who was also a great tea master, an architect, a calligrapher and a gardener. He is often compared to Leonardo da Vinci for his many talents. Enshu's aesthetics and style of tea is called *kirei sabi*, and reflects the stoically simple and rustic concept of *wabi sabi*, combined with

The stone shapes selected for the various parts of this garden differ to appear as natural as possible. Whereas large jagged stones have been used at the tops of the hills, softer rounded stones have been used in the lower part of the garden near the water.

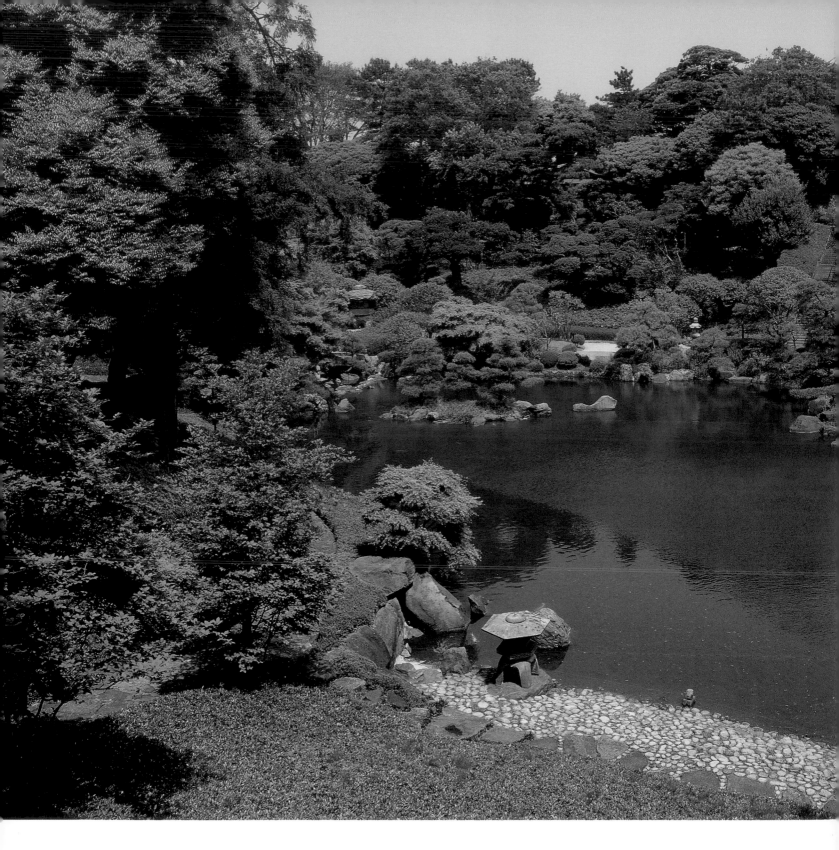

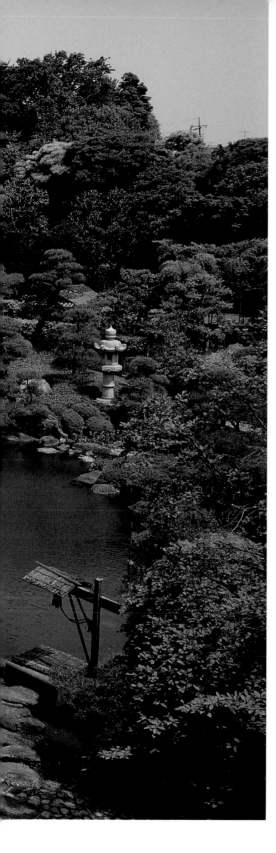

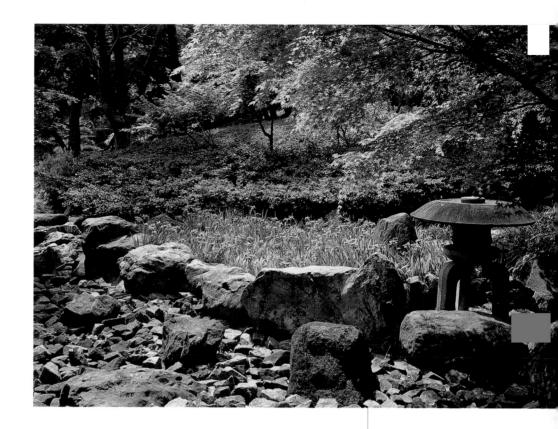

the grace and beauty reminiscent of the Heian aristocratic period.

This garden was the site of an important historic event when Honmon-ji temple became the new government headquarters at the end of the Edo period. It was in an arbor here that Kaisyu Katsu of the Edo forces surrendered the Edo castle to Takamori Saigo, the general of the victorious Meiji forces. Another historic relic buried in this garden is the set of brushes of the famed Meiji period painter Gahou Hashimoto, in a brush mound called Fude-zuka.

The present Syoto-in garden was repaired in 1991, but maintains the spirit of its original design. The 13,000-square-meter area of the garden includes a man-made mountain stream and a large pond. With the green hills as its background, the peaceful pond is home to many species of fish and birds. The garden is meant for strolling, as well as to present a picture-perfect view from the living room of the main temple. Its notable features include a *suhama*, a popular feature in Japanese gardens that mimics a white pebble beach jutting into the water. Other features include *toro*

ABOVE The Syoto-in garden features carefully placed ornamental objects like *toro* (stone lanterns).

OPPOSITE A good view of the entire garden can be seen from the building. The pond is fed by a man-made mountain stream. The miniaturized *suhama* pebble beach in the foreground seeks to mimic nature. The large stones were brought here from a mountain valley. The stone lantern called *yukimi doro*, seen on the left, is situated on the water's edge, as is usual at garden ponds.

(stone lanterns), a special fish-viewing platform made of a single stone, an island of turtle and crane stones symbolizing longevity, and a semicircular arched bridge at the mouth of the river.

The garden also has four tea houses of various sizes, and an arbor. All of its original buildings were destroyed during World War II. After the war the house of Dona Ono, a ceramicist of the Meiji and Showa periods, was moved here, while other buildings were rebuilt. These buildings and the garden can accommodate up to a thousand people for a tea ceremony.

The ravine and mountain stream behind the pond were designed to evoke unkempt nature in contrast to the manicured garden in front. This hilly area is remarkable for its large craggy rocks, and flowers planted randomly to simulate wild mountain flowers. Like a typical Japanese garden, this garden seeks to mimic natural landscape, and is quite successful in doing so; one can get the feeling of walking deep in the mountains, while still being in the middle of the bustling city of Tokyo.

BELOW LEFT This arbor named "Shogetsu Tei" is located in the western part of the garden. Tea ceremonies are held here using chairs rather than having guests sit on tatami mats as is customary.

BELOW Bamboos are a popular plant in Japanese gardens. Fresh bamboo shoots symbolize life force and vigor, since some varieties grow as fast as one notch a day.

RIGHT This lantern is a hybrid type. While its top stone has volutes of the Kasuga style, it is planted directly into the ground without a base stone, a feature typical of Oribe lanterns. The orb on top of the lantern symbolizes the jewel of Buddhist learning.

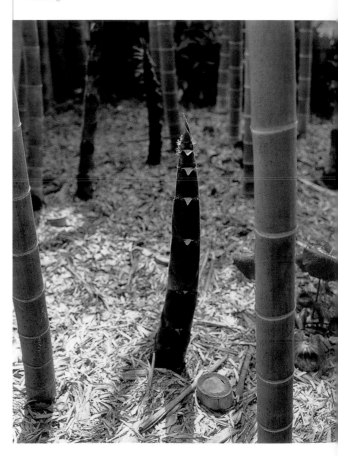

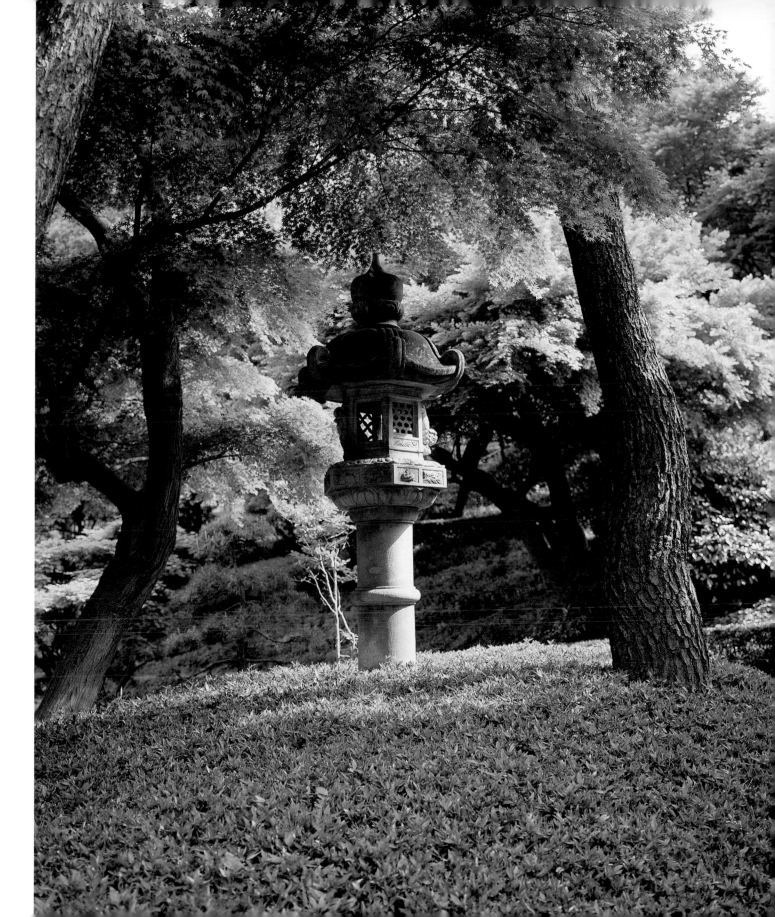

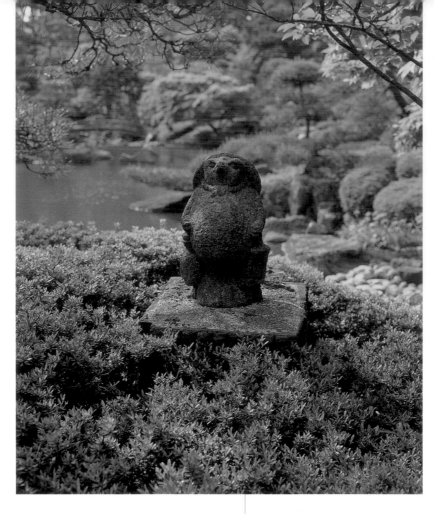

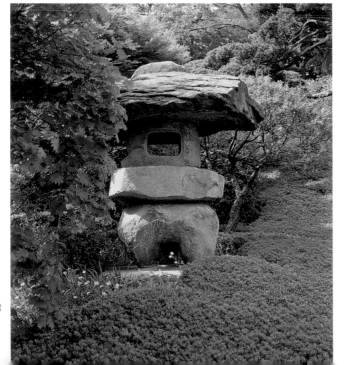

ABOVE This small raccoon dog sculpture is unusual in that it is made of stone whereas most popular raccoon garden ornaments are made of pottery.

LEFT There are 27 stone lanterns in this garden. The oldest one dates from the end of the Edo period.

RIGHT The garden path that runs along the pond has been designed so that one can enjoy a different view at every turn, adding to the feeling of expansiveness. The many crested iris (*syaga*) flowers here make this garden a popular destination in early summer.

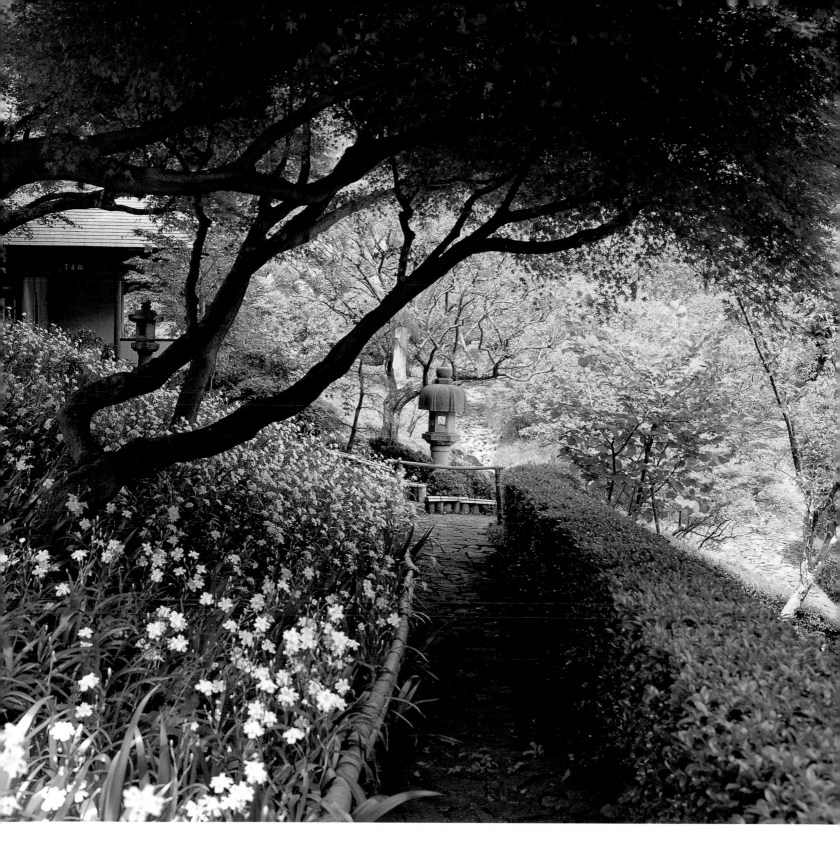

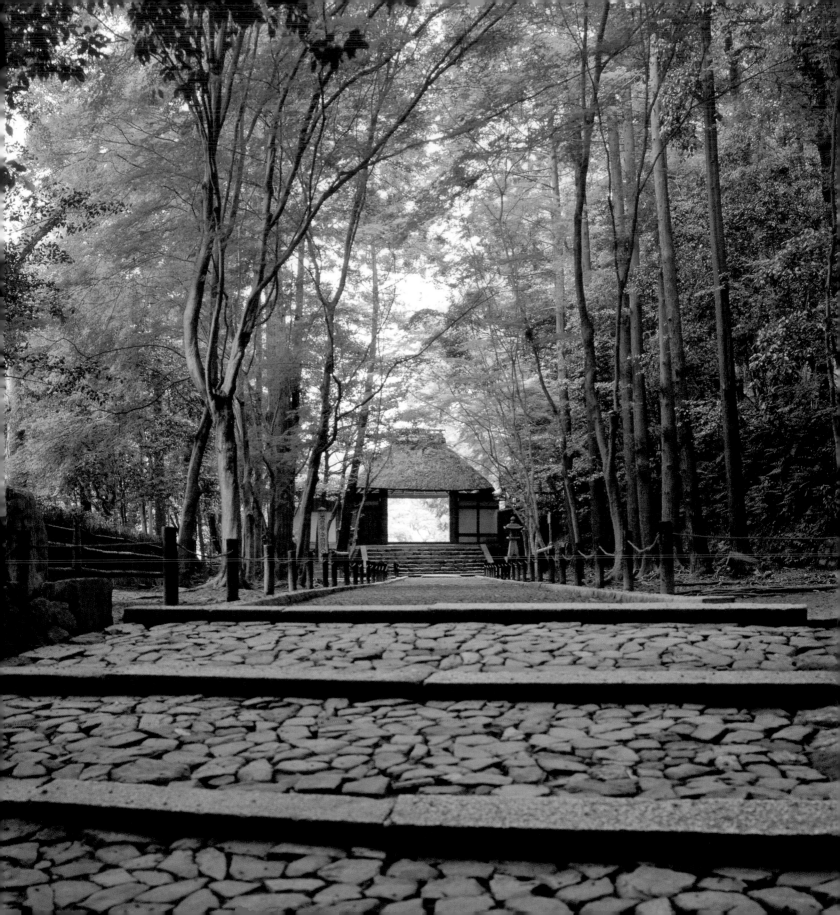

Honen-in
Kyoto

BELOW A lay monk from Honen-in is assigned to rework the sand mounds and the pattern on top every few weeks. The pattern is different every time, and left to the discretion of the assigned monk.

OPPOSITE The approach path culminates at the rustic thatched gate of Honen-in temple. The gate has been raised above the ground level so that one has to walk up and down a few steps to go past it. The higher elevation provides a good view of the raked pattern on the sand mounds as one enters the temple

Tucked away amidst the hills of eastern Kyoto not far from the Silver Pavilion, Honen-in is a good example of the serene and understated moss gardens one expects in Kyoto. The history of this temple began with the Buddhist patriarch Honen (1133–1212) and his two followers who performed twenty-four-hour-long *namu amida butsu* chanting meditation at this site. Honen was later exiled and his school declined until the abbot of Chion-in, a former pupil of Honen, founded this temple in 1680. Honen-in was formerly a Jodo sect temple, but has been an independent sect since 1953. This temple also houses the graves of important Japanese scholars such as the novelist Junichiro Tanizaki, historian Konan Naito, philosopher Shuzo Kuki, economist Hajime Kawakami, and artist Heihachiro Fukuda.

Located at the foot of Daimonji Mountain, part of the Hiei Mountain Range, the grounds of Honen-in hold a series of surprises for the visitor. Although it is near the center of Kyoto, many types of birds, squirrels, flying squirrels, raccoons and even foxes can be seen here. The higher ground where the graves are situated has the feeling of a dark forest even during the day.

The temple is approached by a long stone walkway lined on both sides with pasania, nettle, camphor, maple and bamboo trees. This walkway is loveliest during the fall season when the canopy of trees overhead turns a brilliant medley of colors. This path leads to the entrance gate that is raised above the level of the walkway

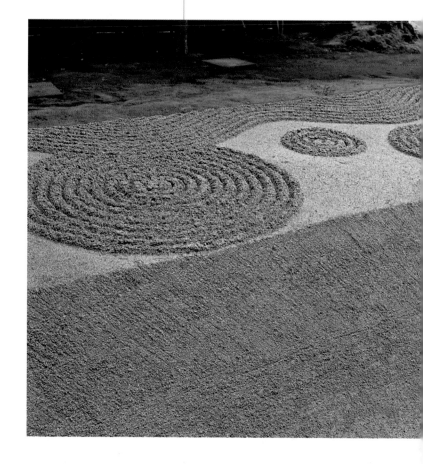

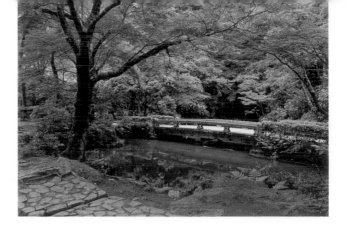

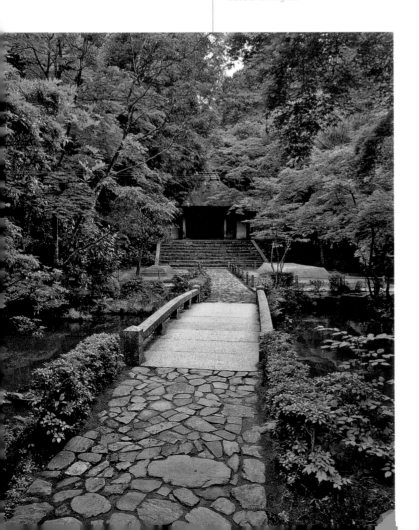

on either side, and is approached by a short flight of steps. This gate has a perfectly proportioned thatched roof with patches of moss that add to its majesty. On arriving at the top of the steps, one is struck by the unusual sight of two raised rectangular white sand mound gardens called *byakusadan*. The size and placement of these two mounds is part of the intrigue of this garden. Such surprises in Zen temples are designed to rid the mind of the constant clutter of thought, and offer the viewer a chance to rise above the mind. Since these sand mounds are also meant to evoke water and cleansing of body and soul before entering the sacred precincts of the temple, the designs on top of the mounds incorporate the motif of water in the form of ripples, waves, or the Chinese character for *water*. Every two weeks or so a young monk reworks these sand mounds early in the morning, finishing them up with a fresh raked design on top. The choice of design is left to the imagination of the monk assigned to the task, but the patterns are always abstract and restrained. The placement and asymmetrical size of these mounds is said to balance the asymmetrical size of the carp pond on either side of the bridge farther down the stone path, although this subtle idea is not easily apparent to a visitor. While the smaller sand mound on the right balances the smaller pond on the left of the bridge, the larger sand mound on the left is said to balance the larger pond and garden on the right of the bridge. The asymmetrical sizes and raked design of the two mounds are in line with the tradition in Japanese design that shuns symmetry and repetition.

The stone path from the entrance gate passes these two sand mounds and continues toward a bridge over a carp pond. A small waterfall on the far right side of the pond produces a pleasant sound, while the trees all around it give it a pleasantly dark feeling. The garden path continues on to the main hall built during the seventeenth century, and culminates at the statue of Amida Nyorai, the Bodhisattva of mercy.

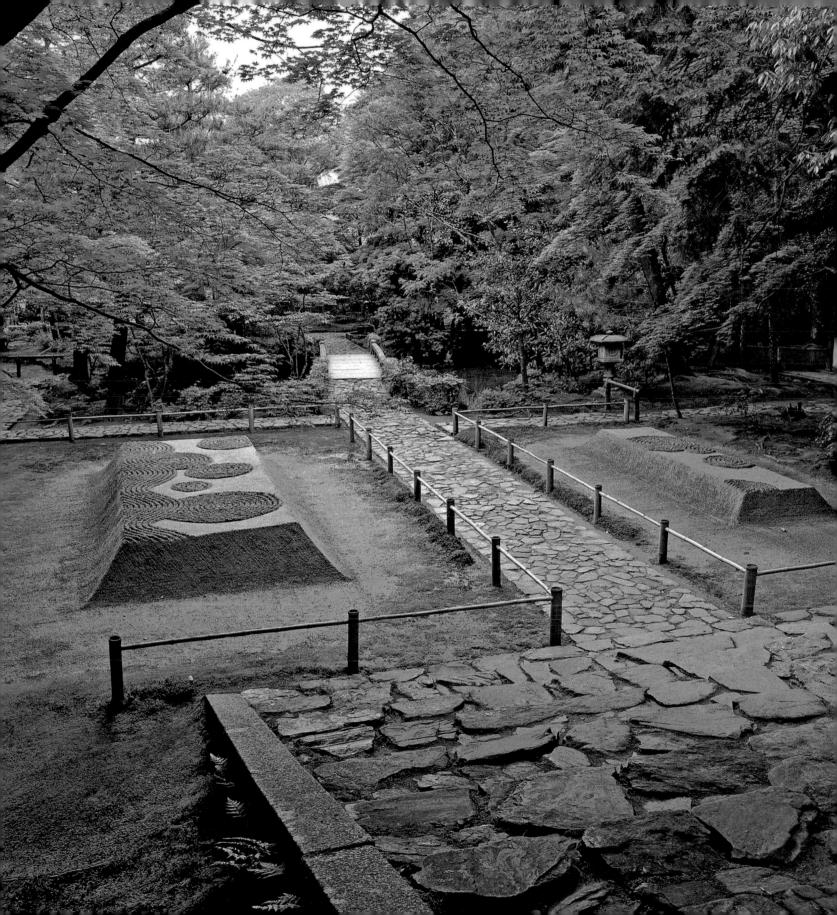

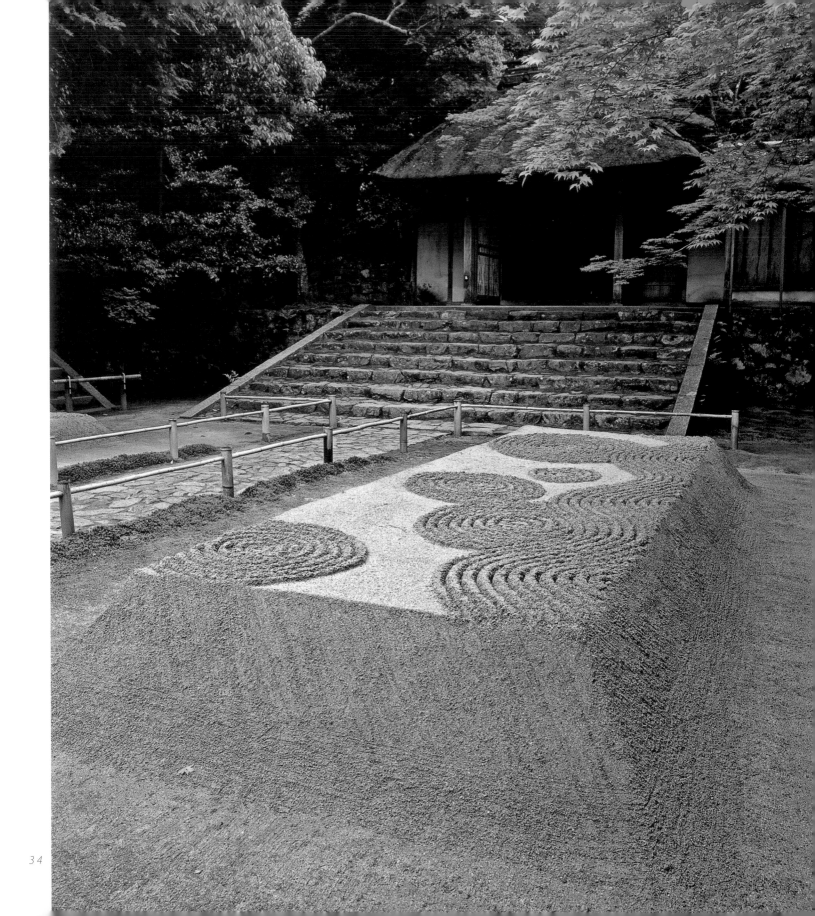

ABOVE AND RIGHT This stone water basin is made in the motif of the lotus flower. Lotus is the sacred flower of Buddhism since it grows in mud but is not sullied by it, thus symbolizing the possibility of being perfect in the imperfect world. Flowers have been arranged in the basin by a visitor.

LEFT Designs selected by the monks for the sand mounds are abstract, but often make a reference to the seasons.

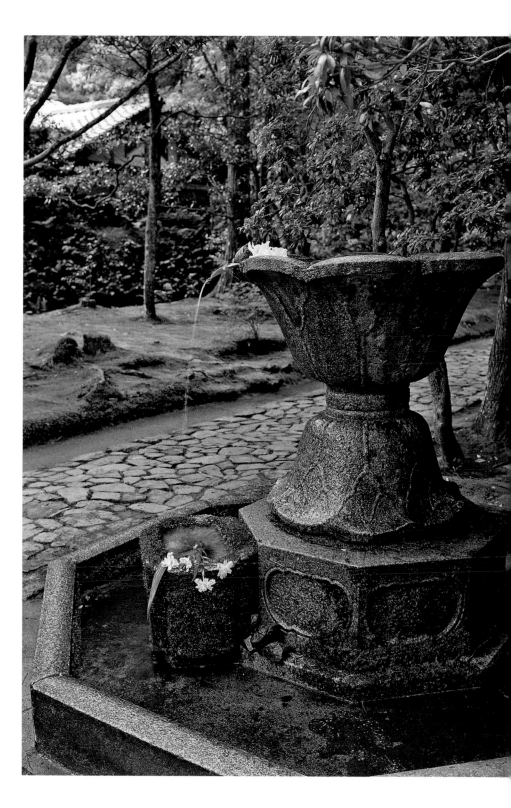

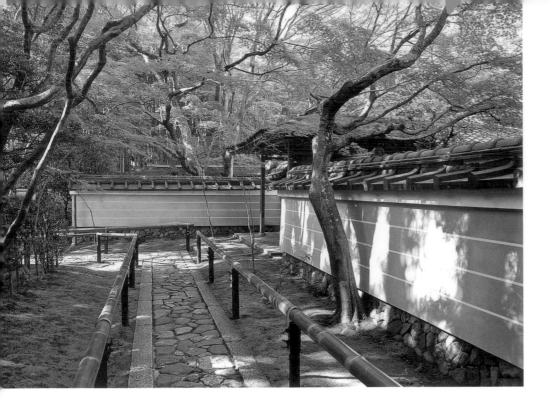

Koto-in
Kyoto

Koto-in is a small but exquisite sub-temple located in Daitokuji, a major Zen temple in Kyoto. Several such sub-temples in Daitokuji were built by wealthy merchants and warriors during the Azuchi-Momoyama and Edo periods. Koto-in was built in 1601 by the famous warrior Tadaoki Hosokawa (1563–1645) to pray for the repose of his deceased father. Besides serving the most powerful shoguns in Japanese history—Nobunaga Oda, Hideyoshi Toyotomi and Ieyasu Tokugawa— Hosokawa is also known for his prowess in tea ceremony and other cultural matters, including garden design.

The approach to Koto-in Temple is one of the unforgettable sights in Kyoto. After a visitor has entered the premises, the stone paved walkway turns a right angle to present a view of the long narrow path leading up to the main entrance. This path is lined with a simple low bamboo fence on both sides and moss beyond that. The thick carpet of moss absorbs sound and adds a feeling of quiet stillness to this place. Sunlight filters onto the path through a filigree-like canopy of maple trees that changes color with the seasons, from a fresh green in spring to the spectacular reds and oranges of autumn. While each one of these elements is ordinary in itself, at Koto-in they all come together in an extraordinary, enchanting experience.

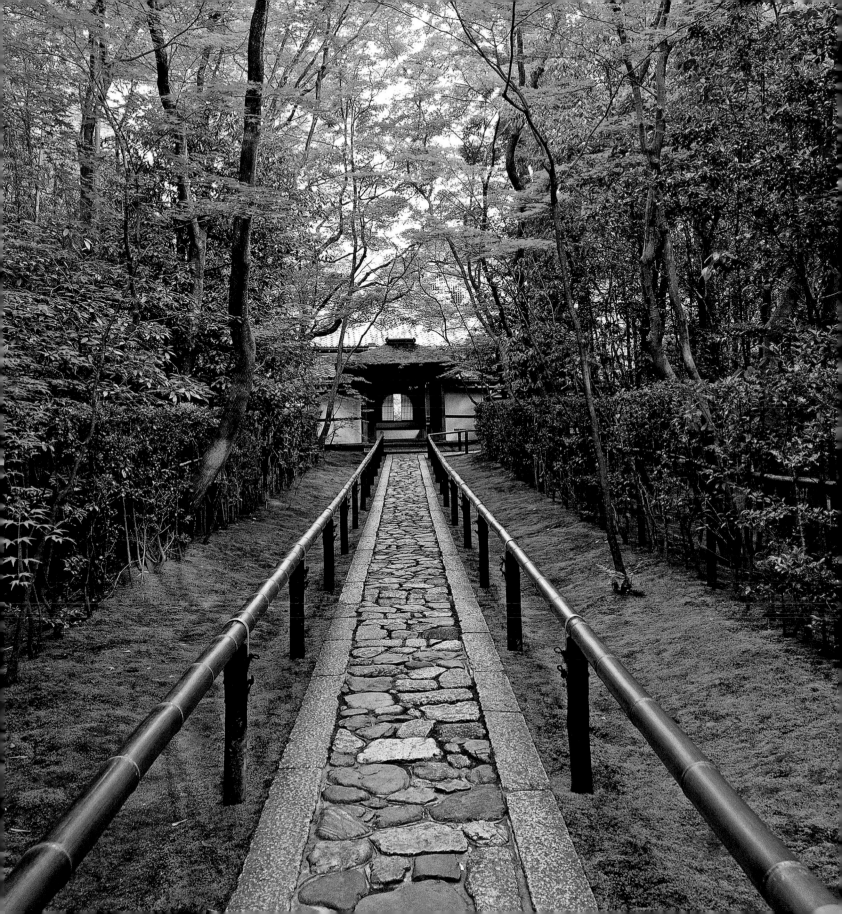

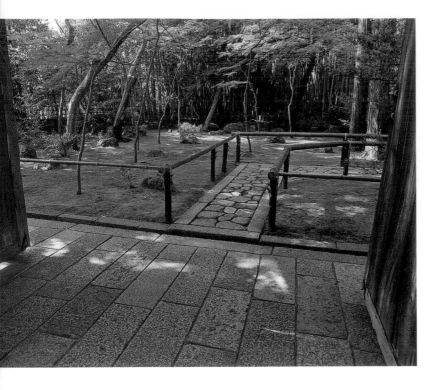

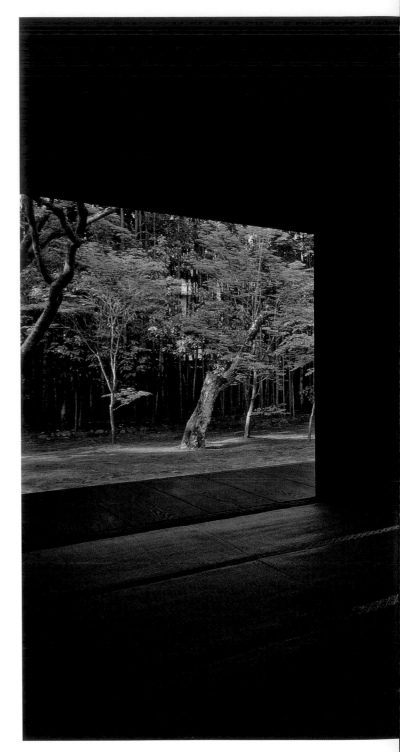

While some parts of the gardens in Koto-in have been designed as tea gardens to be entered and enjoyed, the south garden is meant to be viewed from inside the main drawing room. This *shoin* style room looks out toward the simple garden with a solitary lantern standing in the middle of a moss-covered foreground area. The background comprises maple trees and bamboo groves, making this garden a minimal but effective composition.

The tea gardens of Koto-in Temple contain two famous tea houses. One is known as Shoko-ken and is attributed to Hosokawa, while the other one called Horai was built in the Taisho period. This part of the garden includes typical features of tea-style gardens, including the *roji* stepping stone path, and washbasins or *tsukubai*. The most famous washbasin is said to have been made of the cornerstone of Imperial Castle in Korea, brought to Japan by the samurai Kiyomasa Kato during the Korean wars, and presented to Hosokawa. This washbasin is located several steps below the garden level, so that people using it to cleanse their hands and minds before entering the tea house are afforded an enhanced feeling of solitude.

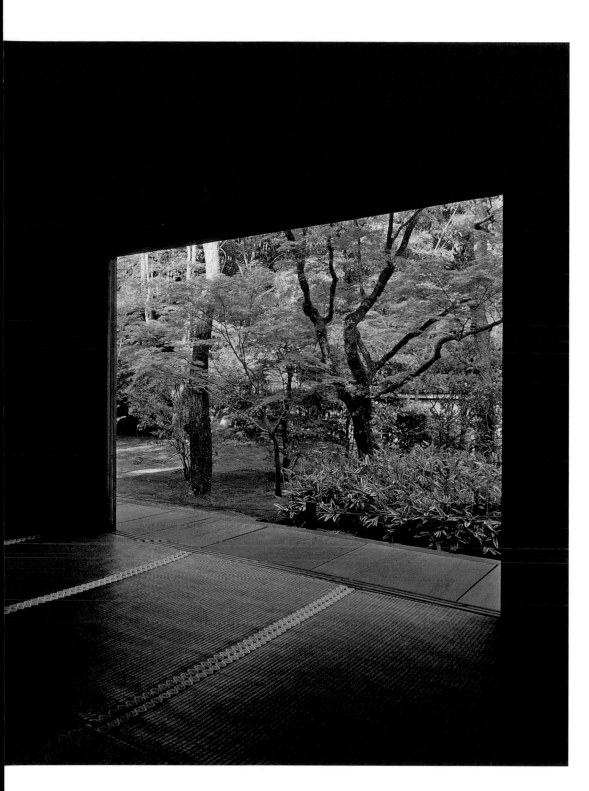

ABOVE AND FAR LEFT The detailing of the humble bamboo fence is typical of Japanese building aesthetics, where the joints are not hidden but instead exaggerated to become design elements. The essential qualities of the bamboo are expressed through such detailing.

LEFT This *shoin* room is said to have been part of the house of tea master Sen no Rikyu, and it was moved to Koto-in. The *fusuma* sliding doors and *shoji* paper screens in this room can be slid aside to present a beautiful view of the garden.

The solitary Kasuga style lantern has been boldly placed
in the middle of this garden. Such lanterns are six-sided,
have a voluted capstone, and are planted straight into
the ground without a base. The backdrop of this garden
is formed by maple trees and bamboo groves, making for
a minimal but effective composition. This garden remains
unchanged from its inception during the early Edo period.

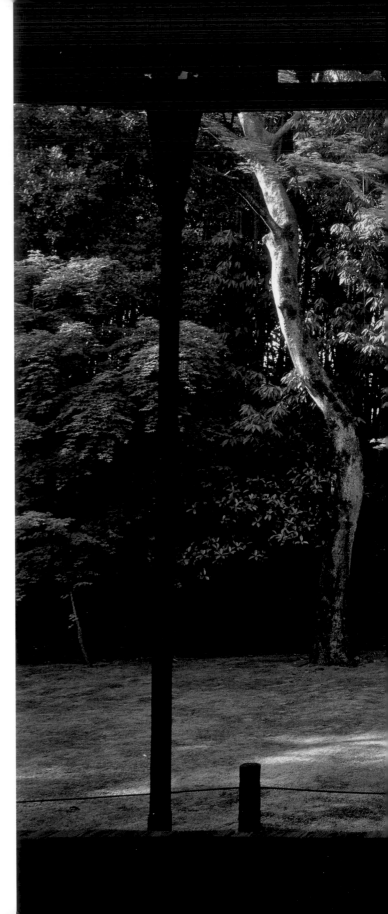

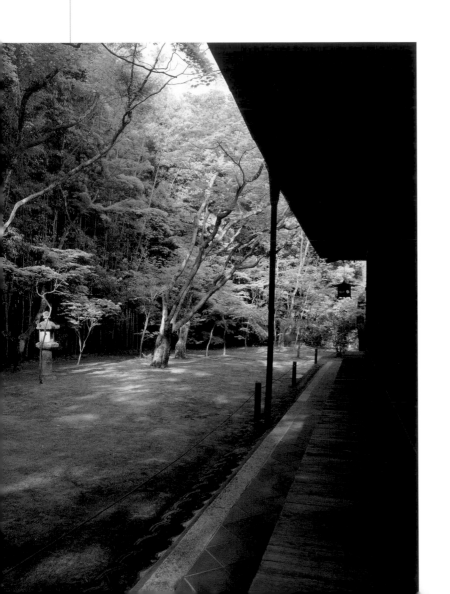

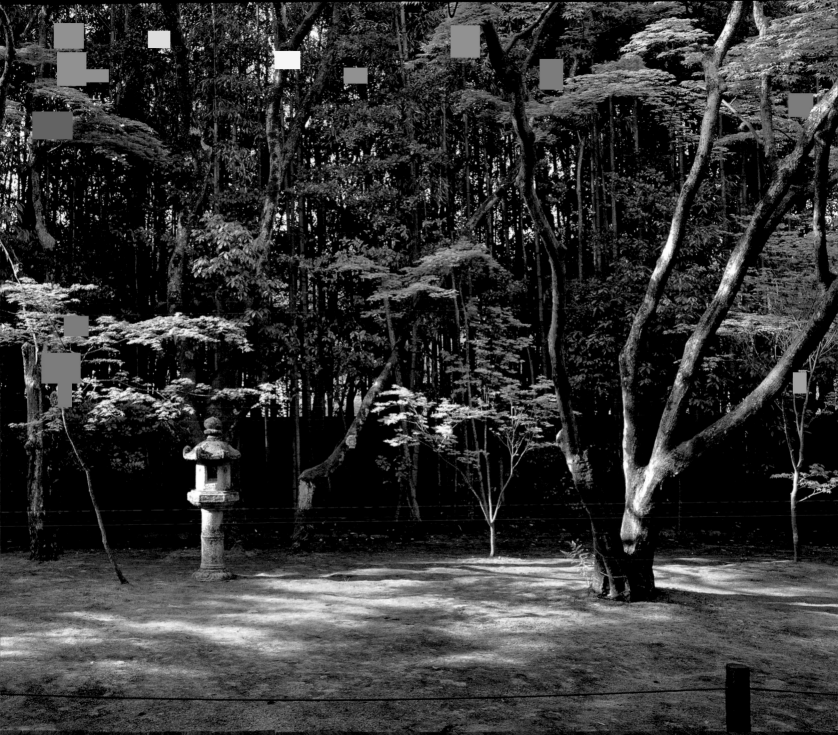

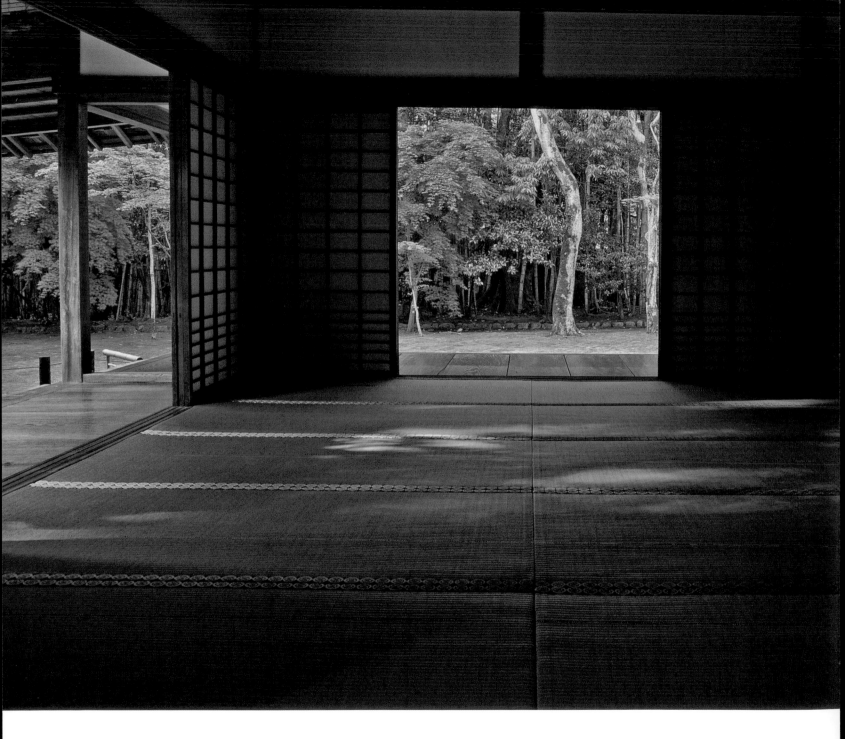

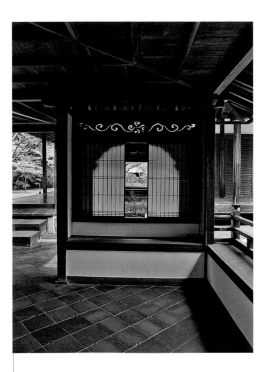

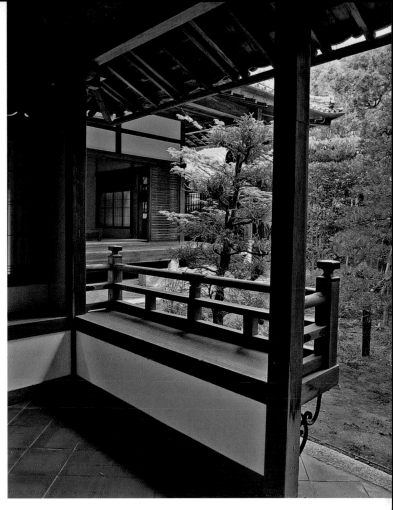

ABOVE LEFT AND RIGHT The cusped ogee arched window and elegant railings are typical of Zen style architecture.

LEFT The design of the garden and architecture are conceived in harmony with each other. The floor of the *engawa* porch outside is located at the same level as the floor inside, thus reinforcing the feeling of unity of the interior and the garden beyond.

Part of the garden at Koto-in has been screened off with a stone wall and shelters the graves of Tadaoki Hosokawa and his wife Gratia, a devout Catholic who continued to practice her religion even when Christianity was banned during the Edo period. A stone lantern that was the favorite of Tadaoki Hosokawa was selected for his gravestone. It is said that the famous tea master Sen no Rikyu had owned this old Kamakura period lantern which was coveted not only by Tadaoki Hosokawa, but also by the shogun, Hideyoshi Toyotomi. However, when the shogun ordered Rikyu to commit harakiri suicide for placing a wooden image in his own likeness in Daitokuji gate under which the shogun was to walk, Rikyu gave the lantern to his pupil Tadaoki as a farewell gift and a final act of defiance. The use of gravestones as garden decorations and vice versa has been popular since the Kamakura period when Muso Soseki used gravestones as garden ornaments spurning the Shinto superstitions about the impurity of death.

Shisen-do
Kyoto

The hills and valleys of the Higashiyama mountains in north-western Kyoto are known for the refined culture that blossomed here from the Muromachi period onwards. Located a short distance from Ginkaku-ji temple, Shisen-do is an exquisite example of this culture.

Live a sparing and diligent life.
Be sure to quench the fire before retiring.
Be sure to lock the door.
Don't resent waking up early.
Always have a clean house.

The wise sayings above, Zen-like in their simplicity, come from Jozan Ishikawa (1583–1672), the builder of the Shisen-do garden complex. A retainer of the Shogun Ieyasu Tokugawa, Ishikawa lost his samurai status due to a disagreement with the shogun after he had served with distinction in the siege of the Osaka Castle. He then took tonsure and retreated to Kyoto to study Chinese classics, tea, garden design, and poetry. Before settling down in Kyoto at the age of fifty-five, he had spent fourteen years in Hiroshima caring for his old mother. Once in Kyoto, he founded Shisen-do, as well as another garden at Shosei-en in Higashi Honganji. Ishikawa lived in Shisen-do as a bachelor till his death at the ripe old age of ninety.

RIGHT AND NEXT PAGES The formal drawing room in Shisen-do juts out into the garden, and can be completely opened on two sides. The wooden floor that borders around the tatami mats is part of the *engawa* corridor, a transitional space that can be integrated with the interior or the exterior depending upon the season.

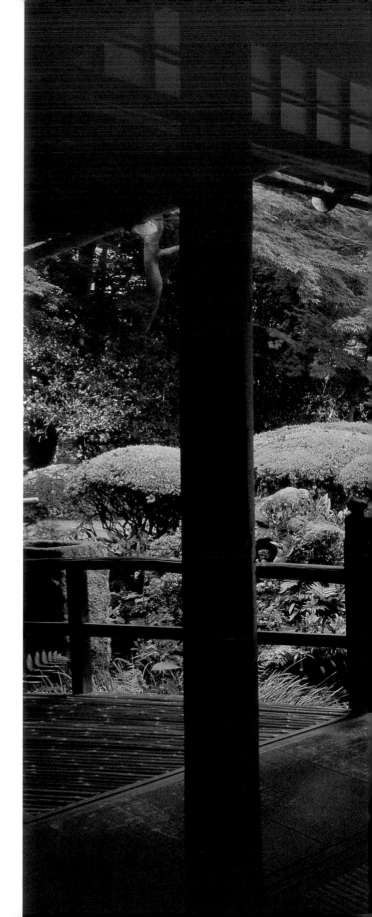

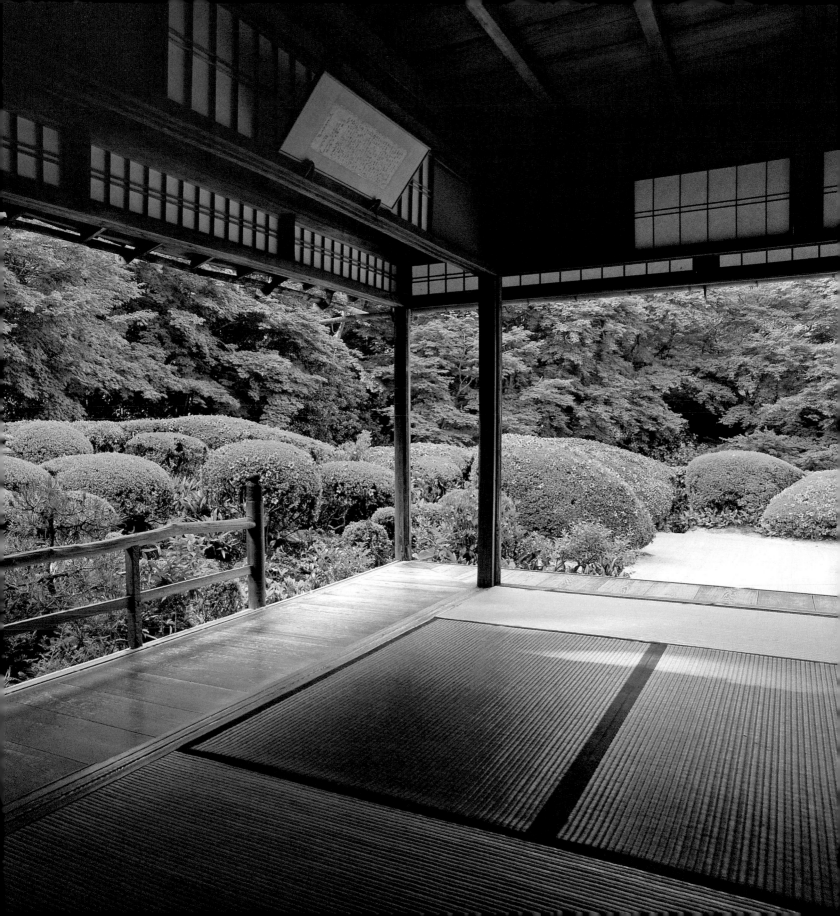

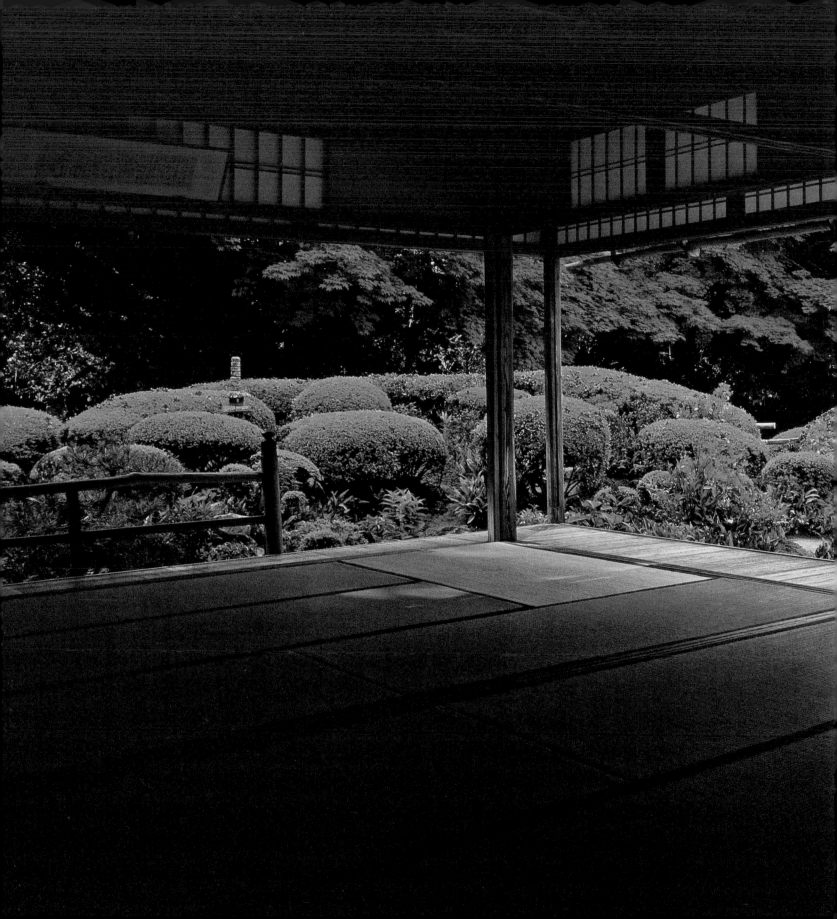

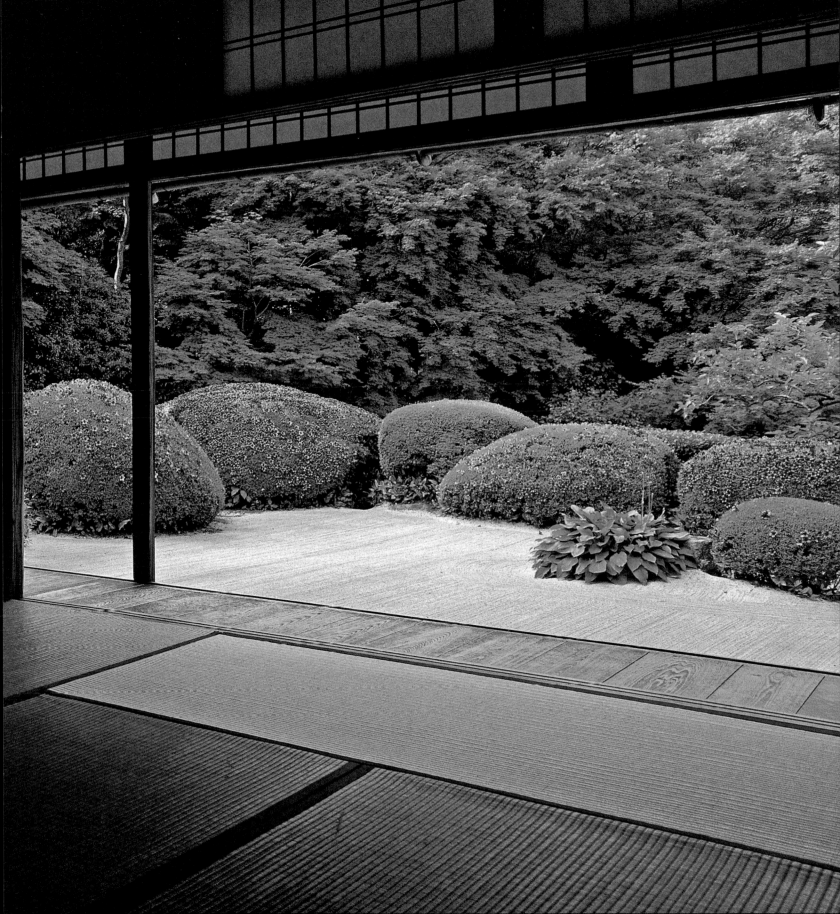

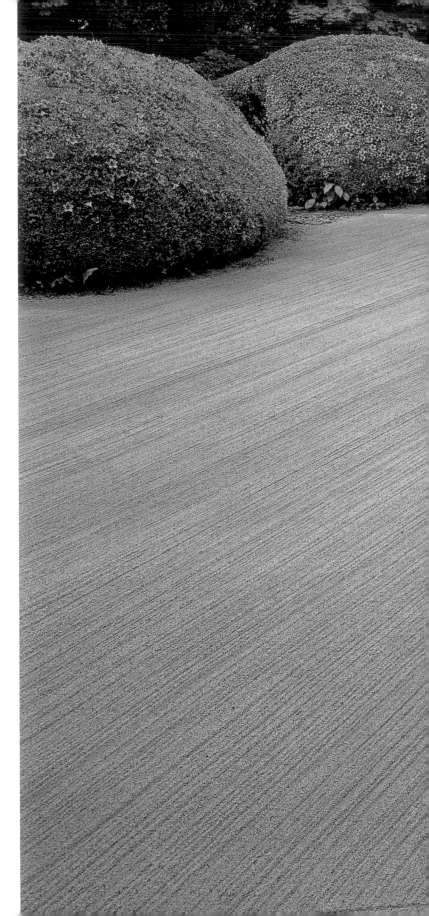

RIGHT Each part of the gardens at Shisen-do has a distinct foreground, mid-ground and background. The foreground is made of raked Shirakawa sand, the mid-ground is of clipped azalea bushes, and the background is made up of the dense groves of trees along the hillside.

BELOW The color of sparking white Shirakawa sand and the dark green of the deep forest set off each other.

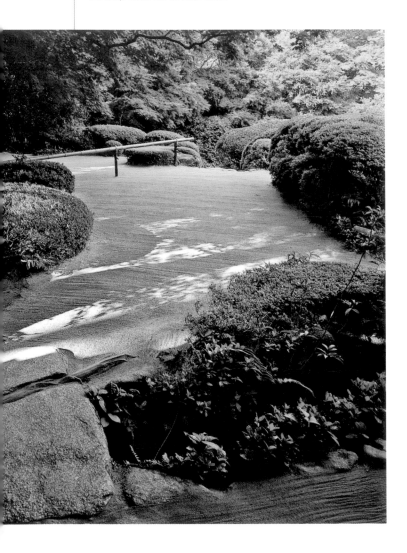

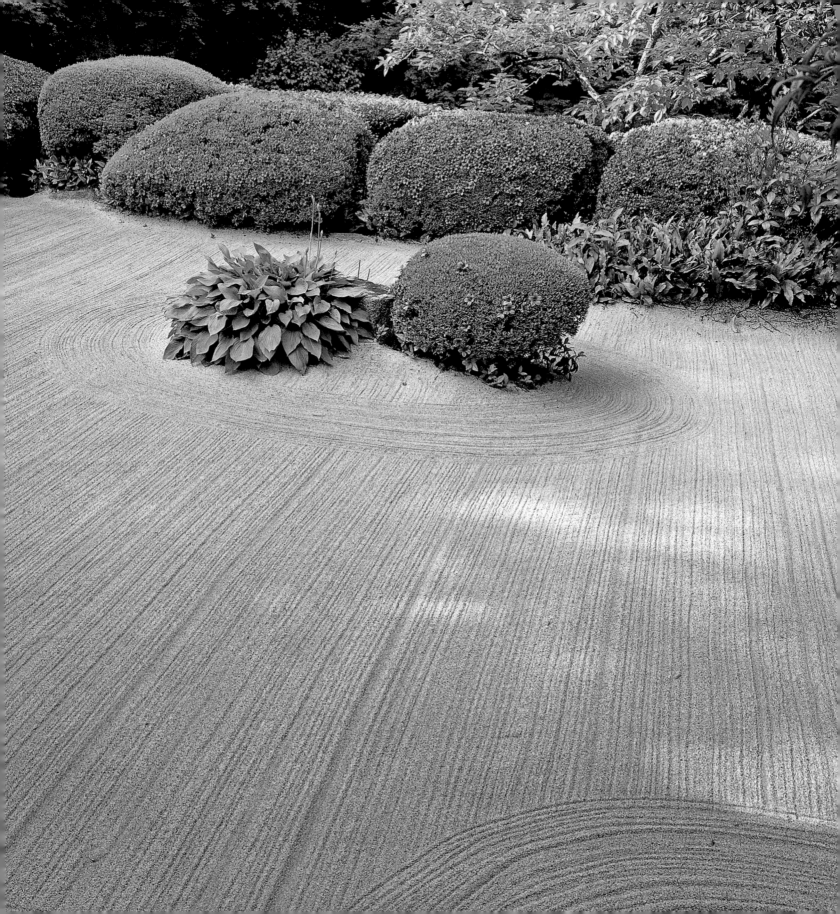

The Shisen-do complex, which includes a garden and a temple-villa, dates back to 1641. Representative of Ishikawa's fiercely independent personality, it is more playful than the garden trends prevalent at that time. Now a temple of the Soto Zen sect, Shisen-do was designed as a personal villa. The word *shisen-do* means "the House of the Great Poets" and originally referred only to the main foyer Shisen-no-ma, where portraits of thirty-six famous Chinese poets were painted by Kano Tanyu, one of the greatest painters of that time. The Shisen-do complex in those days also was referred to as "Ōtotsuka," the house on rugged land.

Located on a steep hill, the complex is entered through a tiny, unassuming entrance that is easy to miss. The delicate aesthetics of this complex become evident right away from the approach

ABOVE The entrance passage has been kept narrow and confined so as to enhance the feeling of spaciousness upon arriving at the garden.

RIGHT Movable foot gates or round stones tied with a rope, called *sekimori-ishi*, gently indicate areas of no admission in a Japanese garden.

that is lined with moss-covered rocks. In keeping with the principle of not revealing the entire garden from any one point, the entrance leads to a fork. The main path on the left leads to the villa and crosses over an area of white sand and stepping stones, flanked by a bamboo grove. The narrow path on the right that leads to the garden is flanked by tall stone walls and continues down some steps to make another left turn and then a twist, before the mid-level of the garden suddenly comes into view. The progression from a narrow path to an open area is deliberate and representative of the deep understanding of spatial perception in Japanese architecture and garden design.

The garden cascades down three levels from the villa at the top. On each level, there is a distinct foreground, mid-ground and background. At the lowest level the background consists of bamboo trees, while the mid-ground at this level is made up of wisteria, and the foreground has a small pond filled with *koi* (Japanese carp). At the upper two levels, the raked white Shirakawa sand in the *karesansui* dry landscape style is bordered by round, clipped bushes of karikomi Japanese azalea (satsuki) and the background consists of variety of trees including maples and massive sasanqua-camellia trees growing in dense clusters, some of them said to be over 400 years old. The dark mass of these trees contrasts with the Shirakawa sand to create a dramatic contrast in the garden.

The spirit of Zen Buddhism is playfully serene and rejects overly serious involvement with any thing. The sayings of Ishikawa quoted earlier, the atomosphere of this garden, and even

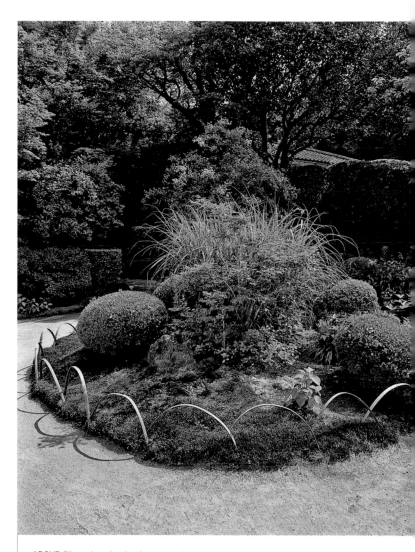

ABOVE Clipped azalea bushes are set off by a clump of common grasses on a mound in this island of green amid raked Shirakawa sand.

ABOVE LEFT Simple bamboo and rope hedges border the raked sand pathway in this garden.

certain devices in it reflect that. The most well known of these is *shishiodoshi*. This contraption is said to have been used by farmers of yore to chase away boars and wild deer. It is made up of a bamboo spout from which water trickles down into another piece of bamboo. The lower piece slowly fills with water till it tips over, emptying out the water and rebounding back to hit a stone, making a sharp sound. Ishikawa must have enjoyed the echo of *shishiodoshi* amid the sound of silence in his garden.

The very narrow steps from here lead up past a small waterfall set in skillfully arranged rocks toward what appears to be the entrance at the central part of the villa. But instead, the road simply leads past this point to the actual entrance a bit farther along the side.

This complex is also an example of the relationship between the interior and the exterior that is a hallmark of Japanese design. The main rooms of the villa have been designed so that entire walls can be opened up to the garden by sliding aside the partition walls.

A charming small thatched chamber on top of the villa, called the Moonlight Poetry Tower, juts out of the roof and was designed for moon viewing and writing poetry. It and the many other features here at Shisen-do garden delight the soul as well as all the senses of the visitor.

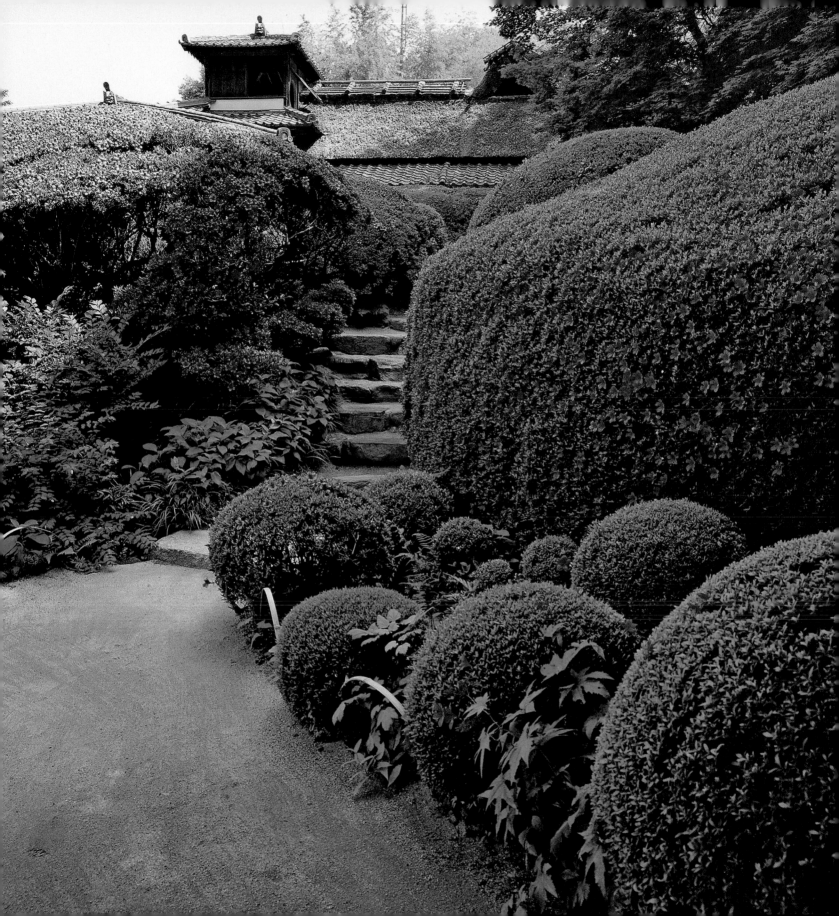

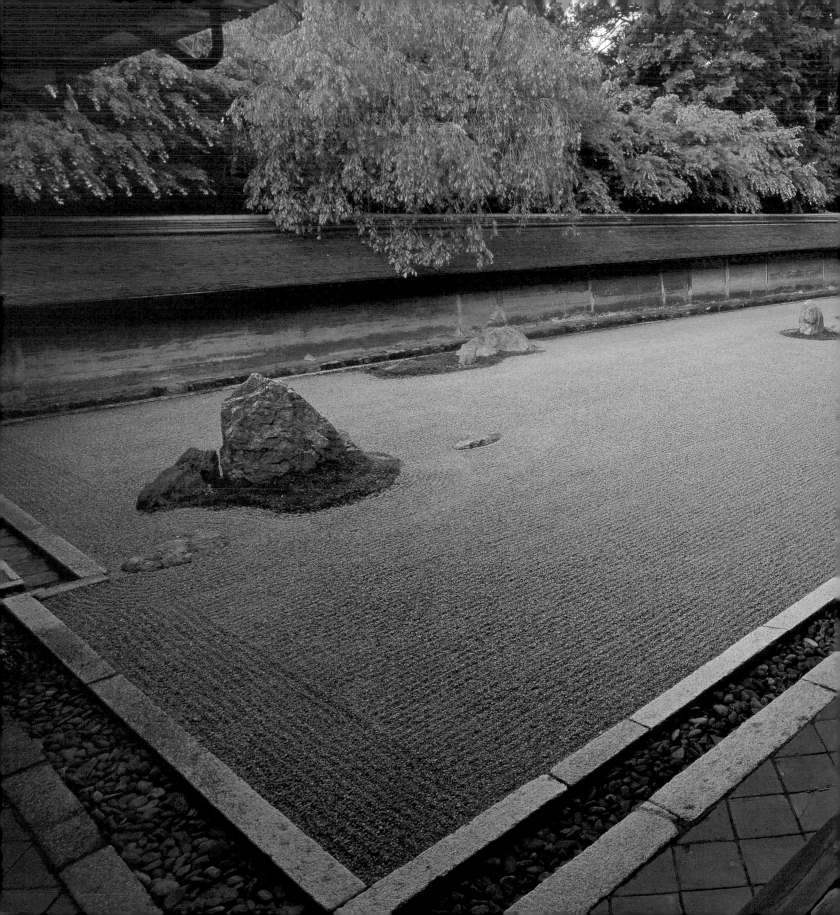

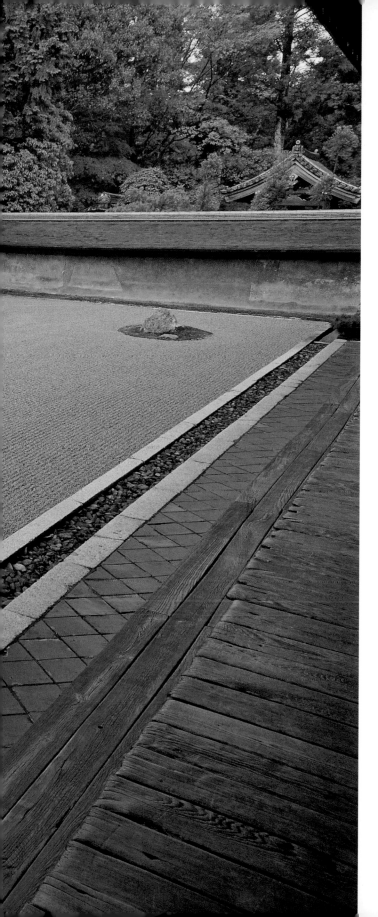

Ryoan-ji Kyoto

Gardeners of eternity,

Those who planted here

Made the garden in the
 image of a desert

And the desert in the image
 of a sea —

Then shrunk the seas to
 the mind's salt, and tasting

Dissolved all thought away.

—John M. Steadman

Designated a World Heritage Site by UNESCO in 1994, the *karesansui* dry-landscape garden at Ryoan-ji Temple is one of the best known examples of the minimalist aesthetics in Japan. No matter how often one has seen it, the simple beauty of it continues to surprise. This meditation garden is meant to facilitate contemplation while seated on the *engawa* covered porch of this temple. Gardens such as this were designed by Zen monks to view and contemplate, not enter. The purpose of these compositions, as in the black-and-white ink paintings or the koan questions created by Zen masters, was to nudge the mind away from the mundane and to allow it to enter a higher level of consciousness.

The cedar shingle roof of the *karesansui* dry-landscape garden's wall was renewed just weeks before this photograph was taken, and still has a strong color that will fade over time and add to the *wabi sabi* aesthetics of the wall.

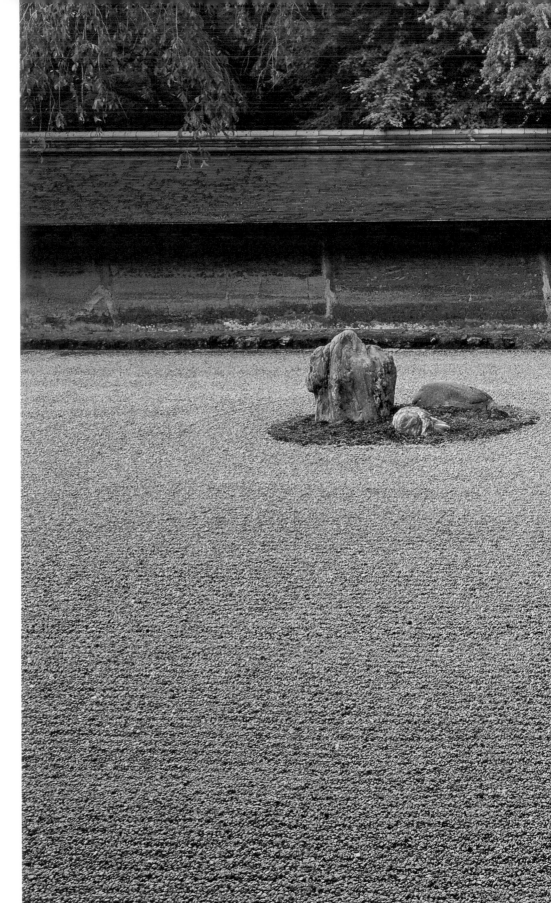

A few rocks strategically placed on moss provide a startling contrast to the raked stones at the dry-rock garden at Ryoan-ji.

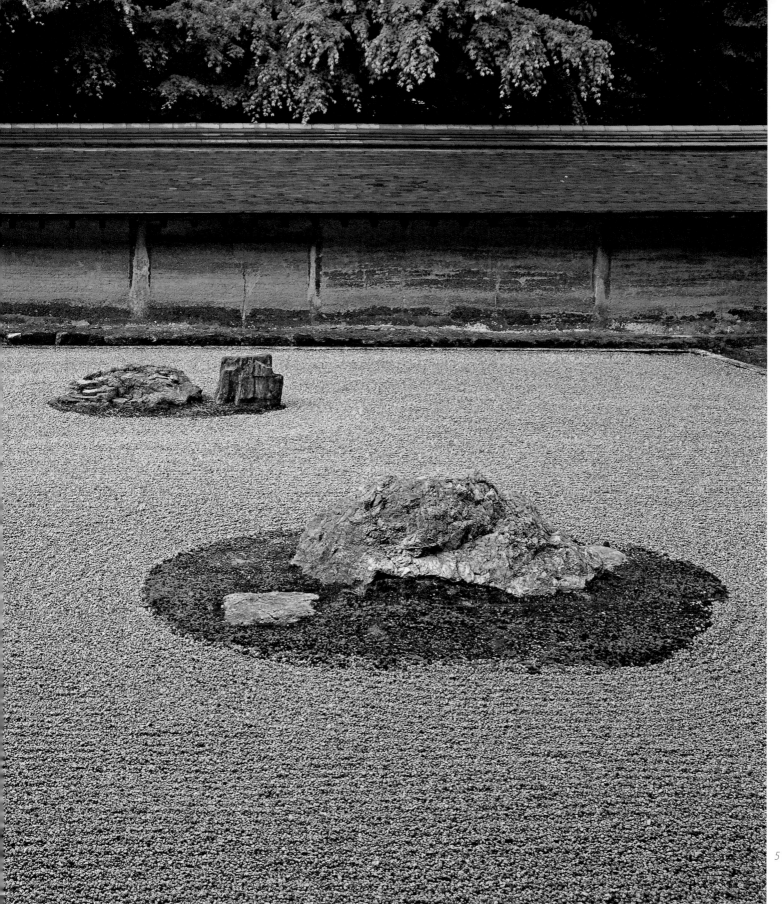

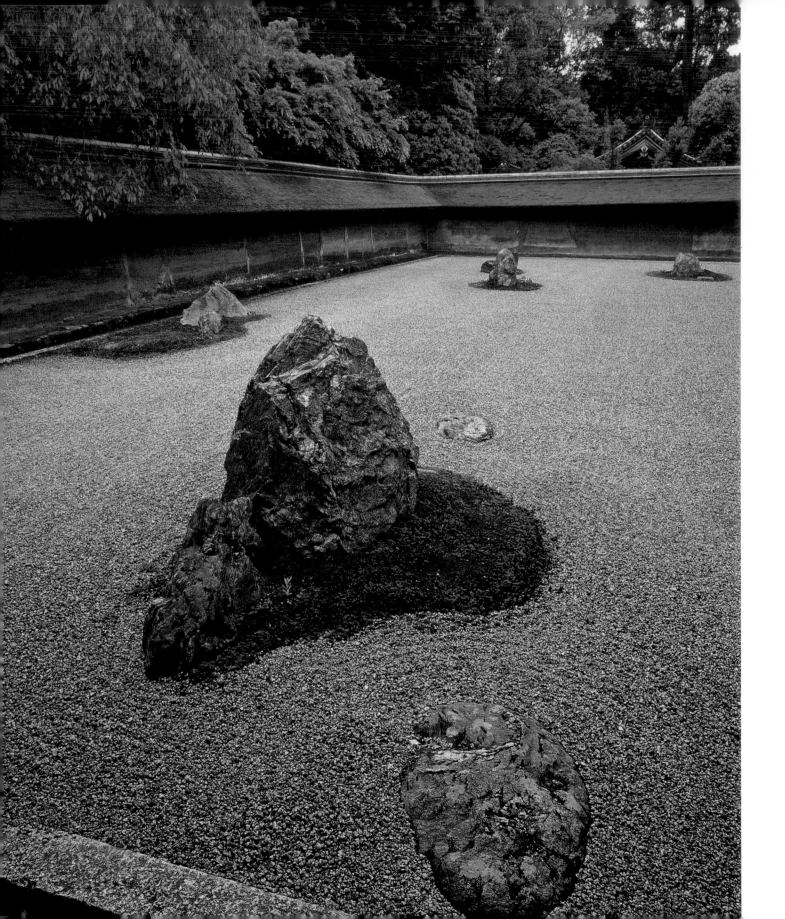

Ryoan-ji, literally translated as "the temple of dragon and peace," belongs to the Rinzai Zen sect. It stands on grounds where Enyuji, a temple of a retired emperor, had existed since the tenth century. This land passed on to military general Katsumoto Hosokawa in 1450. The original building of Ryoan-ji was destroyed during the Onin wars, along with thousands of temples and houses in Kyoto, and was rebuilt in 1499. The dry-rock garden is believed to have been added at that time. The temple was once again destroyed by fire in 1797, and the current temple relocated here. (Moving entire temples like this was made possible by the traditional wood joinery systems employed in ancient Japan in construction of buildings.) The east side of the garden was shortened at this time to make room for the formal Chinese-style gate, or *kara-mon*.

The original designer of Ryoan-ji, as well as his true design intent, are still a mystery. Popular belief attributes it to a well-known artist, Soami, who served Shogun Yoshimasa Ashikaga in the 16th century. The original garden form and intent may have been quite different from what we see today, as early renderings show pine trees in the garden. Ten meters in width and twenty-five meters in length, the garden succeeds in expressing eternity in this small space. The wall on the extreme right tapers down 50 centimeters in height toward the far end to give the garden an appearance of being larger than it actually is. This understanding and manipulation of dimensions to achieve a sense of visual depth or perfection is also seen in some old Japanese temple buildings, notably the entasis of columns in Horyu-ji Temple. The entire garden is also sloped toward the far right corner, in order to facilitate drainage.

The *karesansui* dry rock arrangement consists of fifteen irregularly-shaped large rocks that are arranged in five groupings, perfectly balanced to charge the empty expanse of white raked pebbles around them. The fact that areas of white gravel were used to demarcate sacred precincts in pre-Buddhist Japan may have contributed to the development of dry-rock gardens in Japanese Zen temples. The explanation found in some guidebooks that this garden represents a lioness and cubs crossing a river is counterproductive to the purpose of this garden. Zen Buddhism stubbornly resists imagery and concepts that would get in the way of pure consciousness, a position exemplified by the radical Zen

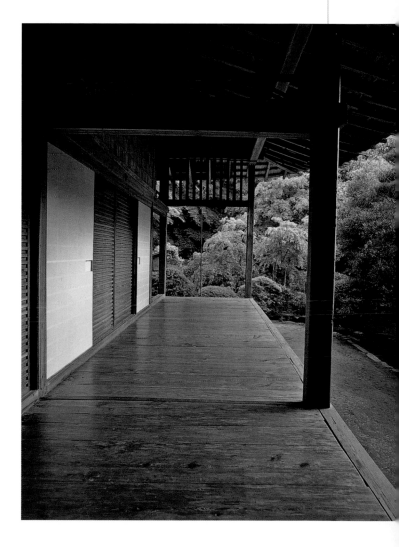

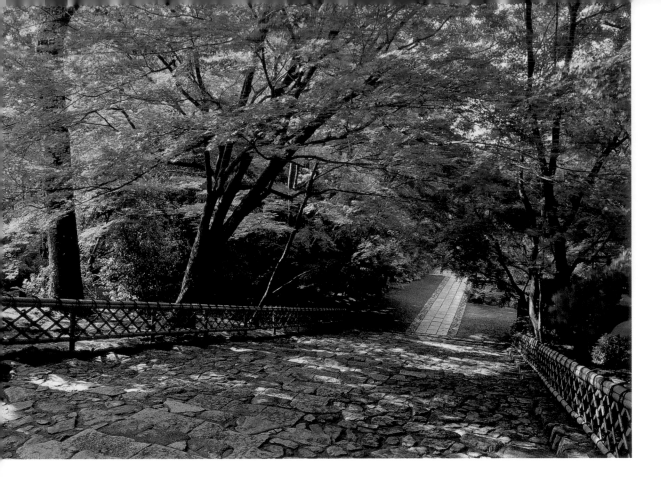

LEFT The bamboo fence at Ryoan-ji has been much emulated around Japan and is known as *Ryoan-ji gaki*.

RIGHT The gate leading to the wall of the garden (this photo is from outside) was repaired just before this photograph was taken, and looks magnificent. The roof is made of layers of thin strips chipped (not cut) from cedar bark.

BELOW LEFT The ambiance of stillness at Ryoan-ji allows visitors to enjoy the beauty of simple details such as this bamboo fence.

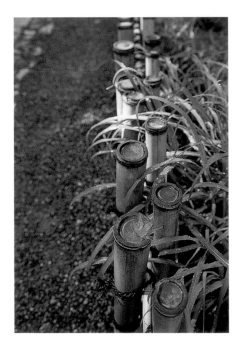

saying, "If you see the Buddha, kill him." Only fourteen of these rocks can be seen from any angle, often interpreted as symbolic of the fact that spiritual enlightenment is needed to perceive that which cannot be seen with eyes.

It is hard to think that the appearance of a dry-rock garden can change with seasons. However, this is true of Ryoan-ji because the trees surrounding the garden are also part of its design. The intense green of cedar and pine trees in summer, a cherry tree that fills this garden with cheer when it blooms each spring, and the snowclad trees of winter lend it a completely different appearance. This phenomenon of borrowed scenery, often including distant mountains, is known as *shakkei* and is a well understood part of Japanese garden design. The walls that surround such gardens edit out the inessential. The continuous flow of space between the abbot's quarters or *hojo*, the *engawa*, and the garden is also a special aspect of Japanese design.

After walking along the dry-rock garden, one turns a corner and is confronted by its counterpart, a lush moss garden. Rounded forms

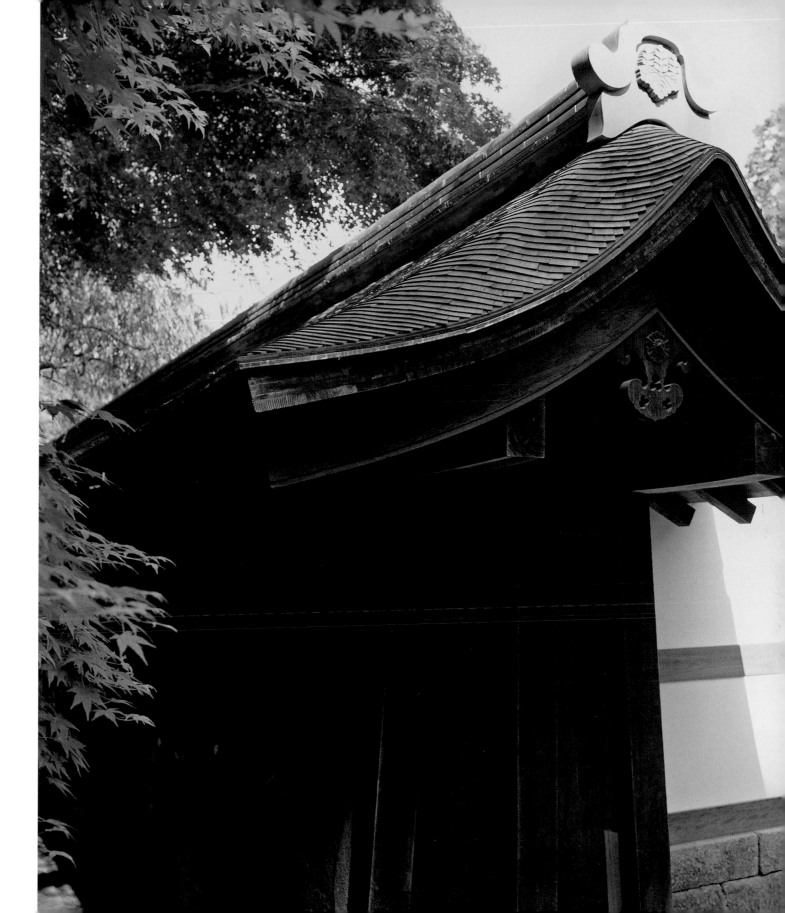

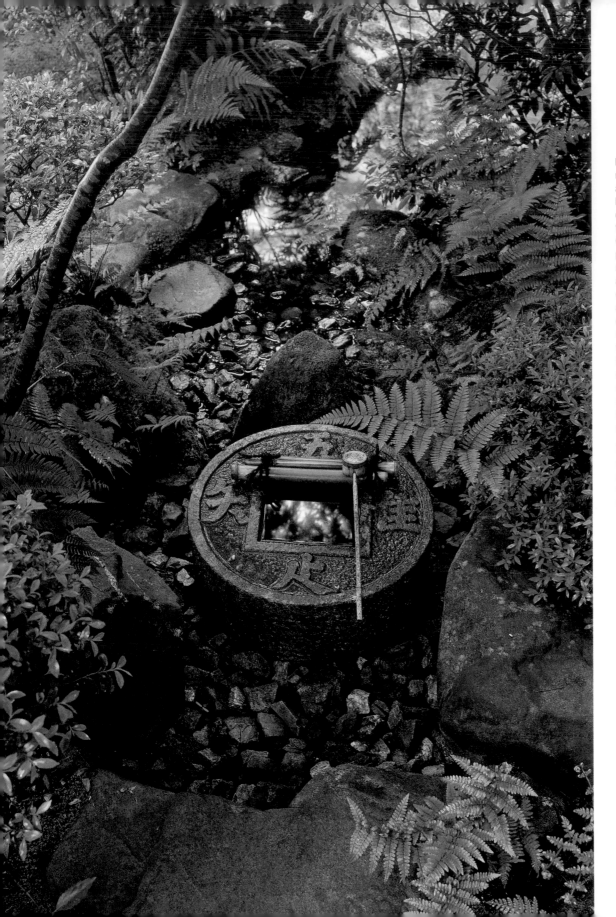

LEFT This stone basin located near Zorokuan tea hut is a famed example of low basins called *tsukubai* or crouch basins, as one needs to crouch down to use it. Crouching down, bowing, and purifying one's hands and mouth are steps in humbling and preparing the mind before entering a tea hut. It has an inscription of four kanji characters, each of which uses the square shape of the water basin as part of the kanji. Read from the top in a clockwise direction, the four characters can be translated as "I just know contentment" implying that one should not allow desires to escalate.

RIGHT Water from a bamboo spout flows into a simple granite basin in keeping with the simple unadorned aesthetics of Ryoan-ji.

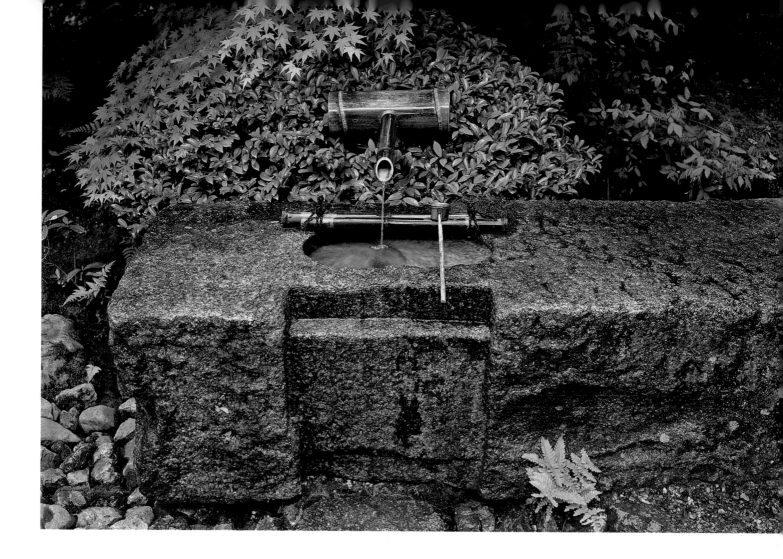

of stepping stones show through the thick moss that's covering them, refreshing the eyes after the *karesansui*. Designing dry-rock and green gardens in pairs has been popular in Japan since the Muromachi period.

The garden at the back is completely different from the former two, consisting of thick foliage of maples, Japanese oak and pine trees. A stone washbasin or *tsukubai*, which is a replica of the original located near the tea hut, has been placed in the foreground. The sound of water tricking into the basin, and that of a rushing stream in the background, are also part of the experience of this garden.

Ryoan-ji Temple includes a small tea hut called Zorokuan, which dates back to the Momoyama period, but was renovated after the fire of 1929. Its name translates to "that which hides six," which in

this case means the limbs, head and tail of a tortoise, a symbol of Gembu, a guardian deity of the North. Shogun Hideyoshi Toyotomi, who was a tea aficionado, is said to have donated the camellia plants for the tea garden here.

The temple grounds outside this *hojo* are also quite beautiful, and would merit a visit on their own even if the dry-rock garden did not exist. They consist of a small lake called Kyoyochi that is popularly known as Oshidori Ike due to the mandarin ducks that used to inhabit it. Besides their beauty, these birds are also symbolic of true love due to their fidelity to their mates. As was common in garden design at that time, the pond has two islands in it. The larger one has a shrine to Benten (Sarasvati), one of the three Hindu deities that are part of the seven lucky gods in Japanese folk Buddhist tradition.

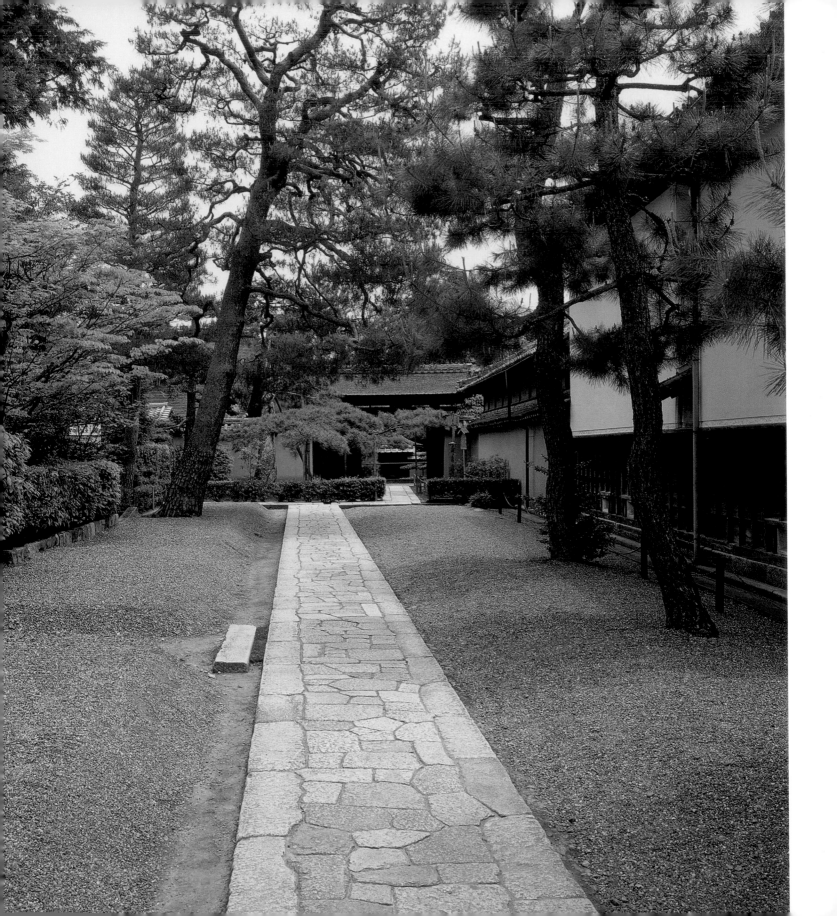

Shinju-an
Kyoto

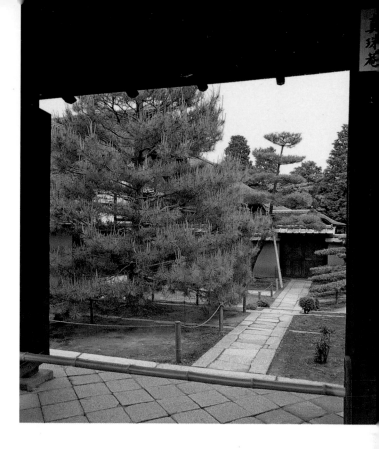

Shinju-an (Pearl Temple) is a small sub-temple of Daitokuji, a great Rinzai Zen temple located in northern Kyoto. Originally built in 1315, Daitokuji burned down several times and was finally rebuilt by the famous itinerant monk Ikkyu Sojun (1394–1481). It gained further popularity when many small sub-temples were added to it under the patronage of the local daimyo warlord and wealthy merchants of the Sakai area. In 1582, Shogun Hideyoshi Toyotomi held the funeral of the former Shogun Nobunaga Oda here, and the association of these powerful men led to further increase in the number of sub-temples added in the Edo period.

Shinju-an was built by Ikkyu, who was by then the Abbot of Daitokuji, during the Eikyo Period (1429–41). It burned down during the Onin wars and was rebuilt in 1491. The *hojo* main hall and *shoin* study date from 1638 or later. The influence of the Shinju-an sub-temple itself can be inferred from the fact that besides the several famous screen paintings by Dasoku Soga and Tohaku Hasegawa and sketches by Ikkyu that it houses, Shuko Murata, the founder of *wabi sabi* tea style, as well as Kanami and Seami, the creators of Nō theater, were all interred here.

ABOVE The first gate of Shinju-an frames an old sculptured pine tree. This front garden leads to the entrance of the building seen in the background.

OPPOSITE The approach road that leads to the first gate of Shinju-an. The wall on the right is part of the central temple building of Daitoku-ji. This approach road meets the path leading to the nearby temple Daisen-in on the left (not seen in the photograph) at a whimsical angle that adds to the sense of the unexpected in simple things, sought after in Zen gardens.

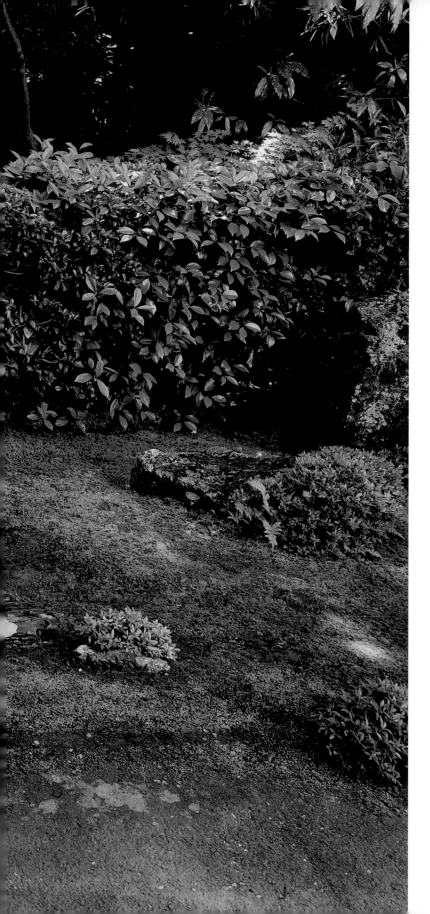

The famous 7-5-3 garden, part of which is shown here, is located east of the *hojo*, the main hall. Since its beginnings, this small garden of a mere 50 square meters has been held up as an example of the Zen art of creating a feeling of eternity even in humble materials and small spaces.

Abbot Ikkyu is known in Japanese history for his eccentricity and irreverence toward the government and other Buddhist sects, and also for being the unrecognized son of the Emperor. Besides embodying the true spirit of Zen, he was a talented poet and artist. He is said to have charged his disciple Shuko Murata (1423–1502) to start a new tradition of tea ceremony in the Zen spirit that would expose the shallowness of the popular tea parties of that time that were held in ostentatious *shoin* rooms with rich pottery and painting from China. Shuko's work led to the *wabi sabi* style of tea ceremony, and veneration of the humble, rustic and imperfect as the embodiment of the tea aesthetic. Later tea masters such as Johou Takeno and Sen no Rikyu further developed this concept. Ikkyu is also said to have given Shuko a parting gift of a Chinese calligraphy scroll to formalize his order. Shuko used this as well as another scroll painted by Ikkyu at his tea ceremonies, thus starting the trend of using calligraphy scrolls in tea huts.

The East Garden of Shinju-an garden is the oldest and a rather inconspicuous part of Shinju-an Temple, but of great importance because it was designed by Shuko. Located between the low hedge and the *engawa* corridor of the *hojo* (main building), it is only about three meters wide and seventeen meters long, but embodies the wabi sabi aesthetics and ambiance that made it a trendsetter, and it may have influenced later gardens such as at Ginkaku-ji and Ryoan-ji. As is customary in tea gardens, it consists of the outer garden and the inner garden. At the time of its building, the *shakkei* (borrowed scenery) of the East Garden included the Higashiyama Mountains, but has now been reduced to the greenery of trees on the other side of the wall.

The main feature of the outer garden is an arrangement of rocks in the 7-5-3 formation set amid lush moss. The choice of these numbers reflects the ancient Chinese belief in auspiciousness of odd numbers. Stones in Japanese gardens often follow a 7-5-3

RIGHT AND BELOW The outer garden to the tea hut Teigyoku-ken can be seen from Tsusen-in, a *shoin* style formal room. The stepping stones lead to the tea hut. Tea gardens sometimes include both an outer garden and an inner garden; but this tiny antechamber seen at the far end is highly unusual because it houses an inner garden *inside* the hut. The stepping stones and stone basin found inside are normally placed outdoors.

formation for this reason, and also for a sense of balance that this combination generates. The numbers 7-5-3 are also echoed in the *shichi-go-san* ceremony in Japan performed at the age of three and seven for girls and at the age of five for boys, as a prayer for their long life and wellbeing.

The *shichi-go-san* garden leads to a small gate, which in turn leads to the Tsusen-in inner tea garden and tea hut Teigyoku-ken built by another renowned tea master, Sowa Kanamori. The relation of the tea hut to the garden is unique in that the *tsukubai* water basin meant for purifying hands and mouth before entering a tea room is located indoors in an antechamber. The indoor stepping stones here form a highly unusual *roji*. The reason for this is not known, but it may have been that Kanamori came from Hida Takayama,

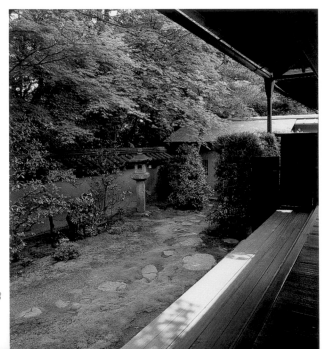

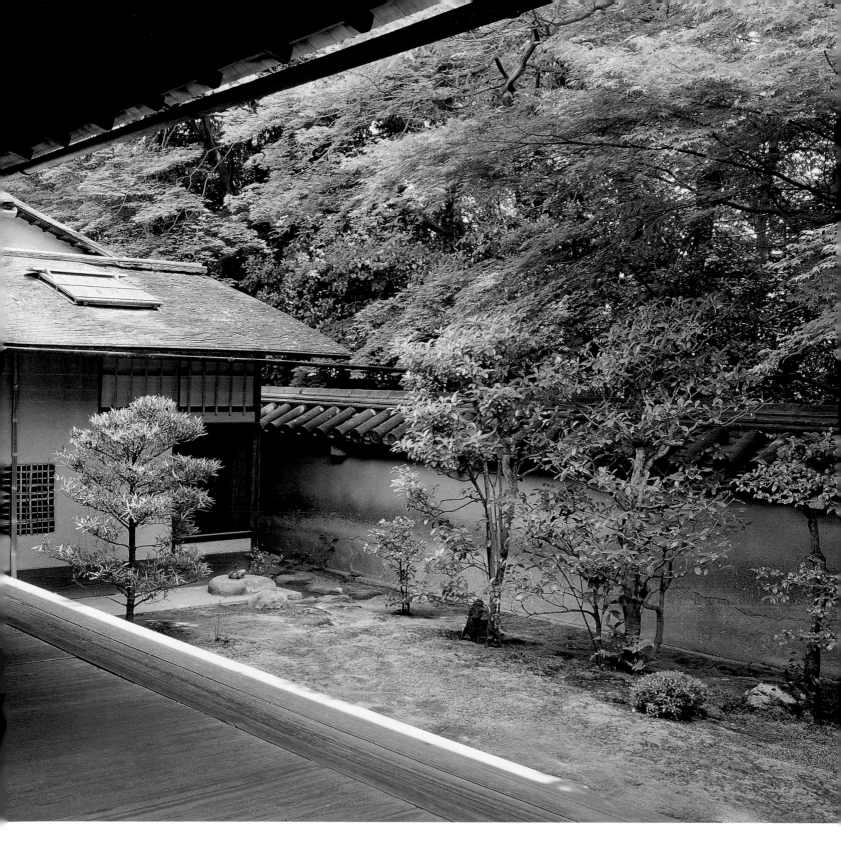

Shinju-an, Kyoto *69*

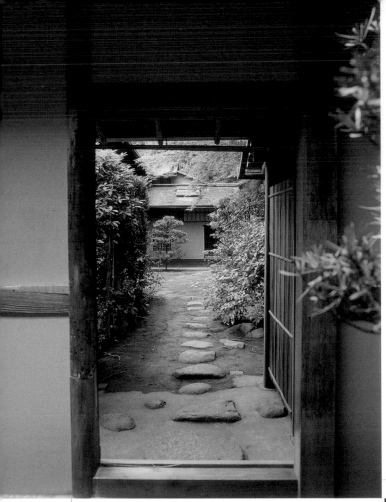

a heavy snowfall area, and wanted to develop a tea-garden style suited to his region.

Shinju-an temple also contains a small inner garden called a *naka niwa* between the *hojo* main hall and the *kuri* living quarters. Glimpses of this *naka niwa* are seen from the corridor that connects the *hojo* main hall to the *shoin* study.

The entrance to Shinju-an is typical of the unexpected delights of Zen gardens. The road leading to it is set at an angle toward a blank wall, past another well-known sub-temple called Daisen-in. From here, the road takes an angled turn to reach the entrance of Shinju-an. This entrance is flanked on the left by a small garden with an old sculptured pine tree and raked sand.

Daitoku-ji currently has over twenty sub-temples in its 225,000-square-meter grounds. Like Shinju-an, many of these temples are of understated beauty, and include small gardens and tea huts. Shinju-an is only accessible to the public with special permission.

ABOVE A *roji* gate separates the east garden from the outer garden of the Teigyoku-ken tea hut. Such gates were meant as reminders of the change of mood expected as one goes deeper into the serene world of tea. The stone path to Teigyoku-ken is almost straight, and leads to the *roji* path inside the wall of the antechamber to Teigyoku-ken.

RIGHT Glimpses of another inner garden can be seen from the *hojo* main hall.

OPPOSITE The inner garden features a highly unusual arrangement of a well, a pine tree and a stone lantern on three islands of moss amid rakcd stones.

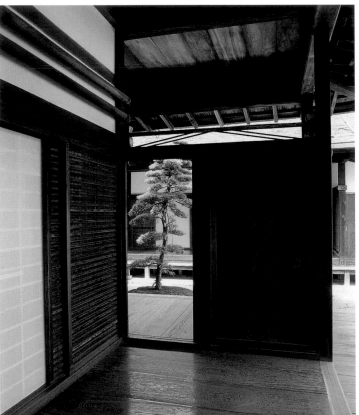

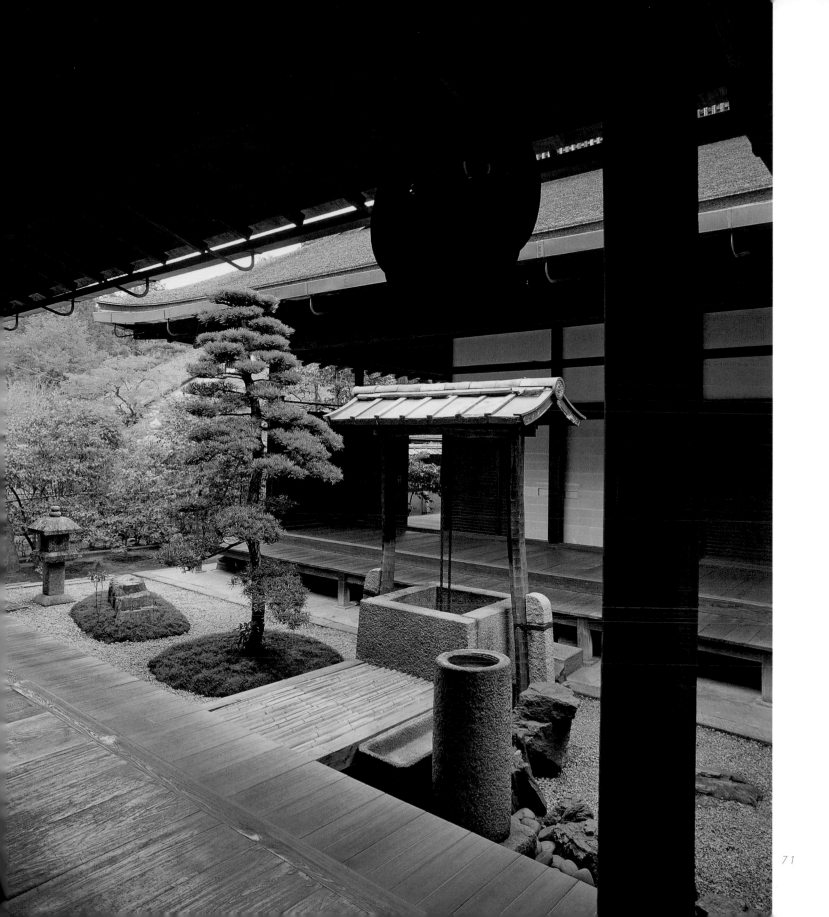

private gardens

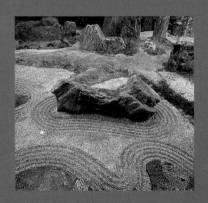

To own a private garden of any size is a privilege that most people in Japan cannot afford due to very high real estate prices in this small and densely populated country. The gardens revealed in this section of the book have been handed down to the current owners by their ancestors, and are a testament to the commitment of the owners to their heritage as well as to garden traditions.

Many of the owners of the gardens featured here, such as Mimou House and Suya House in Gifu, have been forthcoming in sharing stories here of the very personal memories the gardens hold. Many private gardens are tea gardens, since the "way of tea" was a strong cultural presence in historic Japan and continues to be so today. Tea gardens are full of symbolism which imbues stone paths, gates, water basins, trees, and humble grasses with spiritual meaning.

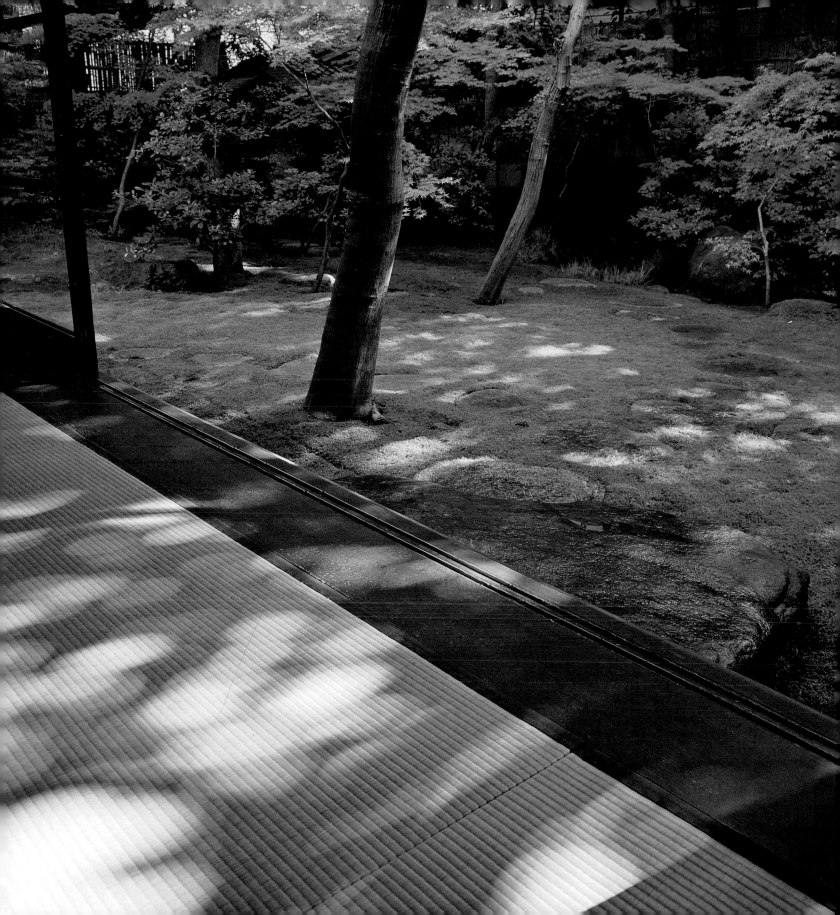

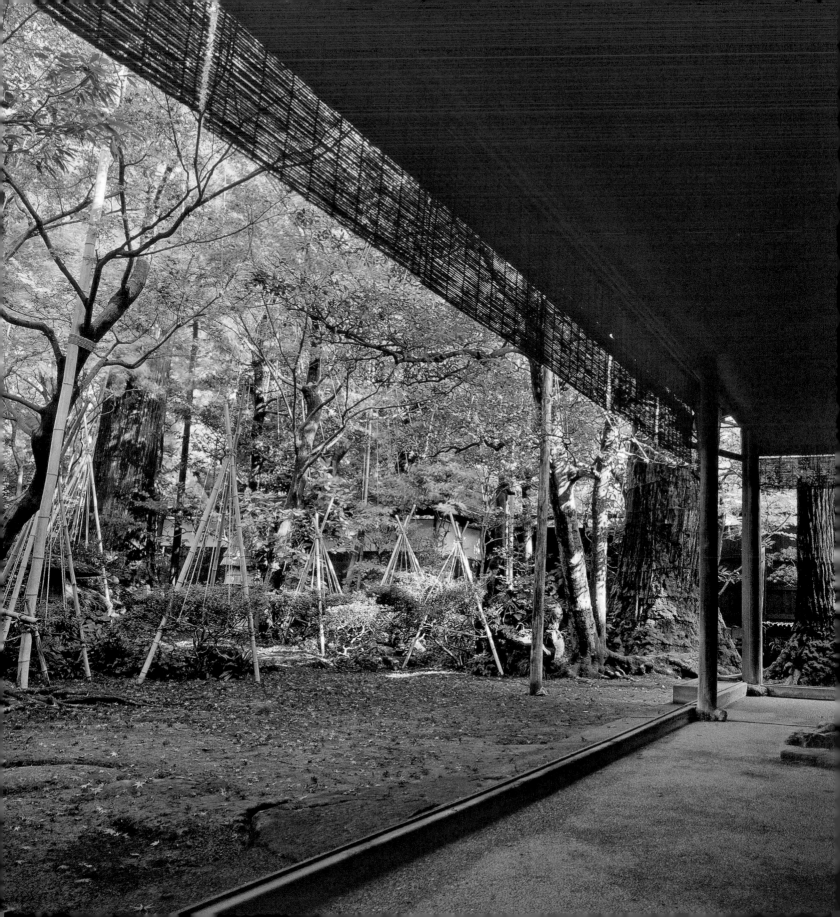

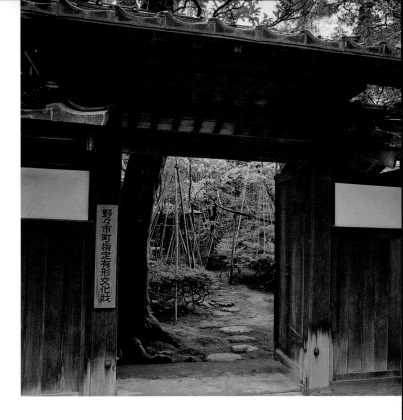

Mimou House
Nonoichi

LEFT The tall *tsukubai* hand-washing basin in the foreground is of samurai style as it can be used without crouching down.

ABOVE The rich green of the moss and the exuberant fall colors of the Iroha momiji (Japanese maple) tree inside can be seen from the imposing entrance gate.

Mimou House and its garden are located in the town of Nonoichi, near Kanazawa. A wealthy town known for its refined arts since the Edo period, Nonoichi was the castle town of the Togashi family about 500 years before Kanazawa castle was built in 1583. Mimou house was built by the influential Mimou family in 1870 and has been in the same ownership ever since. This family traces its origin to Togashi's chief retainer who lived here from 1587 onwards. The family's ancestors include a village chief, several landlords, teachers, and other people of cultural renown. The house is now owned by the eighteenth-generation descendant of the family, Mrs. Michiko Mimou. Michiko is a remarkable woman in her eighties who is a teacher of the tea ceremony and has

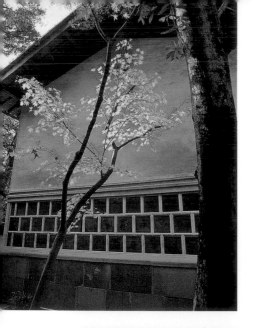

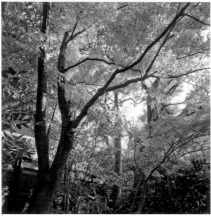

TOP The *namako* style wall of the storehouse provides a perfect *shakkei* or borrowed background for the Mimou garden.

ABOVE The leaves of the Iroha momiji (*Acer palmatum*, or Japanese maple) tree turn brilliant orange and red in autumn. This tree represents autumn in Japanese gardens and art.

OPPOSITE Snow umbrellas of bamboo and rope have been erected over young plants in anticipation of the heavy snowfall in the Kaga region. The impressive girths of several old moss-covered cedar tree trunks in the background contribute to the garden view when seen from inside. Although these trees have died from age and their tops have been cut off at a height of about seven meters, their trunks have been kept for their beauty and as a reminder of the 300-year history of the garden.

infused everything in the house with her refined and yet playful aesthetics. Her son's family also lives with her, and her daughter-in-law assists Michiko in her work.

The house is entered through a tiled roof timber gate set in an imposing exterior wall that was typical of homes located along the old thoroughfare that connected Kanazawa to Edo and Kyoto. Upon entering this gate, one is greeted with the lush foliage of the garden and intensely green moss. From here, stepping stones lead to the tea arbor portion of the house that is used for tea ceremonies and for entertaining visitors.

The garden of this house is understated but elegant, with undulating ground, a small dry stream and a pond. A hill with large cedar trees previously existed on the far end of the garden, but was leveled to make space for a storehouse. The garden still has several older trees with trunks of over a meter in diameter. Michiko smiles as she talks about one stump of an old dead tree that has a new trunk growing out of it. Toshitune Maeda (the third lord of the domain of Kaga) is said to have hitched his horse to this tree in 1616 when he rested at this house on his way to a hawk-hunting trip. Michiko says that if these trees could speak they would have many historic stories to tell, but that would make the garden too noisy.

There are nearly 100 varieties of moss that grow in this garden, with haigoke and sugi-goke predominating. Michiko's daughter-in-law weeds the moss every day to maintain its soft blanket-like appearance.

A unique feature of the homes and gardens in the northern part of Japan is the packed earth area between the interior and exterior called the *doma*, located under the eaves just outside and parallel to the *engawa* porch. The *doma* and *engawa* are provided with removable shutters on either side, so that these spaces can be opened or closed to the garden or the inner living areas. The *doma* in this house is approximately two meters wide. Located at the same level as the garden, it includes elements of the garden such as the stone lanterns and stepping stones. This brings a feeling of the garden to the indoors during the cold winter months when the *amado* shutters shut out the snow-covered garden outside.

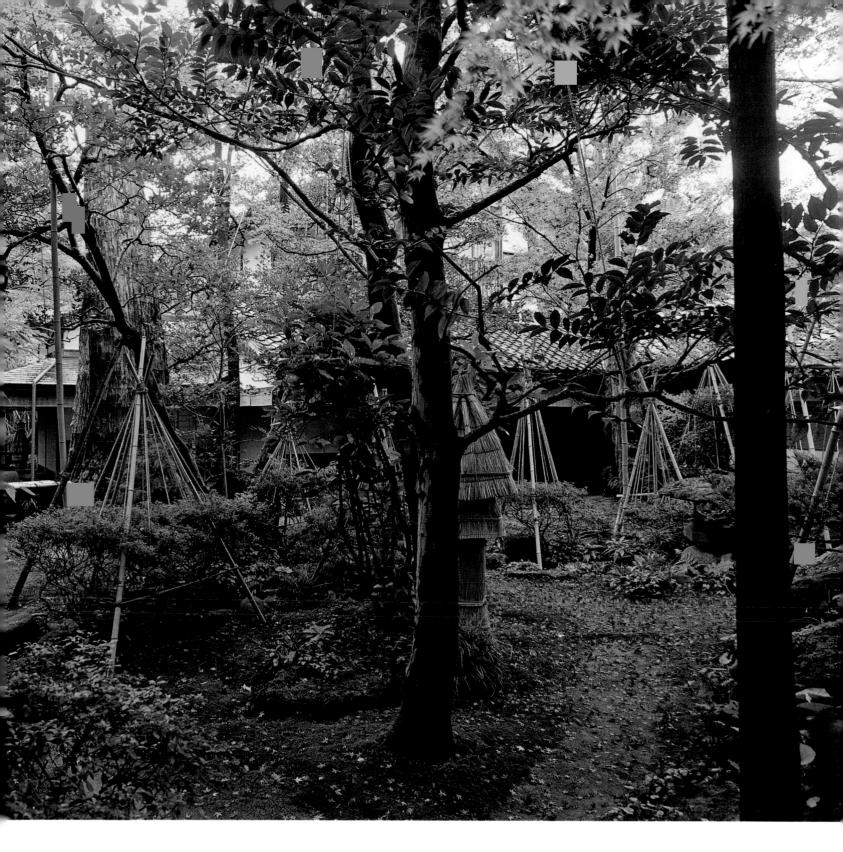

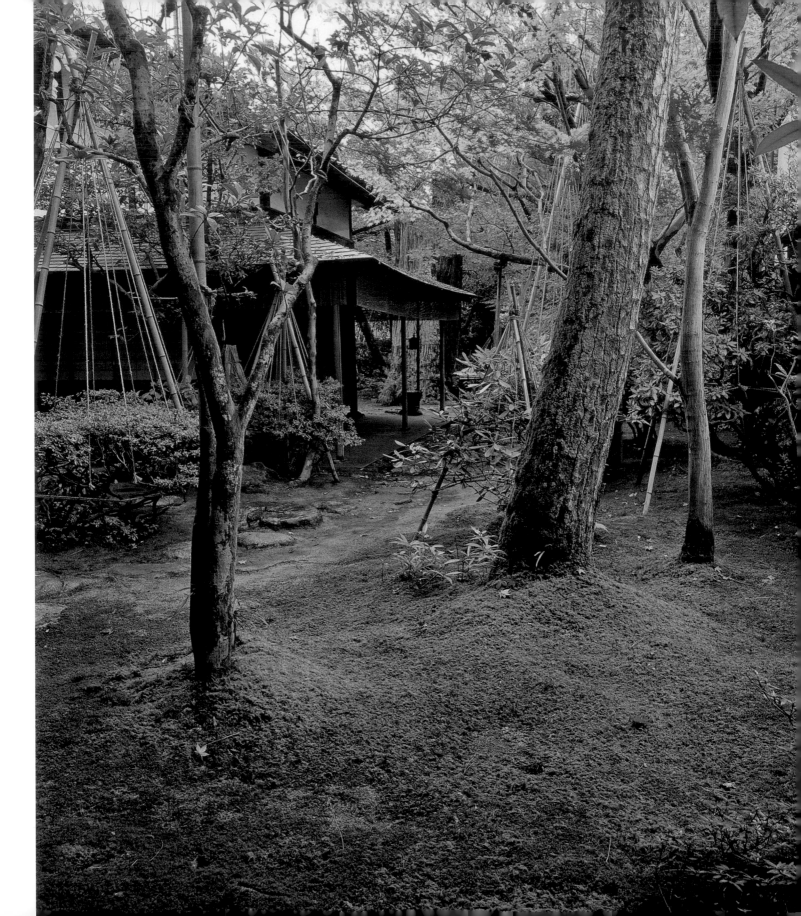

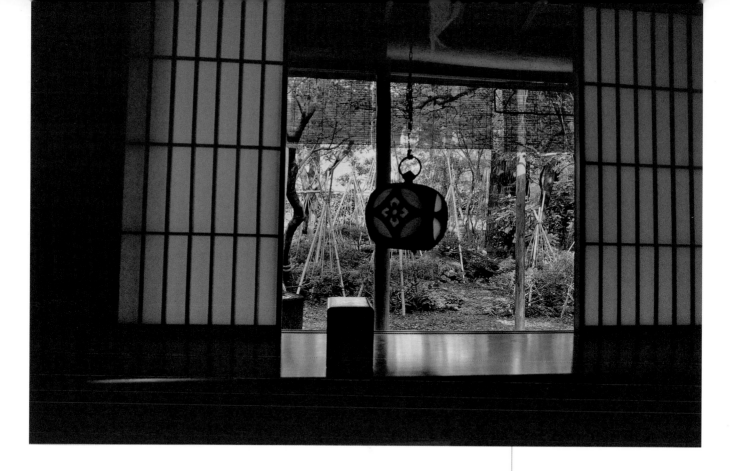

Mr. Kawana, the gardener for Mrs. Mimou, has worked here for over ten years. He trims the evergreen trees before the rainy season and the deciduous trees in summer while their new growth is soft and can be easily removed. He nurtures trees carefully into natural "flowing" forms. Before the snow season, he constructs *yuki zuri* rope umbrellas over certain trees to prevent damage to the boughs. Stone lanterns are also protected by specially shaped straw covers to prevent cracking due to freezing, a beautiful and practical custom typical of the Kanazawa area.

The *dozo* storehouse at the far end of the garden was built in 1869 during the Meiji period and provides a picturesque backdrop to the garden. The lower part of this storehouse is made up of a *namako* style wall with black square tiles set in white raised *shikkui* plaster made from lime, seaweed, and hemp fiber. The lime mixture was used to render the walls waterproof and fireproof. Such walls get their name from *namako* (sea cucumbers) that the raised *shikkui* plaster is supposed to resemble. This storehouse is the oldest building on the Mimou property, since the main house was rebuilt a year later, and the Shika-no-ma (Room of the Deer) tea house was added during the Taisho period.

The garden and the house are integrated in a way that is a special feature of Japanese architecture. Each complements the other's beauty and provides a living space that is deeply satisfying to Michiko. As she shows her garden to visitors, she speaks softly of the sounds of birds and her memories of certain plants, making time move slowly, until a feeling of deep peace envelops the visitor, a beautiful reflection of years of practicing the art of the tea ceremony in a beautiful garden.

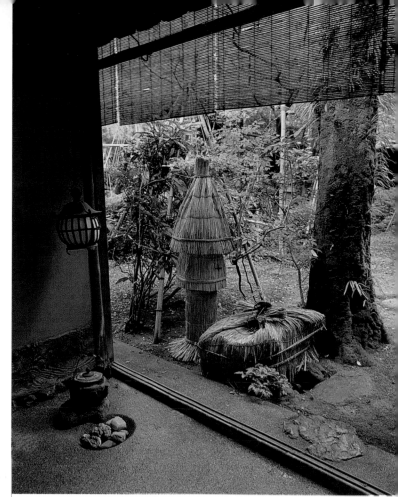

ABOVE This stone lantern and water basin
have been wrapped in straw in preparation for
winter. The wrapping of the short water basin
in the shape of Japanese apricot blossoms
creates a reminder during the cold winter
months of the imminence of spring. The old
oak tree has nokishinobu growing on it. This
plant is prized for its taste but is a parasite
for the tree.

LEFT While weeds are painstakingly removed
by hand from the moss in the garden, a few
autumn leaves are allowed to stay scattered
in celebration of the season. A row of charcoal
logs has been implanted in the ground where
the rainwater drips from the roof.

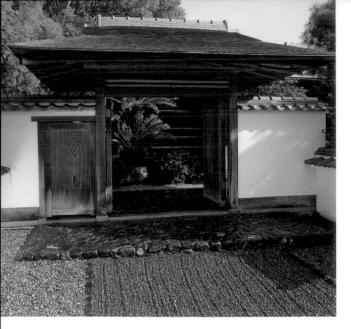

Wafudou of
Ueda Soko Ryu
Hiroshima

Among the many schools of tea ceremony in Japan today, Ueda Soko Ryu is most closely related to the samurai traditions of yore. Its founder, Soko Ueda (1563–1650), was a young general who served diligently under the daimyo Nagahide Niwa and became known for his bravery. He later became an aide to the tea aficionado Shogun Hideyoshi Toyotomi. Ueda Soko is said to have learned tea ceremony directly from Rikyu and Oribe, two of the most well known tea masters in Japanese history. In a famous episode during the Summer Battle of Osaka (*Osaka Natsu no Jin*), Soko Ueda is said to have calmly fashioned two splendid *chashaku* tea spoons from a piece of bamboo lying nearby while awaiting the enemy's attack. Such is the bold spirit of calmness that infuses the Ueda Soko Ryu tea style.

TOP At the southern entrance gate from the street, the sand is sprinkled with water and then raked every morning. Freshly watered stones and paths are a sign of welcome in a Japanese house or garden.

RIGHT Wide eaves are a characteristic of Japanese architecture. The floor under the overhang is made of packed clay, lime, sand, and magnesium.

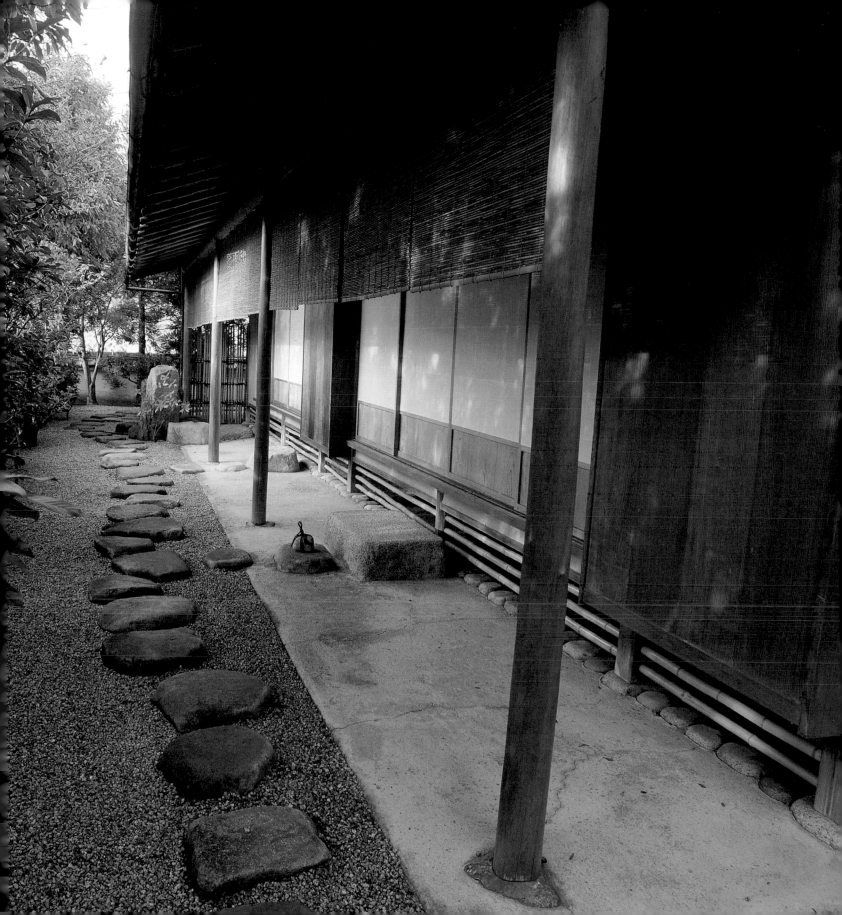

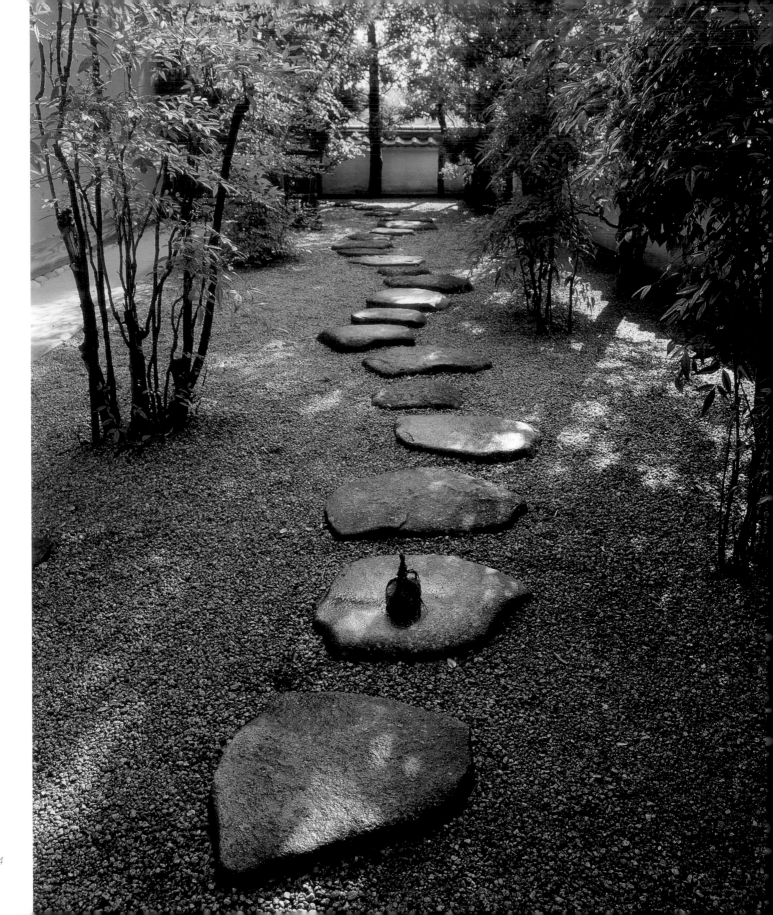

In 1619, soon after arriving in Hiroshima with his liege Nagaakira Asano, Ueda left the city for a secluded mountain village nearby and enjoyed a refined life there. He had already built a samurai house with tea house named Wafudou in Kisyu where he had lived before, and went on to build another Wafudou tea house, garden and samurai residence near the Hiroshima castle area. Ueda became famous for the many gardens he designed during his lifetime, some of which still exist today.

The tradition of Ueda Soko Ryu is now being carried forward by its sixteenth-generation tea masters, and Wafudou still looks beautiful amid its garden in the western part of Hiroshima city. However, the road to this remarkable preservation of cultural treasure has been rocky and eventful. In the Meiji period, like many other samurai residences, Ueda's estate here was turned into a military drill field, and Wafudou was destroyed. The historic garden and documents of Ueda somehow escaped destruction at this time, as well as when the atom bomb was dropped on Hiroshima in 1945. Although many people connected to the Soko

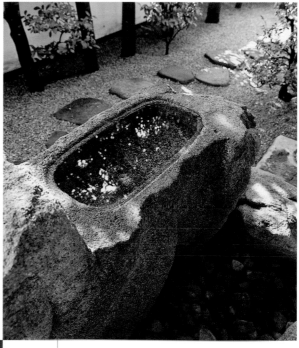

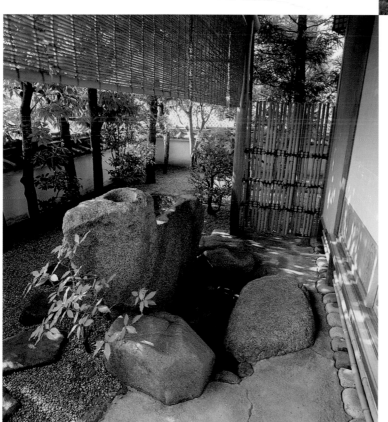

ABOVE AND LEFT This samurai-style tall washbasin in front of Ensho was a special favorite of Ueda. Such washbasins were designed so that samurai wearing swords would not have to crouch down to use the commonly found low washbasins.

OPPOSITE The stone tied with a neat rope knot, called *sekimori-ishi*, is a beautiful way to indicate that entrance beyond this point is prohibited.

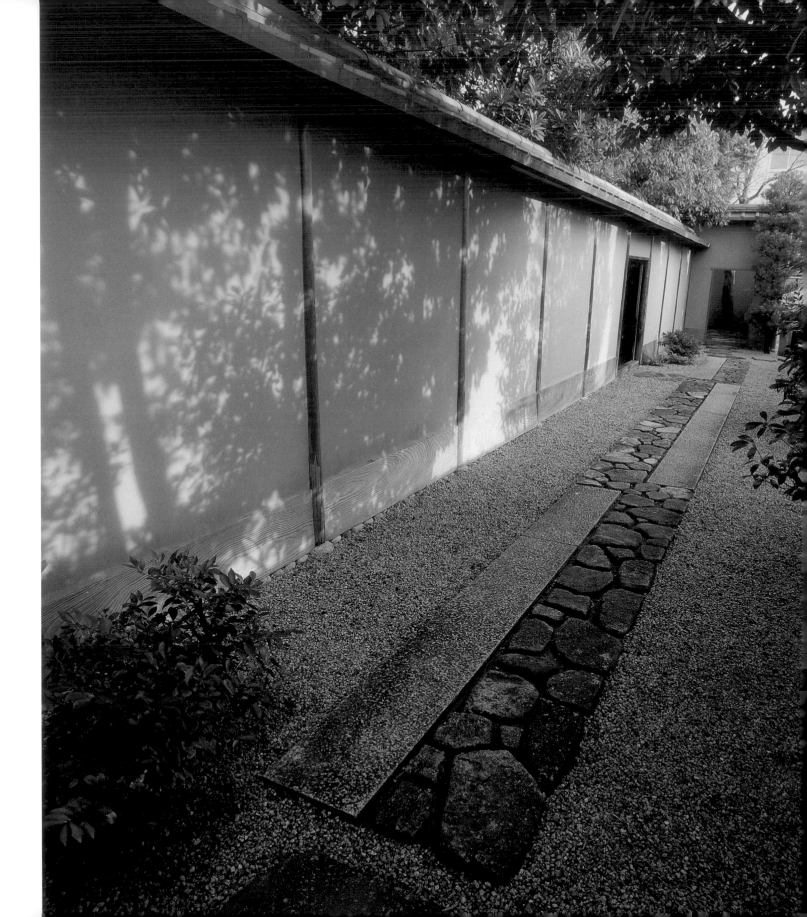

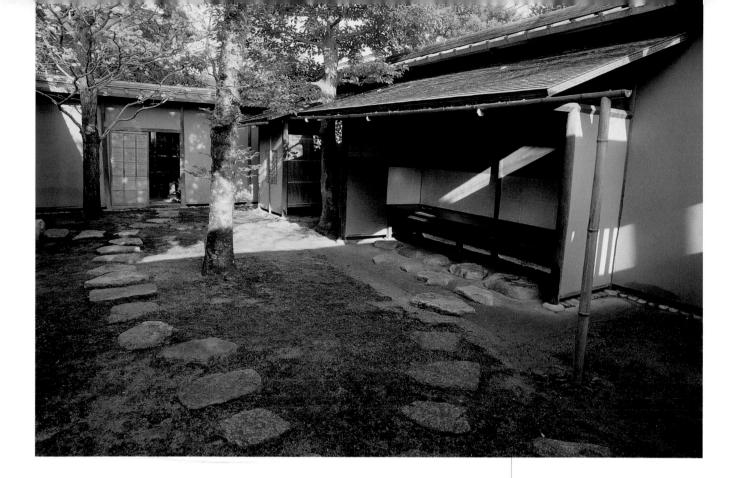

Ueda Ryu School perished, the tradition of his tea style survived and the present Wafudou was reconstructed in 1978, following illustrations of the original one made by Ueda.

The Ueda Soko Ryu garden is laid out in the style characteristic of tea gardens and consists of an outer garden and inner garden. The inner garden leads to the tea hut called Ensho, which means "the sound of bells far away," evoking the deep forest far from a city.

As is typical of tea gardens, this garden can also be thought of as setting the stage for the act of tea ceremony. First, the guest is led to the outer garden where he sits and waits on a bench surrounded by a high clay wall. With just five different tall trees, the simplicity of this garden helps the guest cleanse his or her mind. When the guest is ready, the act of getting up from the bench is a sign for the host to appear and lead the guest past the small gate in the bamboo fence, to the inner garden. The inner garden has an open feeling with many kinds of trees and bushes. Midway along the stepping stone path leading toward the tea hut one encounters a curved arrangement, causing a natural halt here. This spot has

been deliberately designed to allow the guests to catch a glimpse through the trees of the name plaque hung under the roof of the tea hut. The guests then proceed to the samurai-style washbasin located near the tea hut, which is taller than the crouching type of washbasin; this was to avoid the discomfort of crouching for the samurai who were bearing swords. The carved words on the washbasin mean "Admonish yourself." This garden, the tea hut, and the few remaining teacups and spoon made by Ueda Soko that one can see here are reminders of his free spirit and samurai discipline.

Ueda Soko Ryu, the organization responsible for restoring Wafudou, has also started to restore the main samurai residence at this estate to its Edo-period state. This will make it possible to hold contemporary as well as traditional samurai style tea ceremonies in this complex, including some designed to show respect to the guest of extremely high status, such as the Shogun. These ceremonies are a vital part of the cultural history of Japan, and their preservation as well as that of the Ueda Soko Ryu garden is of importance.

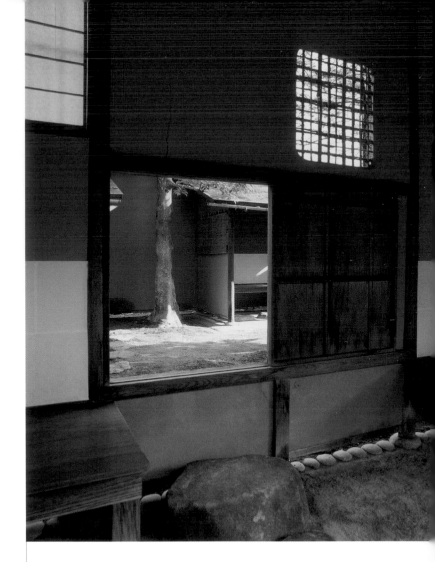

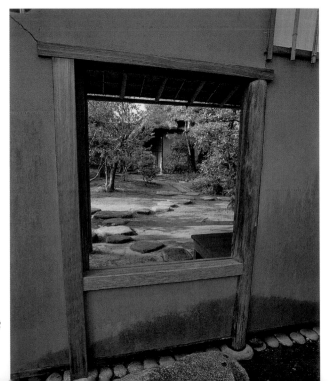

ABOVE The bench for waiting before entering the tea room can be seen through the door between the inner garden and the walled outer garden. The high reed window on the right is popular in tea huts, and made by leaving part of the bamboo lattice wall unplastered.

LEFT This small door is the only entrance from the outer garden to the inner garden. The deliberately high plinth of the door is meant to make the passage through this small entrance a noticeable act, akin to the passage through the small *nijiri-guchi* crawl door of a tea hut.

OPPOSITE The *roji* stepping stones that lead from the inner garden to the outer garden have been laid in a combination of informal and formal patterning. Such changes help to set the moods desired.

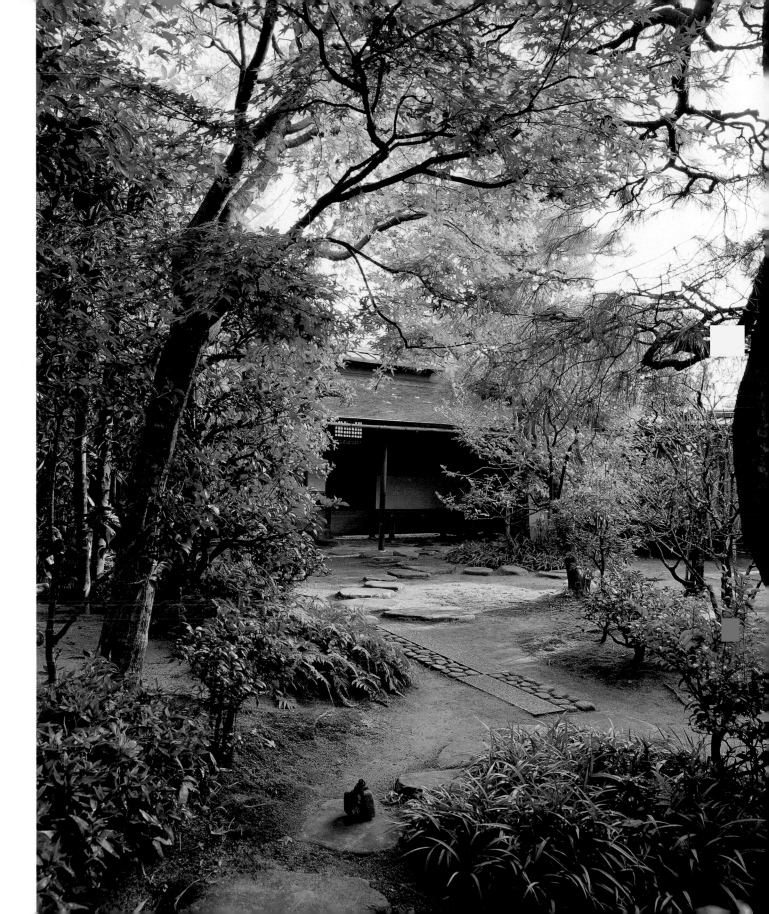

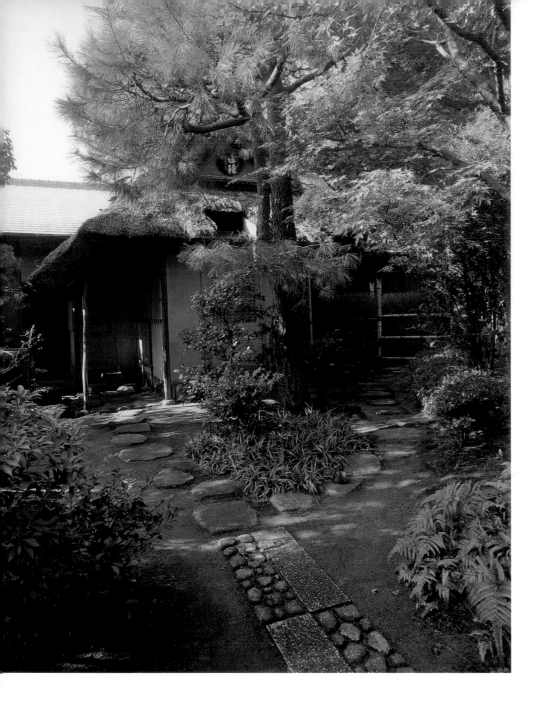

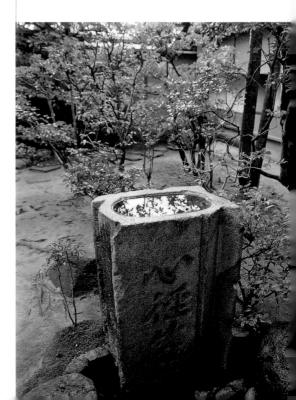

LEFT This path leads to the tea hut Ensho. From here one can see the name plaque of the tea hut through branches of trees. The name "Ensho" is meant to evoke the beauty of wilderness in a deep forest.

OPPOSITE Stepping stones have been arranged at the entrance of the Ensho tea hut to evoke nature in river valleys. The small *nijiri-guchi* crawl door can be seen on the right.

BELOW Located near the Ensho tea hut, this washbasin is said to have been a special favorite of Soko Ueda. Its tall, straight and handsome form with letters is typical of samurai aesthetics. Such washbasins are meant to be used while standing up.

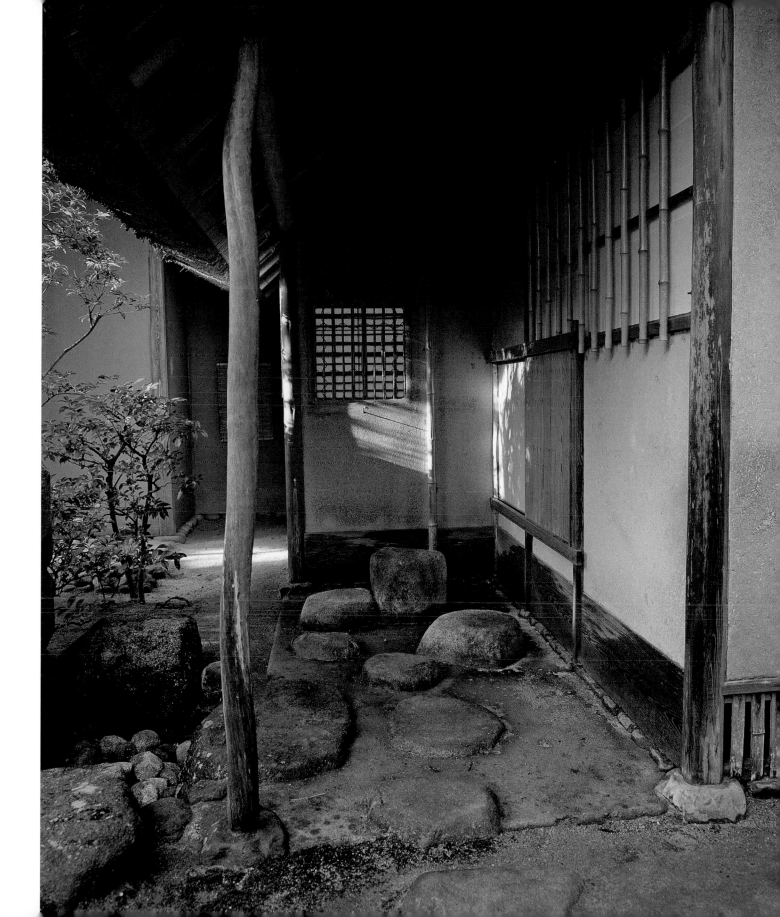

Yabashi House

Ōgaki

Situated in the middle of Japan, the Akasaka area of the Gifu Prefecture is known for the good quality of its marble and limestone. The Yabashi family started in the business of stone processing and construction about 100 years ago, and has helped build many structures of national importance including the Diet Building in Tokyo. With the marble quarries of Akasaka now depleted, Yabashi Marble Company continues its business by importing stone from all over the world.

The residence of Syutaro Yabashi, the president of Yabashi Marble Company, consists of several buildings, storehouses, and gardens. The oldest structure, which is used as a guesthouse and for tea ceremonies, is Mui-an, which means "without anything artificial." It was built around 1925 and moved across the property to its present location by tugs about thirty years ago. The trees and stones on the property are much older than any of the structures.

ABOVE A beautiful view of the roofed gate structure can be seen from inside the house. The upper part of the gate structure has been finished with lime plaster while the lower part is rendered with wooden boards.

RIGHT This balcony made of bamboo provides a pleasant setting for enjoying tea while overlooking the garden.

OPPOSITE The beauty of the garden, the Mui-an tea hut and the guesthouse complement each other in harmony.

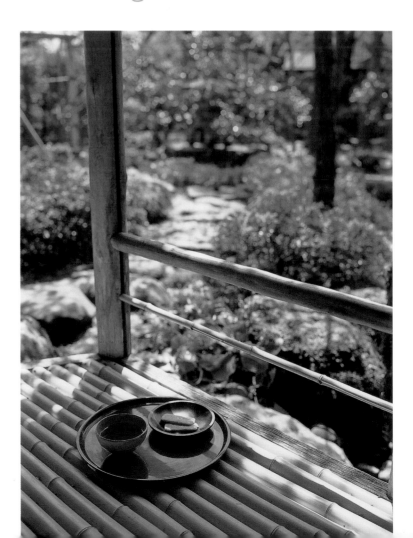

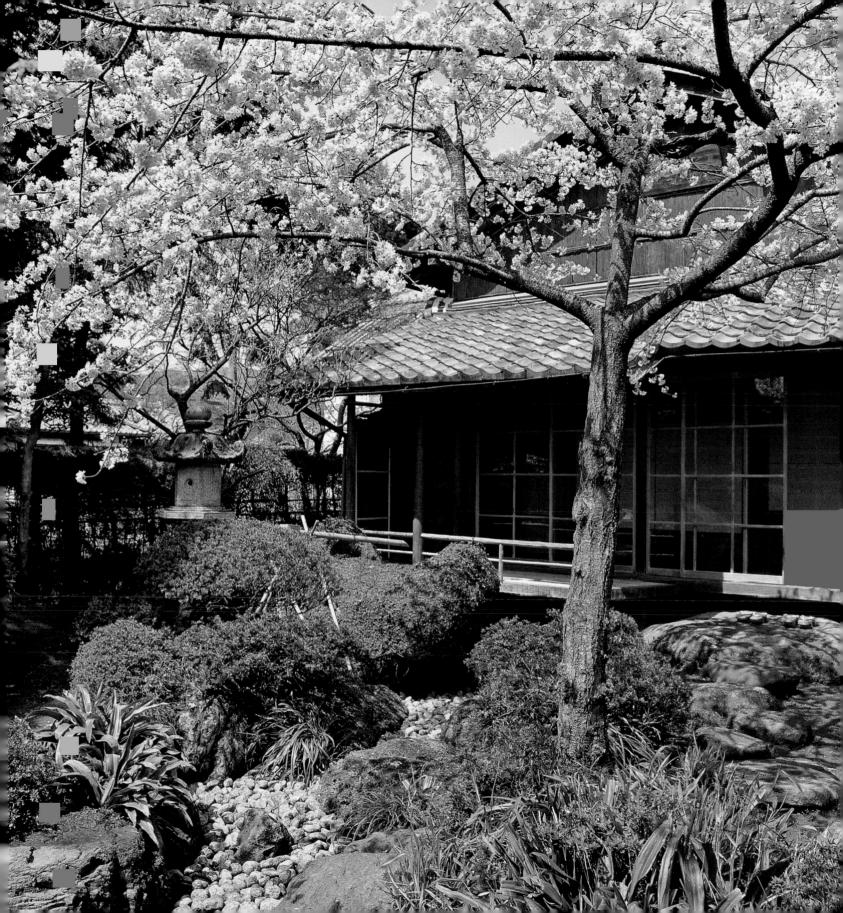

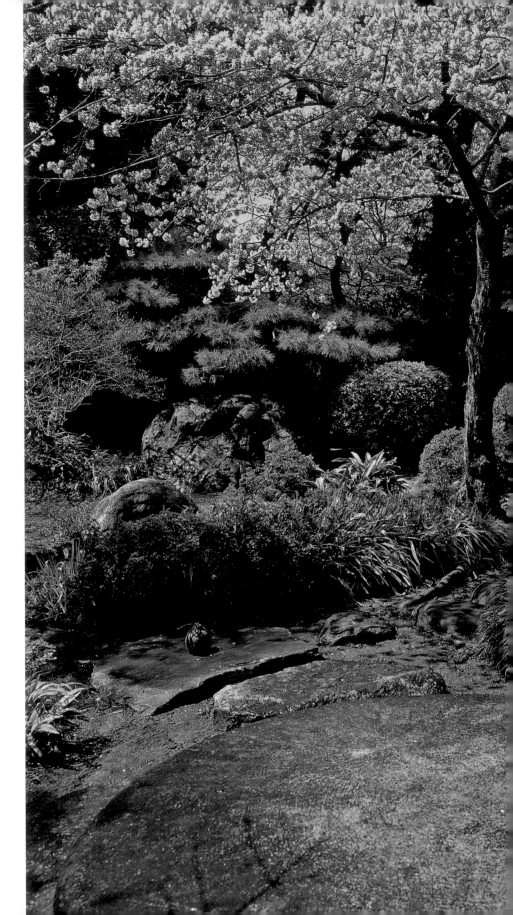

ABOVE Sandals for walking in the garden have been crafted of the outer skin of bamboo, and match beautifully with the mood of this garden.

RIGHT The special large round stone *fumiwake-ishi* has been provided just off the stepping-stone *roji*, inviting people to step aside and enjoy the special view of this garden at leisure.

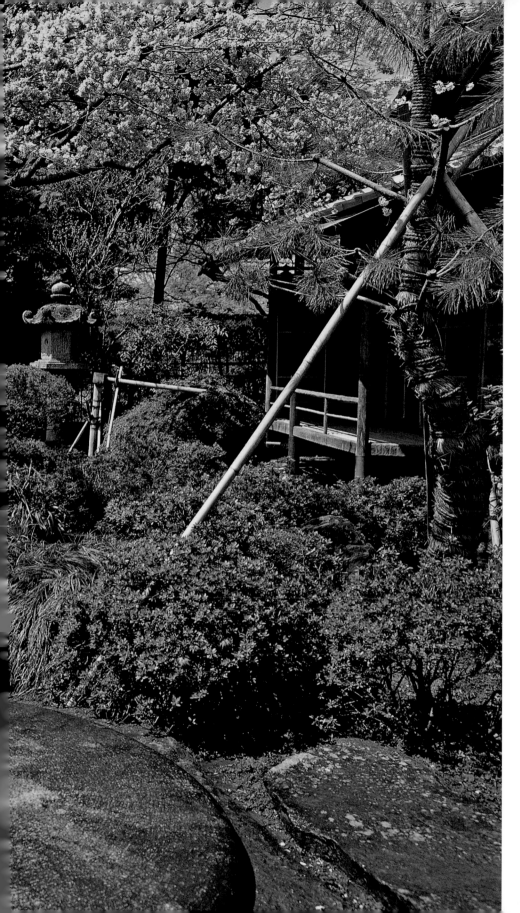

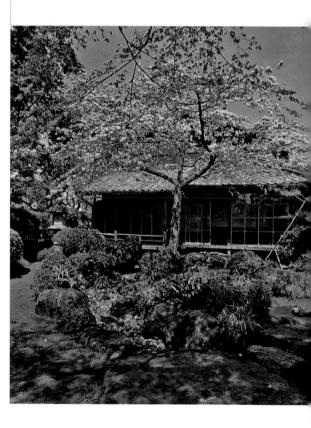

BELOW Buds of this Usuzumi-zakura tree are a deeper shade of pink than most trees of this variety. The main house, not seen in this photograph, is located toward the right.

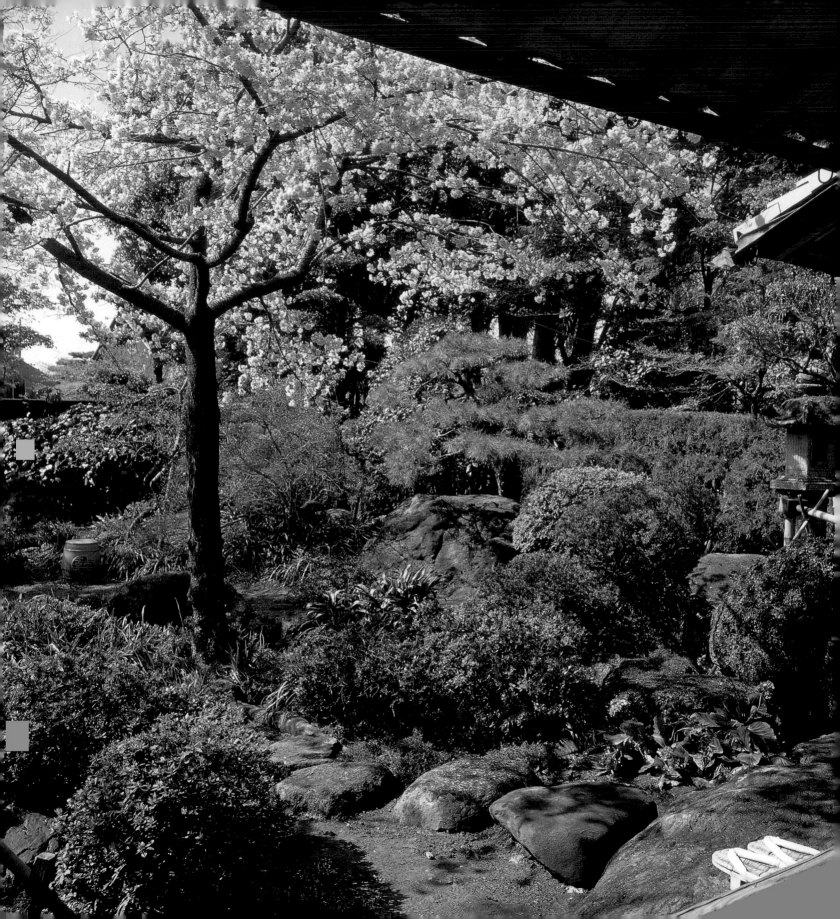

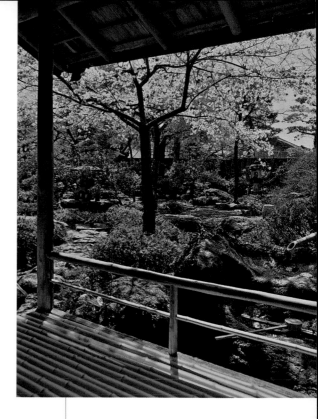

The special stones in the garden, such as "Kurama" and "Ibi," were collected by Yabashi's father, who was very fond of stones.

At the beginning of spring, the unrivalled star of this garden is a special cherry tree. The stepping-stone path from the entrance leads to a large flat granite stone called a *fumiwake-ishi* placed a bit off the path. This stone is situated to provide the best views of this cherry tree, as well as other good views of the garden. Although the most popular sort of cherry tree in Japan is Somei-yoshino, the tree here is of the Usuzumi-zakura variety. Its pink buds turn to white blossoms, which in turn become light gray before they fall. From inside Mui-an, this cherry tree presents a beautiful sight. It is also linked to another Usuzumi-zakura tree in a nearby village called Neo, which is famous for being nearly 1,500 years old, and for the many people who have helped preserve it. A washbasin, with a table nearby for placing a pail and garden lantern, has been situated in front of this tree. Each of these elegant elements is made up of stones in their natural shape.

Yabashi and his wife are classical music enthusiasts, and occasionally invite musicians from Germany to their home to enjoy the old house and the garden.

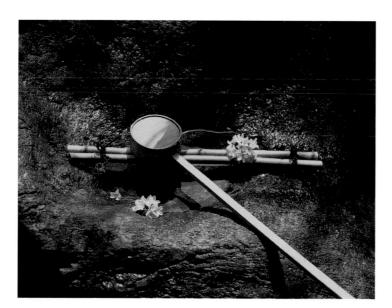

ABOVE Many special stones and trees, some of which have been here for over a hundred years, add character and a sense of history to the garden.

LEFT The washbasin is of hollowed stone in its natural shape. The *hishaku* (dipper) is made of bamboo and rests on the customary two pieces of bamboo tied with a black rope.

OPPOSITE This part of the garden presents a memorable view seen from inside Mui-an. The washbasin on the right is located just outside of the deep eaves. The height of the table for the garden lantern has been designed to light up the washbasin.

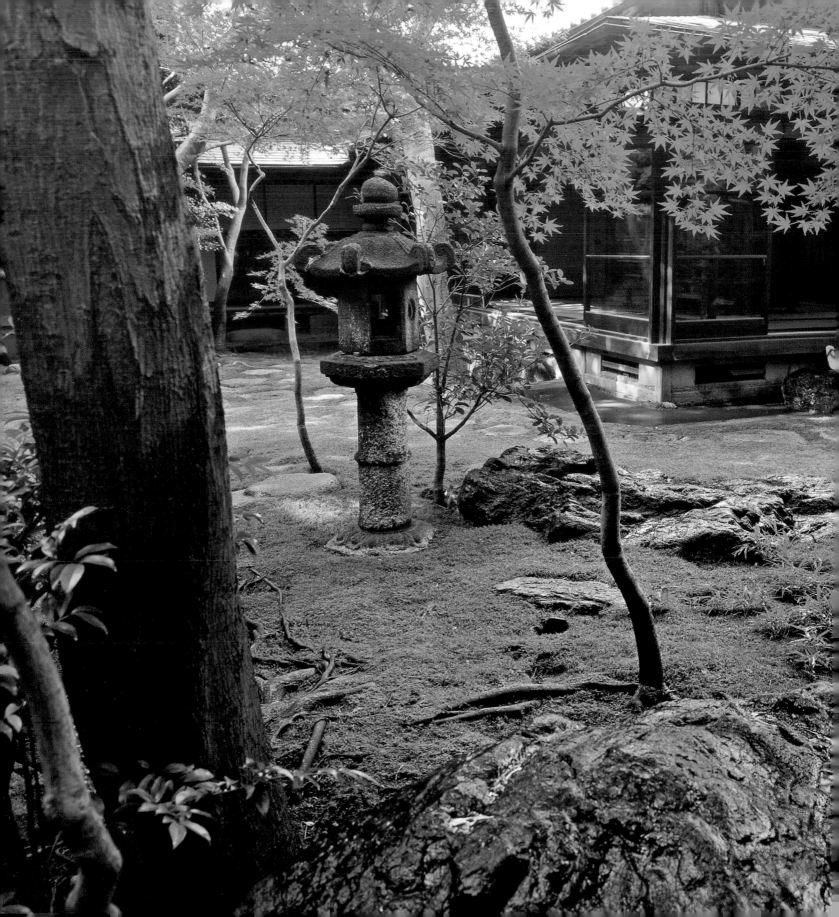

Segawa House
Tokyo

Jostled by tall buildings on all four sides, this beautiful residence symbolizes the struggle to preserve the garden and architectural heritage of Japan in the heart of Tokyo. While works of art can be put inside a museum, gardens take up precious real estate. Many families less tenacious than the owners of the Segawa garden have had to relinquish their treasured gardens due to the high inheritance taxes in Japan, a country that has successfully combined a market economy with socialist policies. Even as efforts toward historic preservation have become more common in recent years, several notable buildings in Tokyo that were built during the Meiji period have been torn down in the last three decades. Although the Segawa house and garden have been designated as a Cultural Property by the Agency of Cultural Affairs, the financial burden of maintaining them still falls upon the owners who fortunately have the passion, wisdom and a sense of noblesse oblige to do this. They have also recently built a new building on part of the property that provides income to pay for the maintenance and taxes for the old house and garden.

ABOVE The height of the *kutsunugi-ishi*, a larger stone provided for changing into garden slippers, is set according to the rule that the visitor's knees should be bent slightly above horizontal when they sit down. The *Benigamo* stone used here changes its color to a reddish tone when watered, and was therefore selected for this special role.

OPPOSITE Maple trees are prized in Japanese gardens for the delicate effect of the sunshine seen through their filigree-like leaves. Other trees in this garden include mokkoku, nezumimochi and hisakaki.

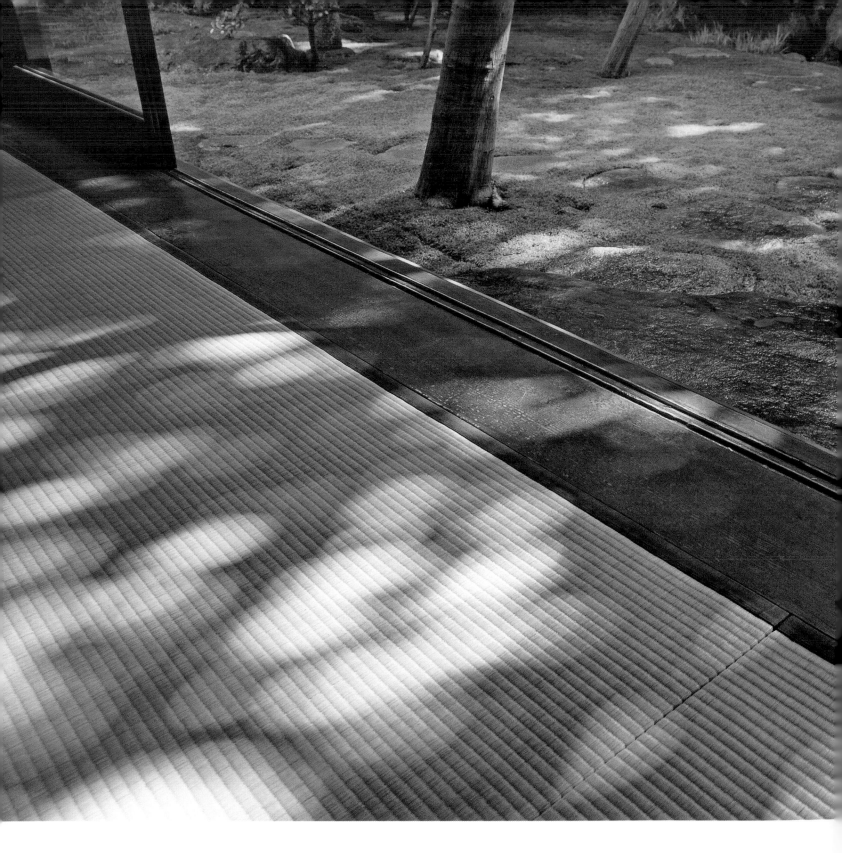

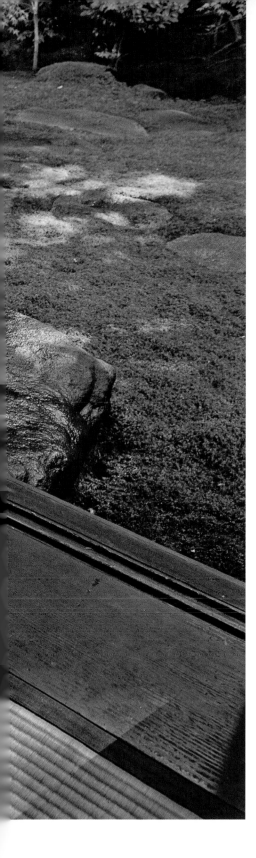

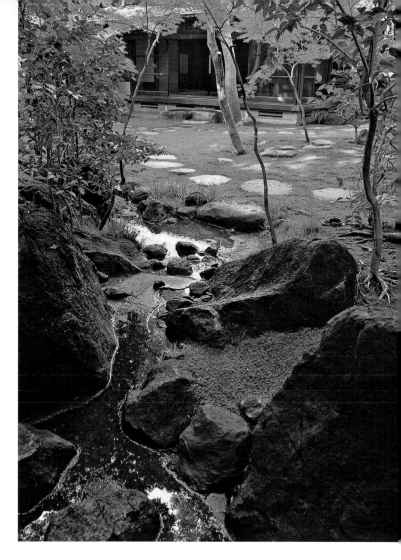

RIGHT The tea arbor Tai-an was situated and designed so that from inside it one can get a feeling of being on a boat in a mountain stream. A squatting type *tsukubai* water basin has been set in the stream as a playful accent.

LEFT The floor of the engawa patio is covered with *usuberi* tatami mats that do not have the usual thick base.

The Segawa garden and the house were originally built in 1887, just as Japan was coming out of its feudal past into the Meiji period's modernization. The original estate was much larger than it is today. Located close to the busy Kasuga Street, this exquisite house and garden are entered from a side street by passing under a multi-storied building, which now stands on what was the front garden of this estate. The gabled entrance of the house is visible from the street, a glimpse of an age of architectural grace seen through a tile-clad high-rise that represents the practicalities that define modern Tokyo. The new building's architect is said to have chosen the color of its tiles to harmonize with the old building.

The stone path laid amid gravel from the entrance leads to two buildings. The gabled facade in the center is the guesthouse, designed to entertain important guests. The guesthouse is laid out

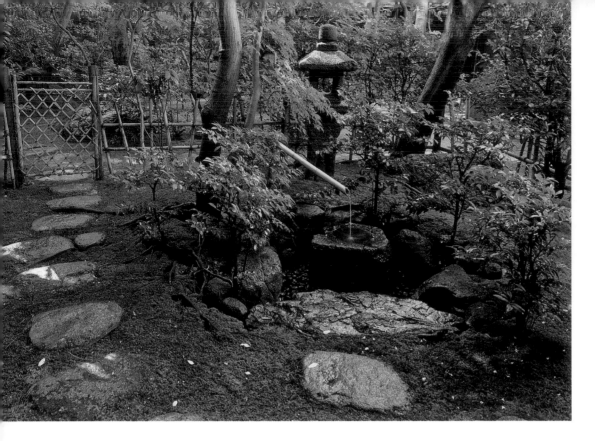

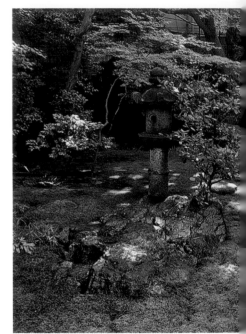

in a zigzag plan known in Japan as goose flight pattern or *ganko* formation, meant to afford views of the garden from various points. Upon entering the guesthouse, one passes through the entrance hall to the Western style reception room that was also used for staging Nō plays in days gone by. This reception room leads to the large *shoin* style Japanese room with twelve and a half tatami mats, and two sides open to the garden. The garden was laid out so as to serve the guesthouse as well as the main house.

The main house, entered along the stone steps to the right, is approximately the same size as the guesthouse and is built on two floors. The Segawa residence was originally built for Koichi Furuichi in 1887. Koichi was a distinguished civil engineer and scholar during the Meiji and Taisho periods. Since many professors and doctors of the University of Tokyo lived in this area during the Meiji period, it was called "doctors' town." Western style rooms in homes, and Western motifs on metal hardware, were popular features of residential architecture at that time. Masayo Segawa, a medical doctor and the son-in-law of Furuichi, inherited the house and moved here when his own house was damaged in the 1923 earthquake. He loved the house and garden, and added

ABOVE This stone lantern is located at the center of the garden under the maple tree (see page 98), and can be seen from everywhere in the garden.

RIGHT A special large red rock at the side of the Isshi-an tea room is for viewing by people as they come along the *roji* stone path to climb on the *tobi-ishi* stepping rock before entering the tea room. The stone lantern is an old Ōribe *toro*.

OPPOSITE Every room of the house has been designed for enjoyment of garden views, and has stepping-stones leading into the garden. Gardeners take special care in selecting natural stones with a flat surface for use as stepping stones. The gravel between the two rows of curved vertical tiles dug into the ground is for catching rainwater from the eaves of Isshi-an.

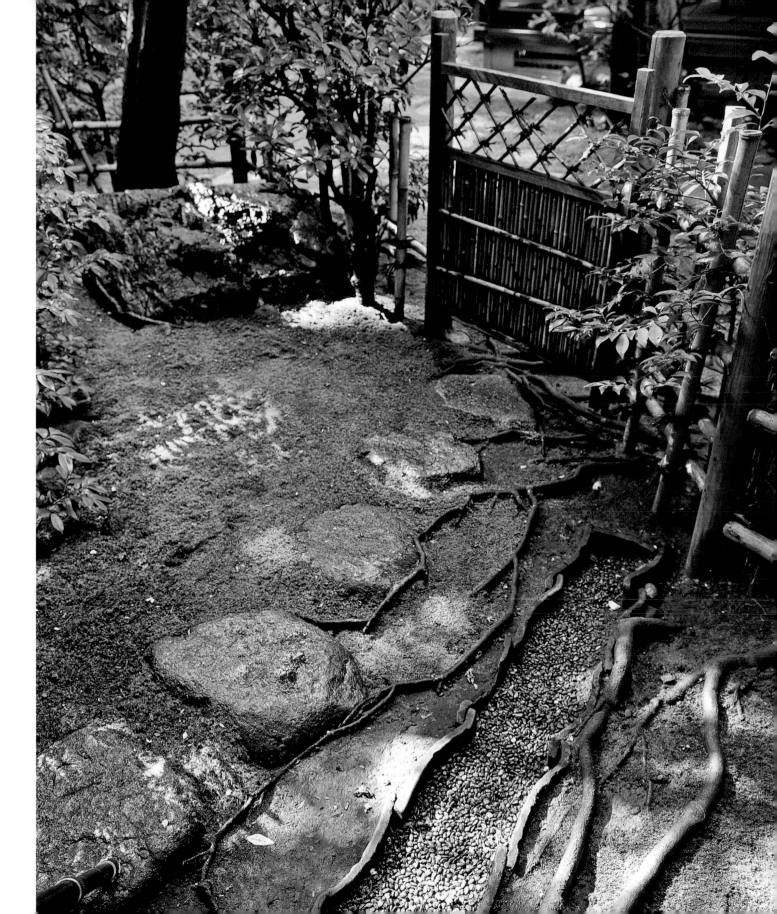

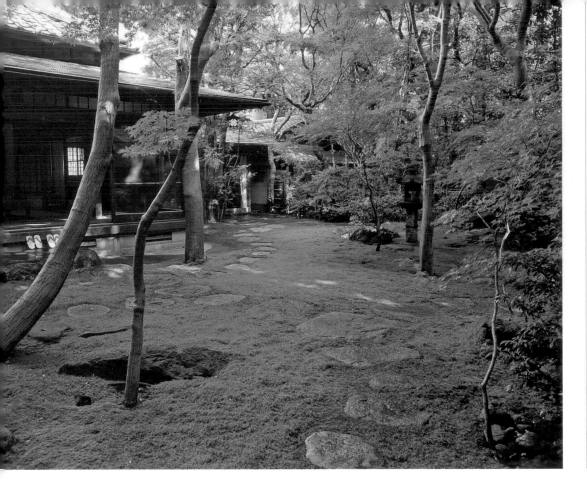

a large tea room, the eight-mat Japanese style Buddha room, and the tea room named Isshi-an during the early Showa period. The house again escaped damage during the World War II bombing. Masayo's son, Isao Segawa, was also fond of the house and added the moss garden from 1952 onwards, a feat that was considered impossible before this time. He made the tea arbor, named Tai-an, in 1959 for his wife under the guidance of the famous gardener Taiami Tanaka. Currently, this house and garden are being maintained by the members of the fourth generation of the Segawa family.

The garden is the integral part of the design of the main house as well as the guesthouse. It has been planned in a swirling pattern around the central mound on which there exists a sprawling old shinoki tree and several large rocks. This mound backs up against the wall and keeps the line of sight from being disturbed by the modern buildings behind it. From here a small rivulet meanders through the garden, and stone paths lead to the tea room and the tea arbor, the main guest room and the main house. The tea arbor

is so positioned that once inside, one gets the feeling of floating on a boat along a rivulet.

The lush moss in this garden is rare in Tokyo, which unlike Kyoto and Kanazawa does not have a climate conducive to its growth. Isao Segawa had brought in moss of various types from all over the world to start this garden, and the species that successfully adapted to the Tokyo climate abound in this garden today. The predominant species of moss is from Okutama, the western mountain region of Tokyo, and is called chochin-goke. This sort of moss grows vining on top of itself, occasionally growing into a carpet as thick as five centimeters. Isao cared deeply for this moss and watered it personally every morning and every evening.

The Oribe lantern in front of Isshi-an tea room is one of the oldest styles of garden lanterns in Japan, and was first produced in the Momoyama period. Such lanterns are named after Oribe Furuta, the famed samurai tea master. These lanterns do not have a base and are planted straight into the ground.

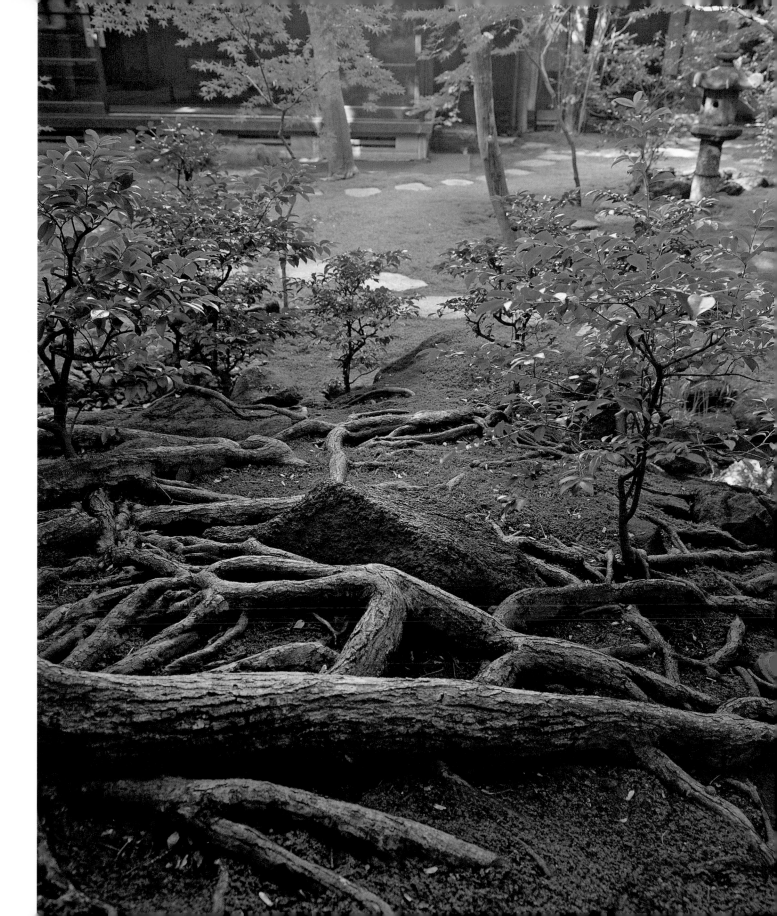

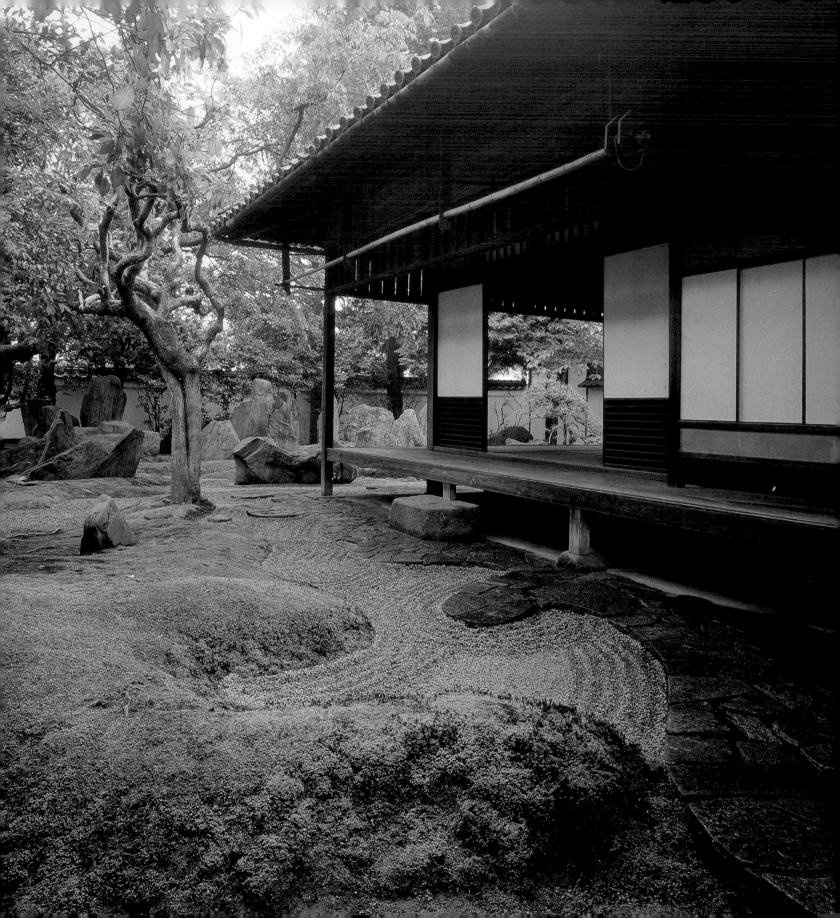

Shigemori House

Kyoto

Driven by the urge to make the invisible, mysterious forces of nature tangible, man saw a particular substance stand out in the gloom of primeval nature — a solid, immovable rock. — Kenzo Tange, architect (1913–2005)

Mirei Shigemori (1896–1975) was a poet of rocks. A scholar trained in ikebana, painting, and tea ceremony, he became interested in garden design when he compiled the first ever survey of Japanese gardens, which took up twenty-seven volumes. Perhaps this breadth of understanding of Japanese and Western arts helped him to redefine Japanese gardens. He created over 180 gardens in Japan between 1924 and 1975, including the much-celebrated gardens at Tofuku-ji, Zuiho-in, Sumiyoshi Shrine and Fukuchi-in. However, Shigemori is also one of the most controversial garden designers in recent history. His compositions are bold and deliberate, each different than the others. While

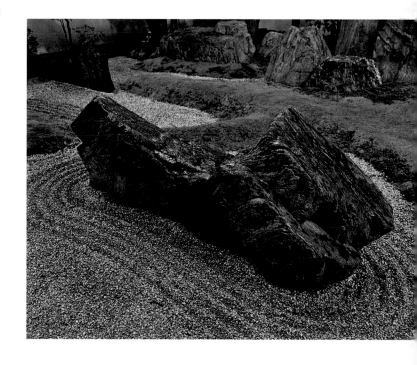

RIGHT This boat-like stone is from Awa, a place famous as a source of blue stones that turn a deeper shade of blue when wet. The boat symbolizes the need to transport one's mind from the mundane to the sublime.

LEFT The wave pattern of stones surrounds the *engawa* patio of the formal room in the house, and is a pattern boldly used by Shigemori, one of the most innovative garden designers in Japanese history.

The four rocks next to the circular worship stone represent the Sennin (also called Shin-sen) islands thought to exist far out in the ocean according to Chinese legends. These islands are supposed to be inhabited by Sennin monks who have the elixir of life. In Japan, this arrangement of rocks traditionally represents the concept of eternal youth.

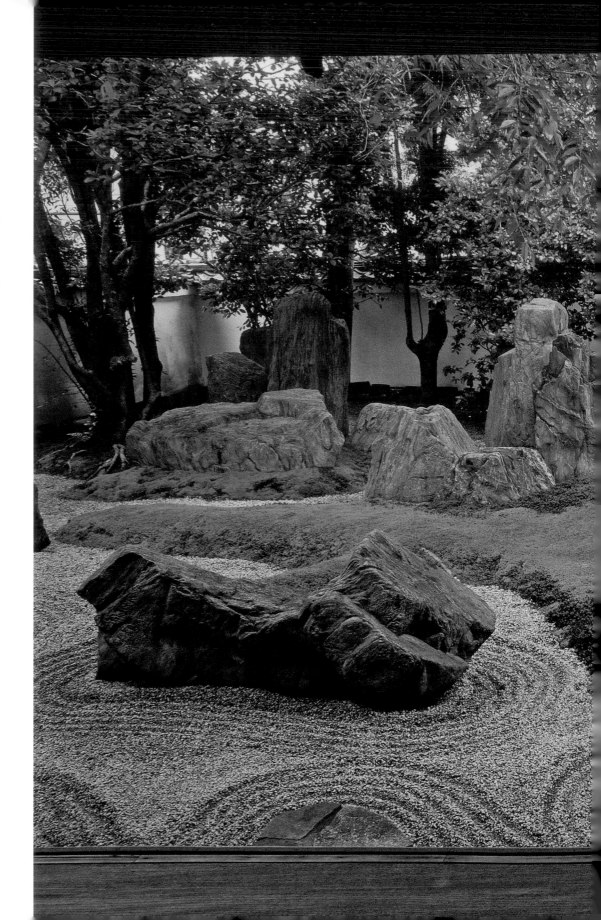

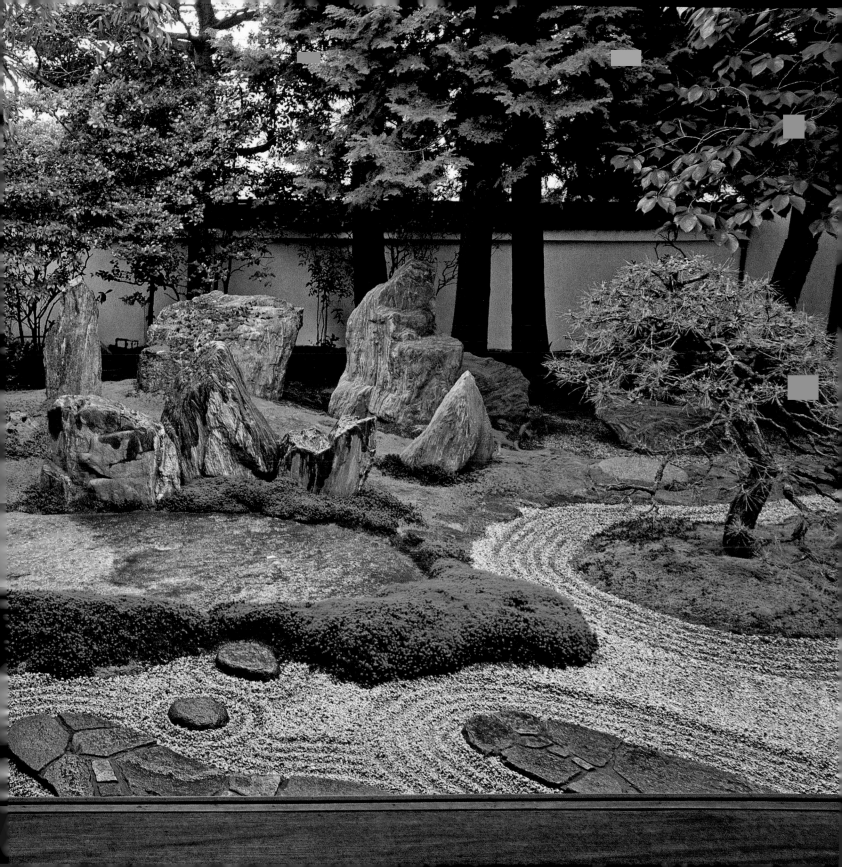

most people credit him with modernizing the Japanese garden, others criticize his venturing too far away from the spirit of what a traditional garden is. Whereas traditional gardens are content to mirror nature, Shigemori chose to combine concepts and materials from nature with contemporary materials, shapes, colors and techniques for innovative new compositions. According to him, a garden should have timeless modernity. He was enthusiastic in redefining traditional gardens and thought that they should also be used as performance and exhibition spaces. Shortly after the completion of his *karesansui* garden at the Kishiwada castle, an exhibition of avant-garde flower art was held there. He also produced a traditional dance performance for the event, in which the theme was the straight line and curved line. His 1969 design for a tea house, known as Tenrai-an, featured a design of stepping stones in a painted cement base, which was more like a sculpture to walk on rather than a garden.

In the design of the garden of his own house featured here, Mirei Shigemori seems to have enjoyed pushing the limits even further. The Shigemori house and garden were originally the property of the nearby Yoshida Shrine, and can be traced back to the mid-Edo period. Shigemori acquired this property in 1943, and gradually redesigned the garden and the house, adding two tea huts called Muji-an and Kokoku-an in 1953 and 1969 respectively. The main garden surrounds the house on two sides, and there are two small *tsubo niwa* gardens near the tea huts. The living room of the house is designed with an *engawa* porch on two sides facing the garden. This room can be completely opened up to the garden by sliding the partitions aside.

RIGHT The wave-like pattern of paving stones is a good example of Shigemori's creativity. The Tanba Kurama granite stones toward the left have been set in red mortar made of cement mixed with bengala, a red pigment originally imported from Bengal in India.

FAR RIGHT Flouting the rules generally followed in Japanese gardens, Shigemori grouped large vertical stones together with great flair. Care was taken to put more than half of a stone in the ground for stability.

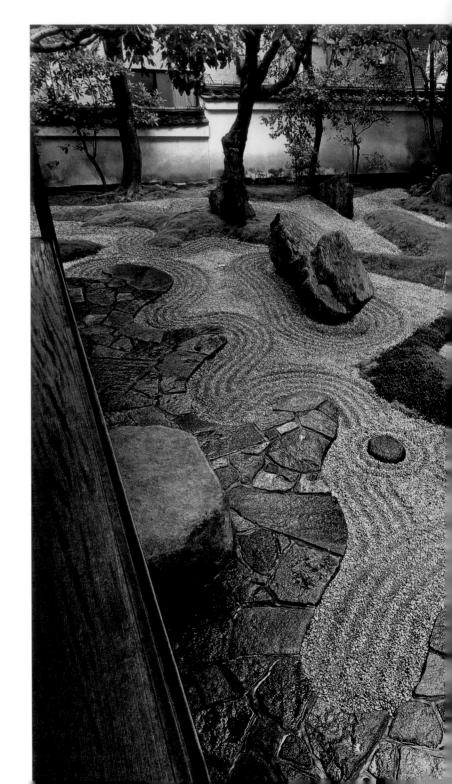

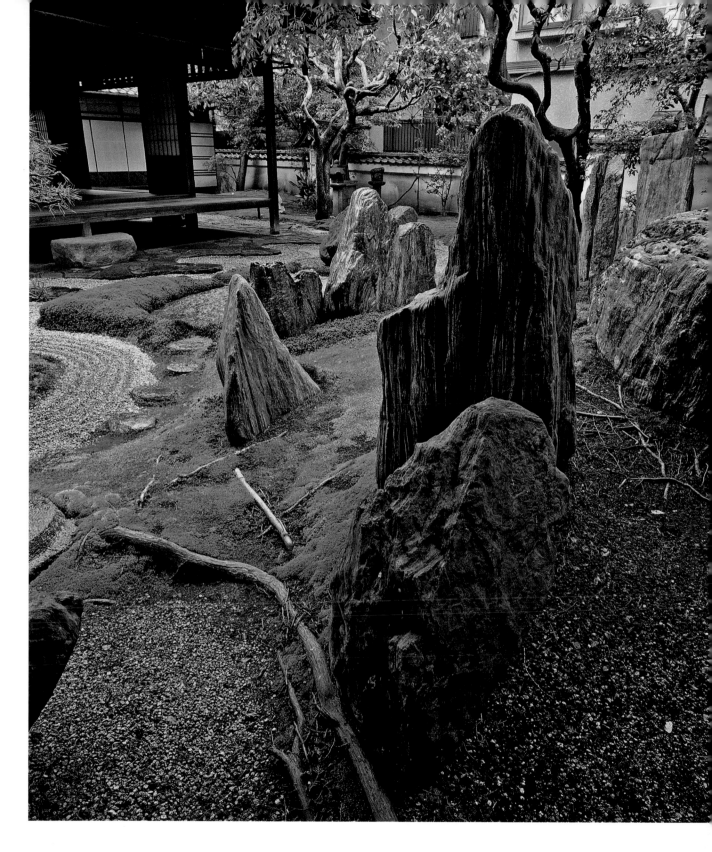

Shigemori House, Kyoto

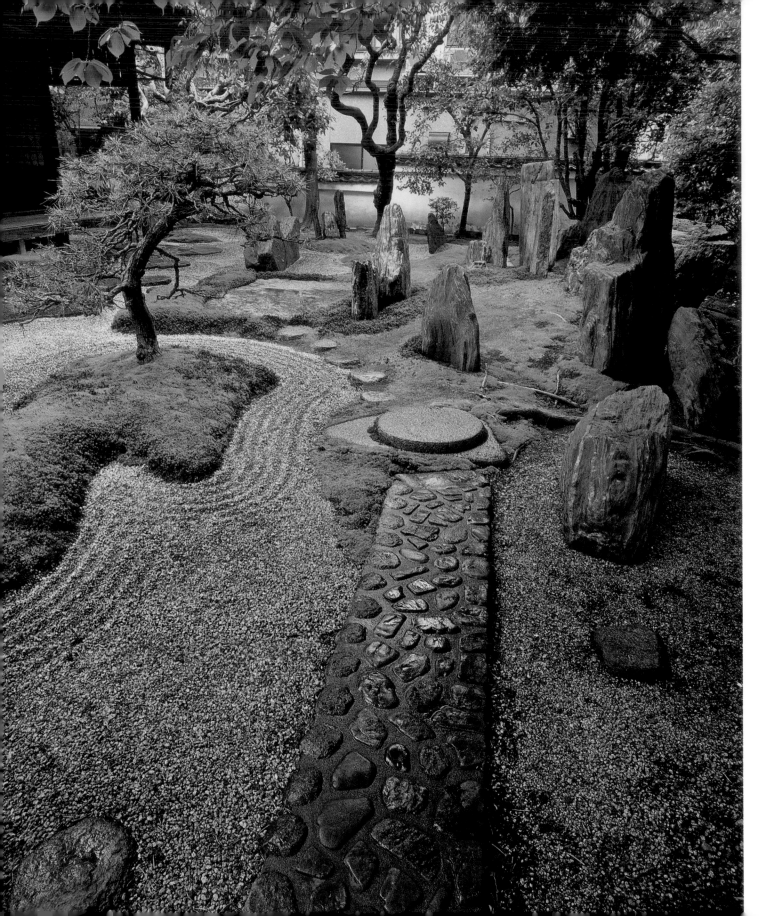

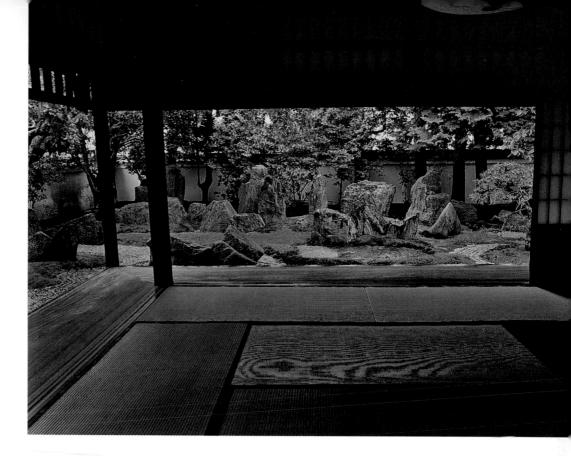

RIGHT The main garden is spectacular when seen from the *shoin* drawing room. The large worship stone in the center was here before Shigemori acquired this house.

LEFT A straight stone path leads the eye and the guests from the entrance to the interior of the garden. One can enter the house by following the pathway at the far left. This approach formed a perfect entrance for the tea ceremonies that Shigemori sometimes held for his artist friends.

In keeping with the principles of Japanese garden design, the *karesansui* or dry landscape garden at Shigemori house has a distinct foreground, mid-ground, and background. The foreground is made up of stepping stones, moss forms and undulating expanses of raked pebbles in a dramatic wave-like pattern. The colors of the dark stones (bluish stones from the Awa region in Shikoku) against white sand and the green moss are typical Japanese garden materials, but used here in an innovative modern way. However, the mid-ground provides the biggest surprise, with very large stones arranged in a radically unconventional fashion. Traditional Japanese garden books warn against setting many large rocks in a vertical position close to each other. However, this rule has been trounced over and over again in this garden with great success.

Many of the rocks in the garden also tell a story. The four-rock formation in the center of the garden represents four islands of the Buddhist heaven or the mythical Sennin, the monks with superpowers from Taoist belief. Nearby, a tall rock represents a crane, while the low rounded rock next to it represents a turtle, both Japanese symbols of longevity. A large flat "worship rock"

in the center was meant for standing on while facing the Yoshida Shrine to pray. Another rock is shaped like a boat, a frequent symbol in traditional Japanese gardens that represents the means of transporting one's mind from the mundane to the sublime, or the journey to the world of Buddha. The background of all these dramatic rocks is made up of still larger rocks and trees near the outer wall of the garden. Some scholars believe that a red pine tree that existed in the middle of this garden when Shigemori acquired it was used by him as a symbol of Mount Horai, the center of the Buddhist universe. However, since this tree does not exist any more, the tall rock there may now be interpreted as Mount Horai, and the low rocks around it thought of as Hojo, the heavenly islands. In either case, the present garden may not be fully representative of Shigemori's intentions.

Taking care of a garden such as this is a very expensive and time-consuming process. However, Mirei Shigemori's house and garden are at present fortunately in the hands of Mitsuaki Shigemori, his grandson, who has taken it upon himself to preserve them and also make them accessible to the public. He is planning to continue doing so with institutional as well as corporate support.

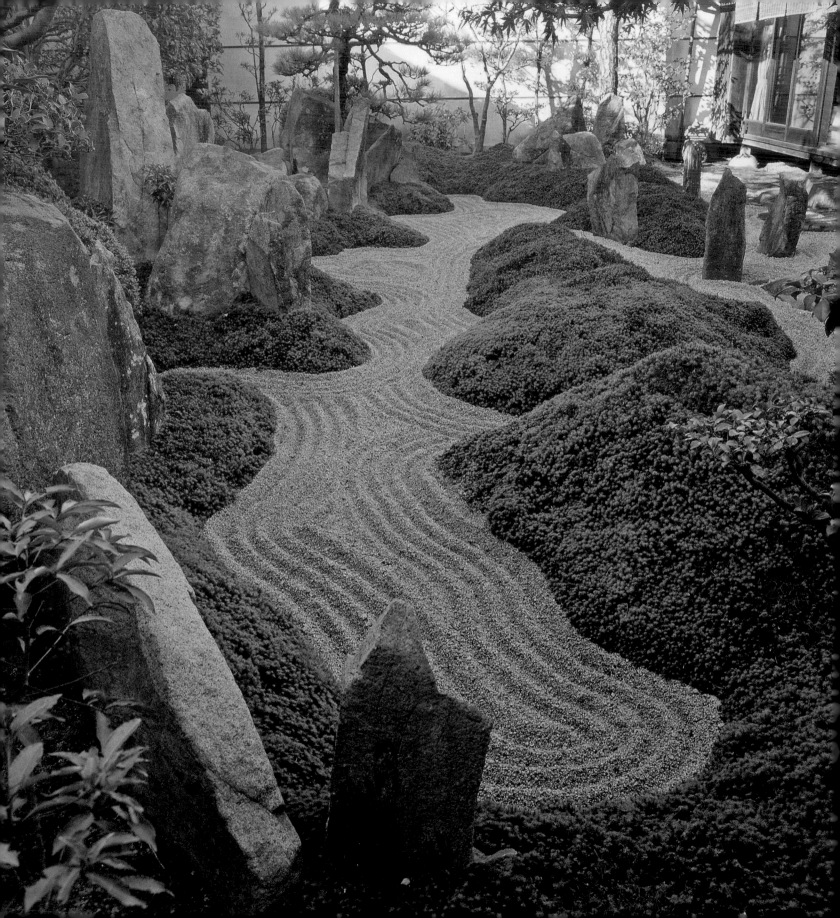

Kamoizumi House

Higashihiroshima

Sake, the Japanese rice wine, is usually produced in locations with
access to good spring water. Kamoizumi Brewing Company chose
the site of Higashi Hiroshima and has been making sake there
since 1912. Although sake making practices have been changing
since World War II, this company has sought to revive and
preserve traditional methods. Hisao Maegaki, the third-generation
president of this company, has in particular been working on
popularizing *jyun mai syu* sake made just with rice, *koji* and water,
without the use of alcohol or saccharine.

The Kamoizumi house and storehouse were originally built nearly
240 years ago, and several extensions and renovations have been
carried out to the property since then. Hisazo Maegaki, the father
of the current owner, built the main drawing room in 1955, and
had wanted to rebuild the garden in front of it too. Coincidentally,
the famed garden designer Mirei Shigemori happened to visit
the house after an introduction made by a relative. Known as a
pioneer of modern Japanese garden design, Shigemori was quite
busy with working on bigger temples and public buildings at

RIGHT The sake produced by the Kamoizumi brewery is not clear like
usual sake, but has a bright yellow tinge because activated carbon is not
used during the filtration process. The result is sake that is mellow, rich,
and full-flavored.

LEFT The garden has a perfect balance of stillness and dynamism sought
in Japanese aesthetics. Except for Shirakawa sand and some rocks, all
other material including the stones, flagstones, sand and moss have been
procured from the local area.

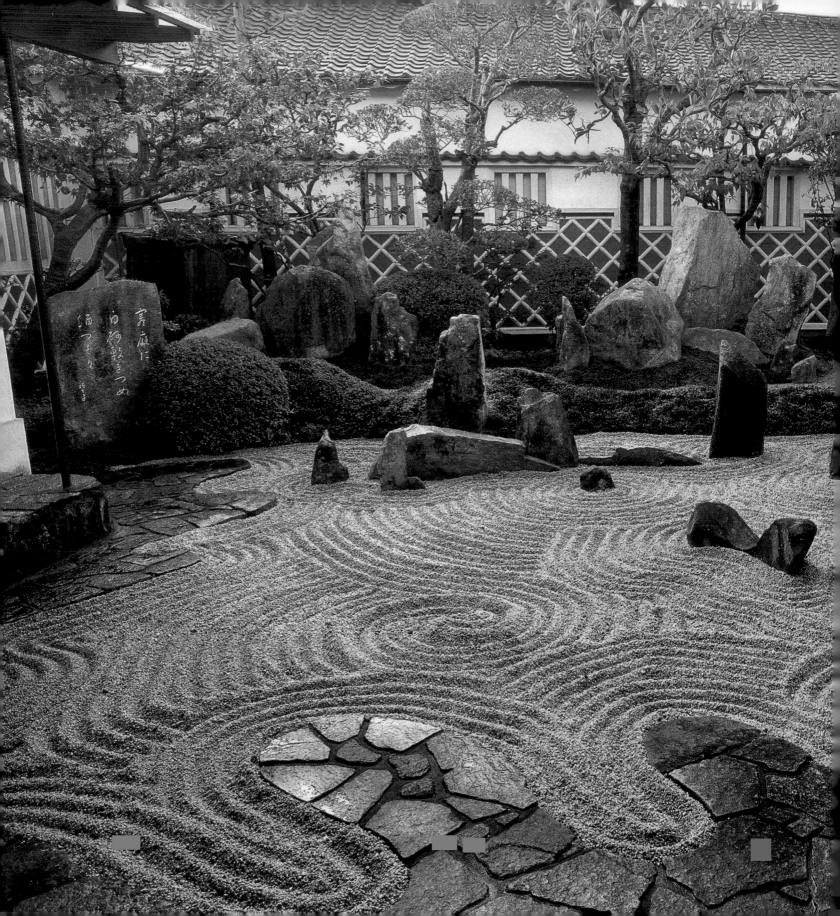

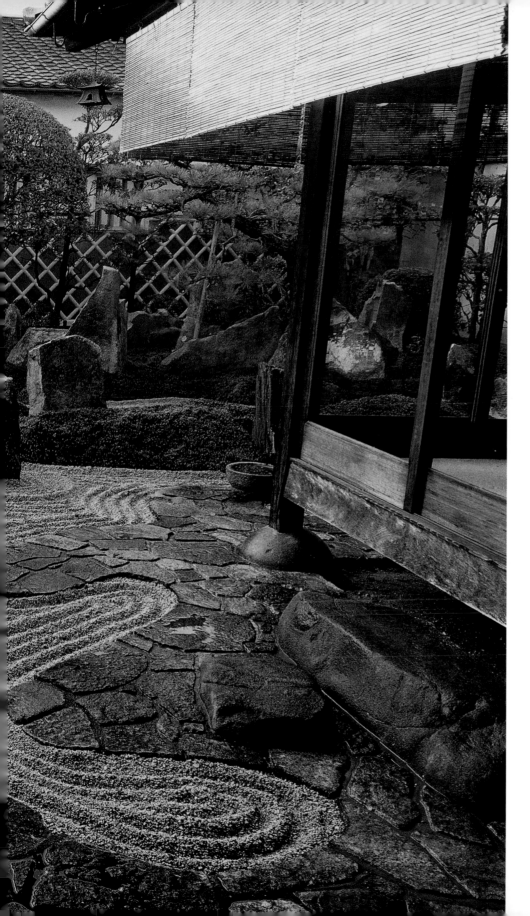

ABOVE This stone tablet is inscribed with a haiku poem by Seishi Yamaguchi, a well known poet. It can be roughly translated as "Making sake near white sand in severe cold winter season."

LEFT The garden view here is seen from inside the house through the *engawa*. The white raked stones from the Shirakawa River in Kyoto are referred to as Shirakawa sand, a hard-to-find commodity these days.

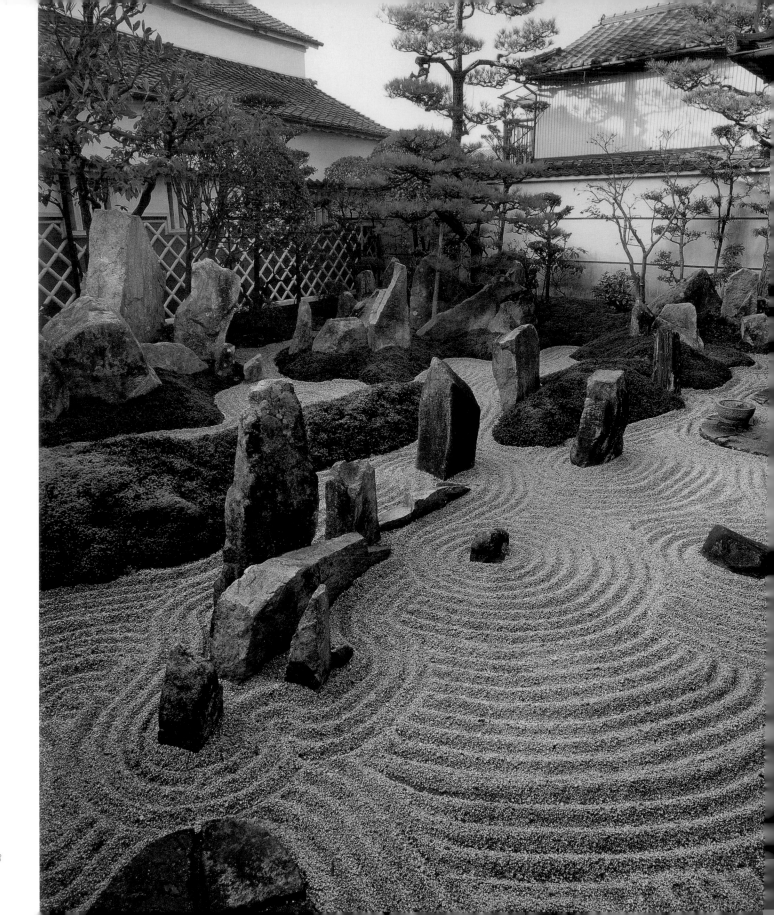

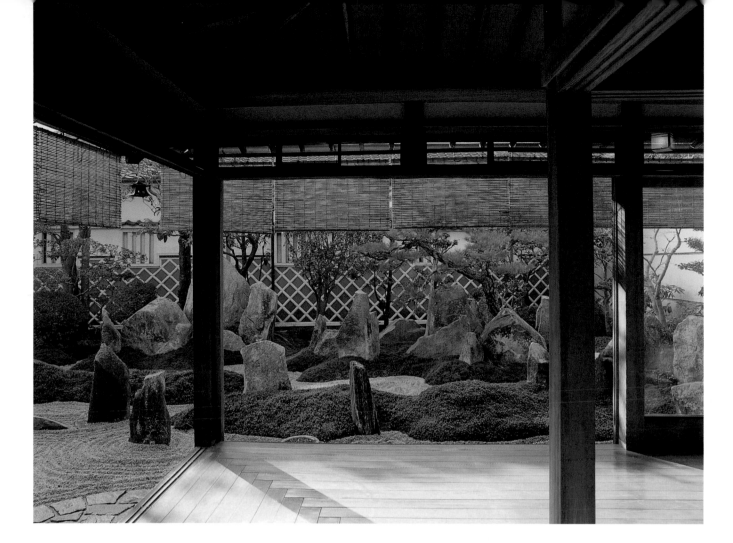

that time. However, he fell in love with Kamoizumi house. Soon after he left it, he sent a telegram to Hisazo to inform him of his intent to design the garden, and the day he planned to start work. Shigemori arrived on the appointed day with his many followers and set to work to create the beautiful garden we see today.

Shigemori wanted to use an existing storehouse in the back of the garden as *shakkei*, or borrowed scenery. Typical of storehouse construction in the area, the wall of this building had been finished with *namako* black tiles set in white lime plaster. However, since the wall of the storehouse was considered too short for the purpose by Shigemori, the Maegaki family rebuilt it to the desired height. The garden itself was designed by Shigemori incorporating trees that had existed on the site before. He also went to the

mountains owned by the Maegaki family and selected rocks by marking them with his walking stick; these were then brought back by his followers. Shigemori carefully directed the positioning, direction, and combinations of each rock that had been brought, according to the plan he had in mind when he selected them, so that not a single rock that was brought went unused.

ABOVE The deep *engawa* porch allows the family a perfect place to enjoy the garden.

OPPOSITE The walls of the storehouse in the back of the garden have been used as *shakkei*, or borrowed scenery. Typical of storehouse construction in the area, the wall on the left has been finished with *namako* black tiles set in white lime plaster.

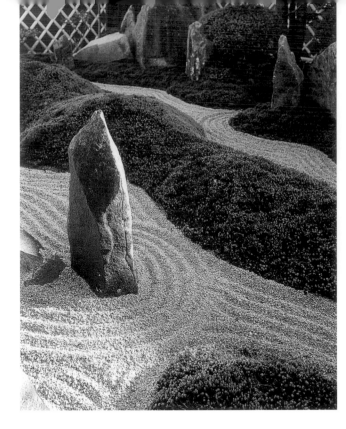

LEFT AND BELOW The highest ideal for a Japanese gardener, architect or artist is to be as invisible in their creations as possible, and to create something that may look like it was always there. Shigemori succeeds in doing this in small details, which together make up a dramatic composition.

RIGHT This small courtyard has been made into a memorable place simply by the arrangement of stones and white sand. The Maegaki family enjoys raking various patterns on the Shirakawa sand.

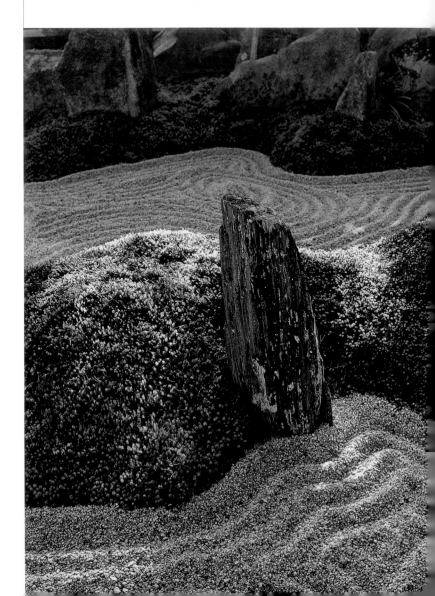

In the half century since its completion, the garden has matured. Pine, fragrant olive and maple trees form the background, while gentle hills covered with moss and stones stand in perfect harmony forming the mid-ground. The flat flagstones are arranged in shapes of waves along the *engawa* of the house to form the foreground. The remaining foreground is filled with white Shirakawa sand on which wave-like patterns are raked. The background of the *namako* wall of the storehouse indeed forms a perfect complement to the garden, even though its white lime plaster wall has changed color with the passage of time and rainwater washing over it, just as Shigemori envisaged over fifty years ago.

The current owner Hisao explains that this garden design had been inspired by the Setonai-kai sea located not so far from his house, which has a lot of small islands. His father had enjoyed watching this garden as he got old, while he himself had played with the stones in the garden as a child, imagining the flat stones to be sailboats in the sea. Although the garden is a work of art, it is not like a museum piece for him but rather a living part of his family's life. He considers this to be the true beauty of this garden. He enjoys welcoming guests to his house to share his garden and tea with them.

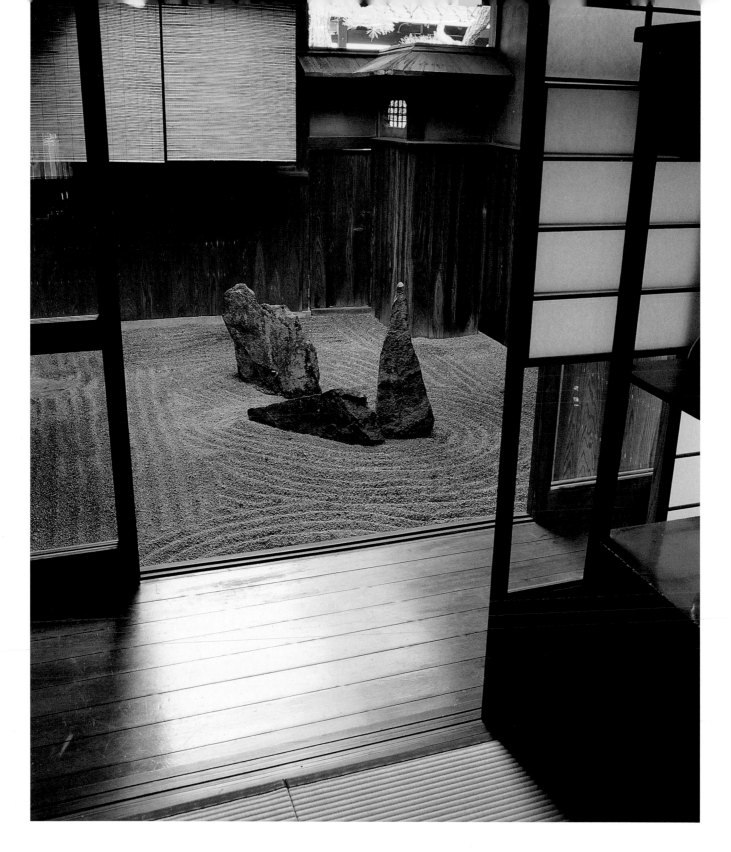

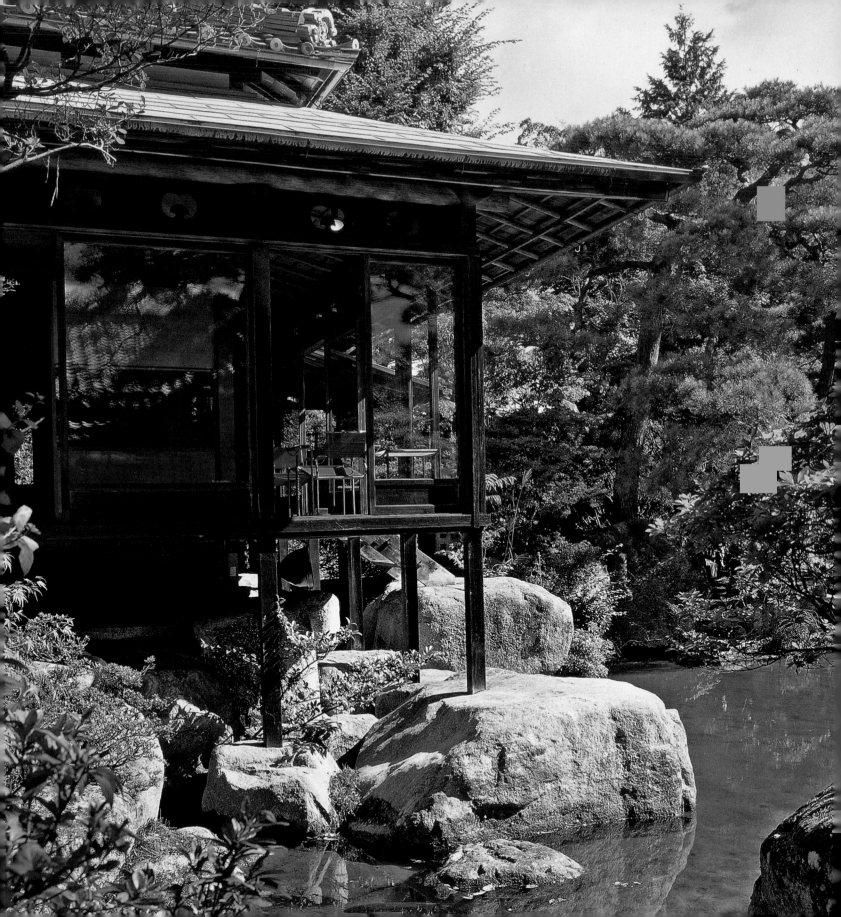

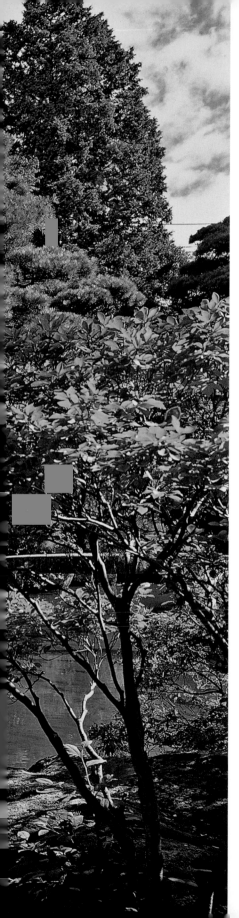

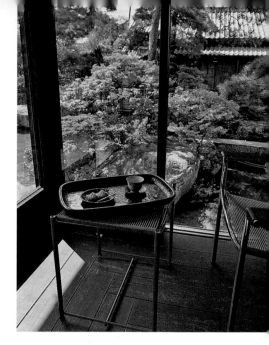

Suya House
Nakatsugawa

Made of crushed chestnuts with a subtle hint of sugar, *kuri-kinton* is a special sweet enjoyed during autumn in Japan. Eating fresh *kuri-kinton* is said to prolong life by 75 days, probably from the pleasure it gives. The history of this sweet goes back to Edo period, when the great-grandfather of Ryoichi Akai, the eleventh and current head of the Akai family, started making it. Before that, the Akai family ran a pawnshop and was in the vinegar making business, which gave them the name Suya (*su* means vinegar and *ya* means shop). When the traffic on the Nakasendo highway

ABOVE *Kuri-kinton* sweets make a nice complement to green tea.

LEFT The house has been raised on a base of large stones, with a terrace that juts out over the water and helps integrate the interior and the garden. This terrace is also the coolest place in the house, since garden breezes blowing under the house help cool it in summer.

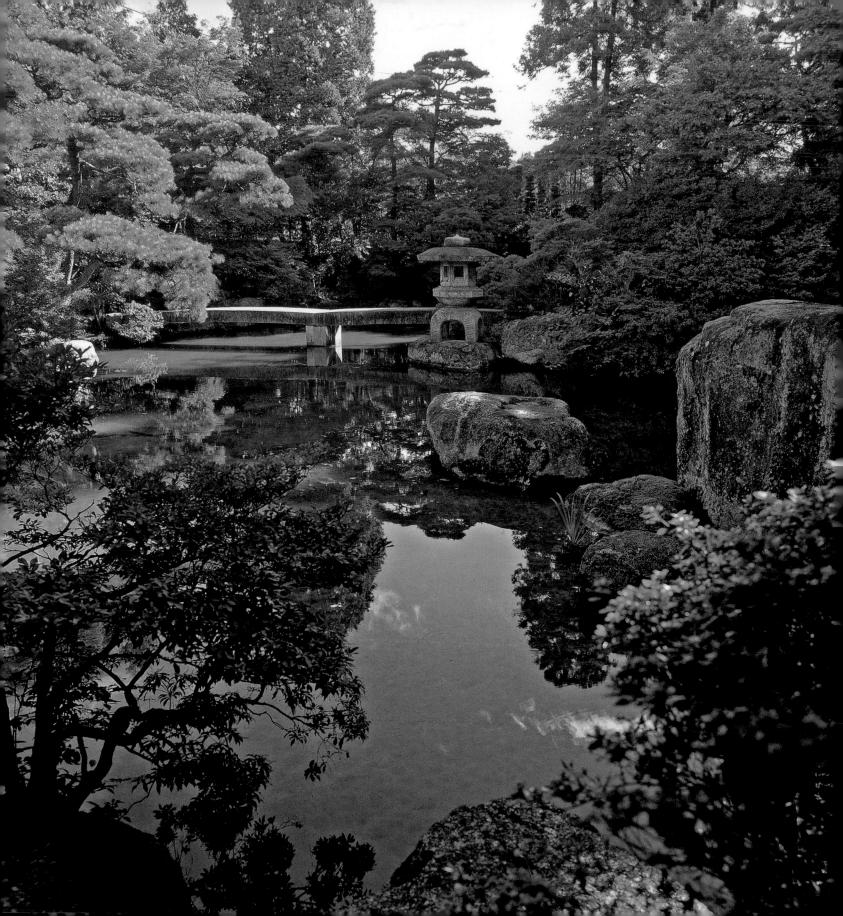

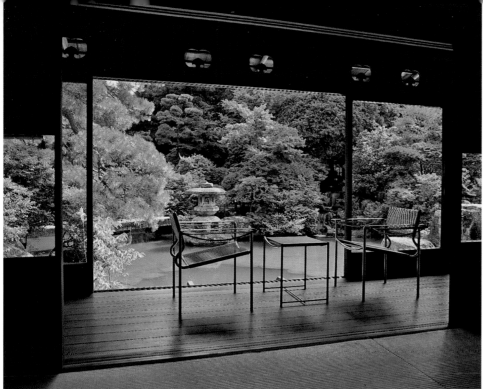

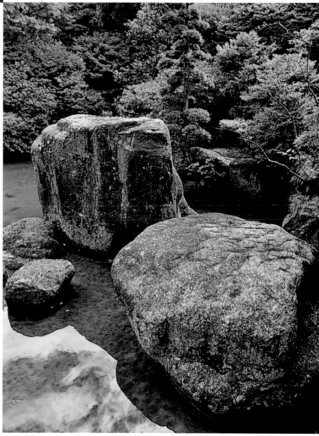

connecting Edo to Kyoto picked up, Suya started a wholesale business supplying tea-sweets to shops along that road. Their location in the inn-town of Nakatsugawa on the highway in Gifu prefecture has assured them an abundant supply of the chestnuts that grow in this area.

The present Suya house and garden are located at the foot of Mount Ena not far from the center of Nakatsugawa city. The house was built in 1917 as the summer villa for Mokuemon Hazama, a powerful landlord who is said to have owned enough property to go across town without having to cross other people's land. After this house changed hands a few times, the Akai family who were relatives of the Hazama family acquired it in 1980.

The Suya garden was built in the style of Kyoto gardens, by a gardener from Kyoto. The important feature of this garden is the use of abundant water from the mountains nearby. The garden pond is fed by an aquifer from Mount Ena that eventually flows into the Nakatsugawa River, keeping the building cool during summer. This pond was once full of golden carp, but over a period of time they have been lost to weasels, wild boar, and herons. The garden includes many large carefully laid stones. The one

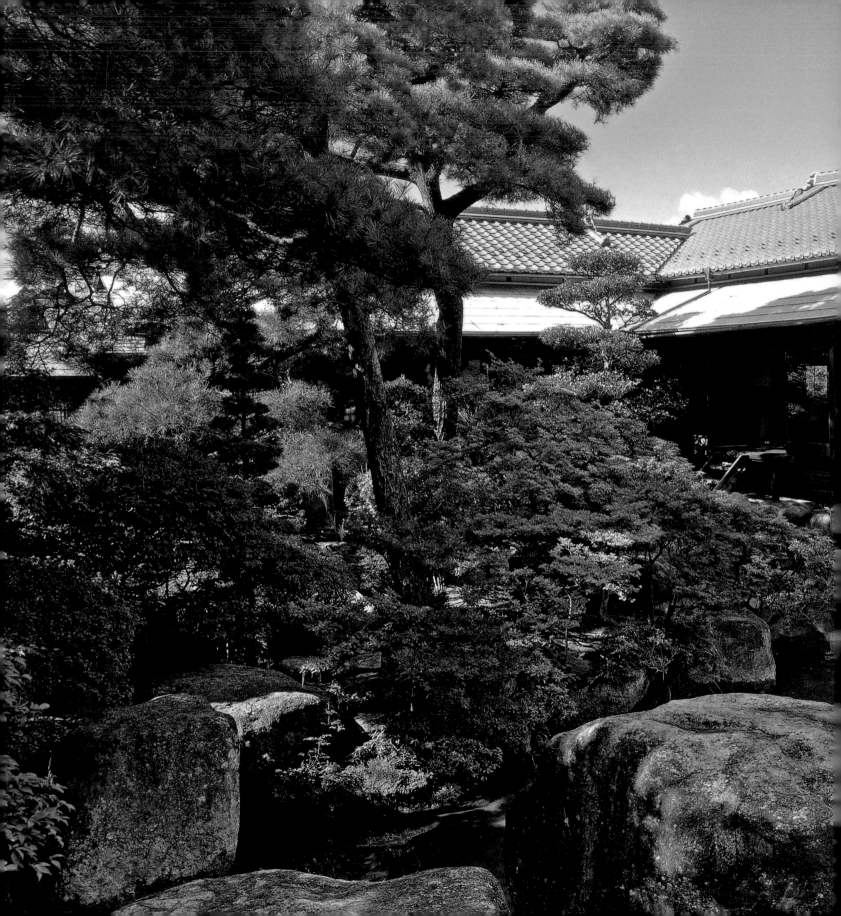

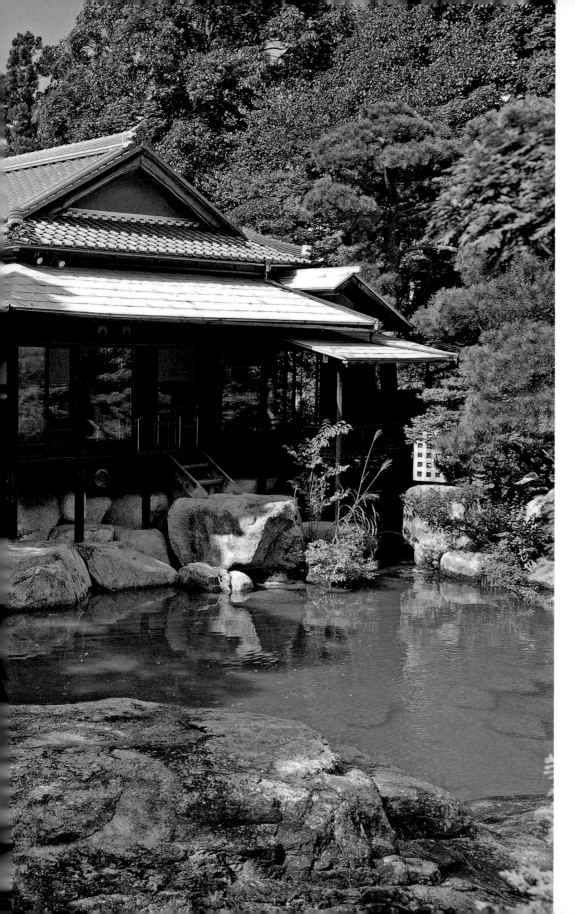

With part of it perched on top of stones in the pond, this house is well integrated with its garden. The pine tree toward the left and several other shrubs are pruned so as to keep them from growing too big and disturbing the balance and scale of the garden.

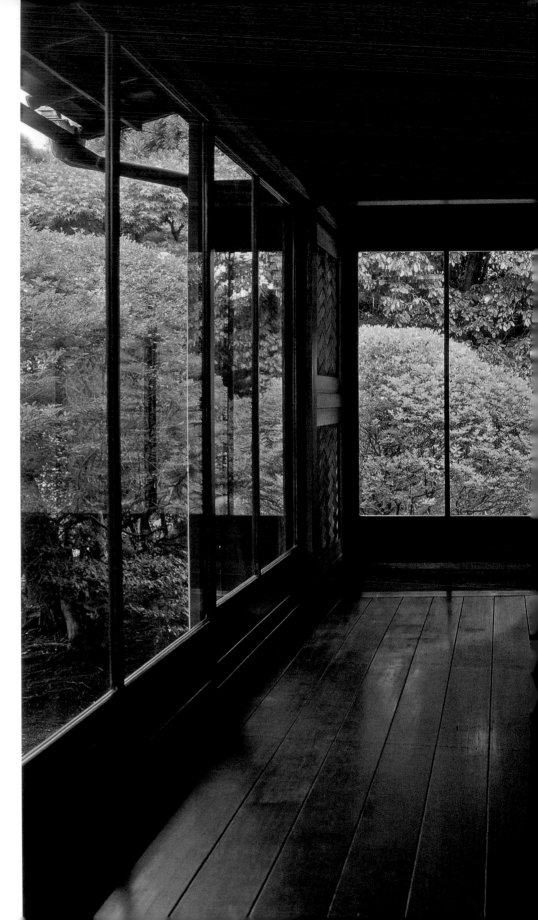

RIGHT A deep timber *engawa* porch wraps around the tatami room. It is a transitional space that can be opened up to unite the indoor and garden areas, or closed to provide additional living space.

FAR RIGHT While the *engawa* on one side of the house juts out over the pond, the *engawa* on the opposite side faces the Nakatsugawa River, not seen in the photo. The floor level of the house has been kept high to allow ventilation under the house.

BELOW This washbasin from the Taisho period is remarkable for the modernity of its design. The pattern on each of the four faces is different. The crabs on top are made of iron.

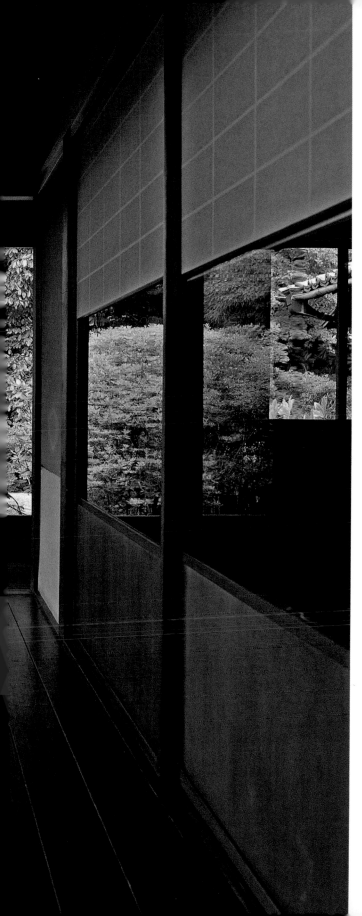

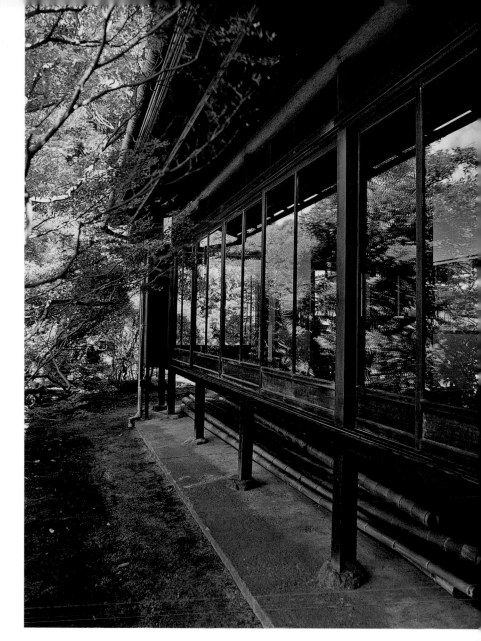

that forms a bridge is the largest among them, and is said to be from the same quarry as the stone of the *torii* gate of the nearby Nishinomiya shrine.

Mokuemon Hazama is said to have organized summer boating parties around his garden pond during the full moon in bygone days. It is easy to imagine the guests enjoying the reflection of the moon on this pond, to the accompaniment of music and dancing.

Araki House

Kyoto

The calm residential area in the western part of Kyoto near the famous Moss Temple Saiho-ji still retains the charm of days gone by. Built in 1993, Sukenobu Araki's house is a perfect example of the understated but elegant quality of even the newer homes in this area. Araki had lived in an old two-story house here before, but when he retired and his children left to pursue their own lives, he and his wife decided to live in a smaller home. They asked architect Shuri Kakinuma to design a small but well-lit single-story house for them on the same site where they had lived before.

The house designed by Kakinuma wraps around a small courtyard so that every room has a good view and natural light. He worked carefully to achieve a pleasant quality of soft brightness in the house, without the use of too much glass that may cause glare.

A well-known gardener, Kazuyoshi Ikeuchi, was commissioned to design the small garden in front of the house. Araki opted for a feeling of open space rather than a thick tree grove for his garden. Ikeuchi did not conceive of the garden on paper, but rather on the site itself. The first thing designed was the approach from the street to the house. The route as well as slope of this short walkway was carefully thought out. The trees, stones and stone lantern of the old house were reused as much as possible. Araki's father, who was fond of stones, had bought several of these from stone peddlers who used to come around selling stones from their

A glimpse of the understated elegance of this house can be seen from the porte-cochere and the sliding gate with an open *shoji* frame. The approach toward the main entrance is designed to set a mood of tranquility.

130

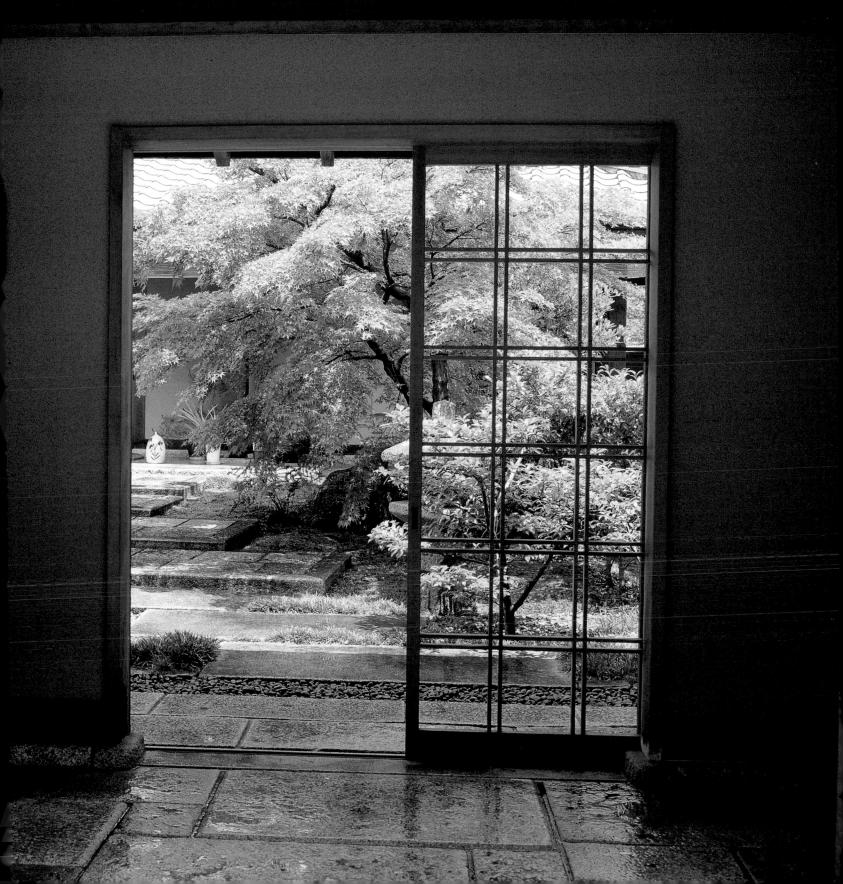

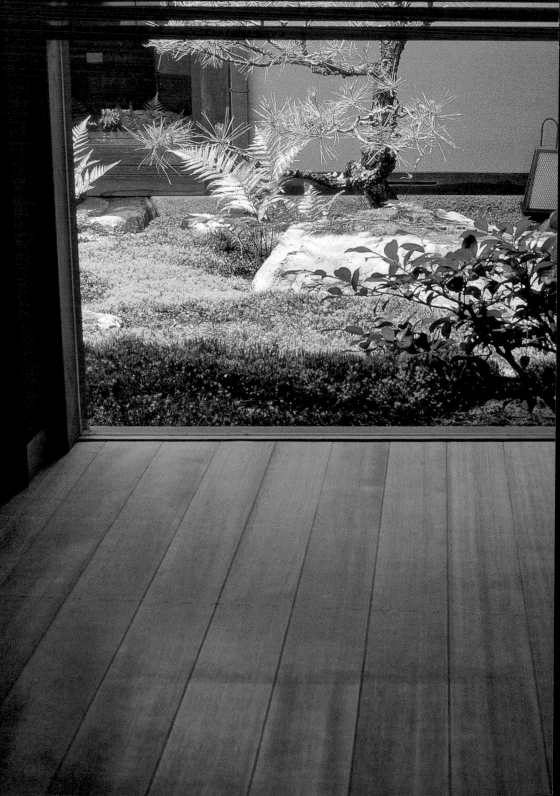

The pine flooring and wood walls of the entrance lobby frame the inner courtyards of the entrance area. Although small, the inner garden is full of variety and tantalizing delicate details. The dark interior of the house contrasts with the bright courtyard garden visible from every room.

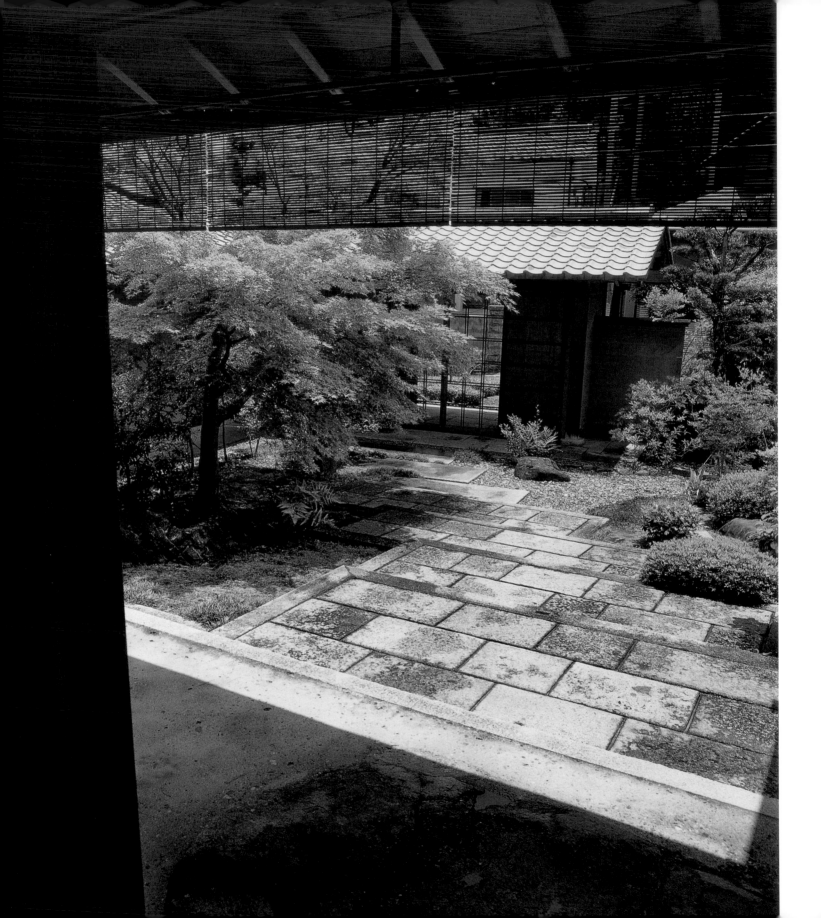

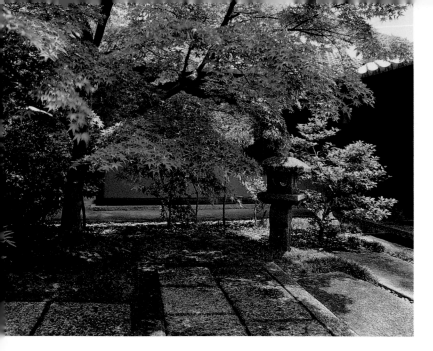

trucks. The paving stones selected were formerly used for the tracks of tramcars that ran in Kyoto from the end of nineteenth century until 1978. Innovative reuse of stones with a storyline or history is a popular feature of Japanese gardens. Some of the old trees were moved and replanted in their new locations. Araki talks wistfully of an old pine tree that could not handle the transplanting well and died. The garden now has several maple, cedar and mokkoku trees, and hedges of azalea, Japanese quince, kinmokusei and sazanka. The plants have been chosen to provide a measure of privacy from the street, as well as for their year-round beauty. The ground is covered with sugi-goke cedar moss. Ikeuchi says he cuts the sugi-goke down to the ground when cherry blossoms bloom, pegging his activities to natural cycles rather than calendar time. Cutting sugi-goke moss very short in that season helps it to grow back into a beautiful groundcover-like blanket.

Passersby can get a glimpse of this beautiful garden through the porte-cochere and sliding gate of open *shoji* framework. From this shaded gate, a visitor walks along the bright stepping-stone path, viewing trees and lanterns. Once he or she approaches the entrance in the relative shade under the eaves, the sliding front door is opened to let in the guest, revealing the bright inner garden. The planned sequence of light and dark spaces, hidden details that are deliberately and slowly revealed, and the mood that the meandering entrance path creates, are the main features of this small garden.

ABOVE A large stepping stone to the entrance of the main house is a Kurama stone, named after a place of its origin near Kyoto. Such stones are prized for the red patina of their surface. The floor around this stepping stone is made of beautiful gravel stones rammed into earth in *fukakusa-tataki* style.

ABOVE LEFT The ornaments in the midsection of the lantern represent the twelve zodiac signs, and are fashioned after lanterns in the famous Kasuga Shrine in Nara. The Oribe style or "planted" lanterns do not have a base and get their name from Oribe Furuta, a famous tea master and samurai from the Momoyama period who favored such lanterns.

OPPOSITE Flagstones from the old tramcar tracks form the entrance path to the house.

public gardens

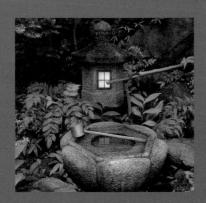

Most public gardens in Japan started off as private gardens of powerful warlords, aristocrats or temples, and have come into the public domain since the Meiji Revolution in 1868 due to Japan's commitment to social justice via land reform and tax laws. Several private gardens also passed on to hotels or institutions and are well-documented and cared for. The gardens of the International House of Japan in Tokyo, the Ishikawa International Salon and Kincharyo are good examples of these.

Visiting Happo-en during cherry blossom season or Kamo Hanashobu Garden during iris season is an unforgettable experience. Keenly attuned to the communal celebration of seasons, the Japanese people visit the gardens in thousands during these times; it's not only a chance to view the gardens' beauty, but also to connect with the deep appreciation of nature among the Japanese that extends across the social and economic spectrum.

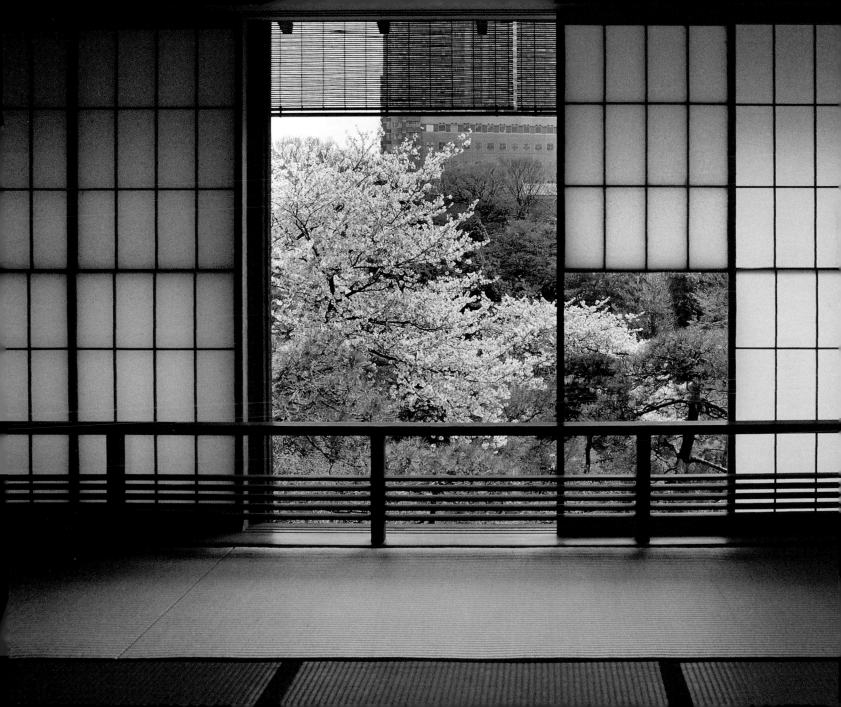

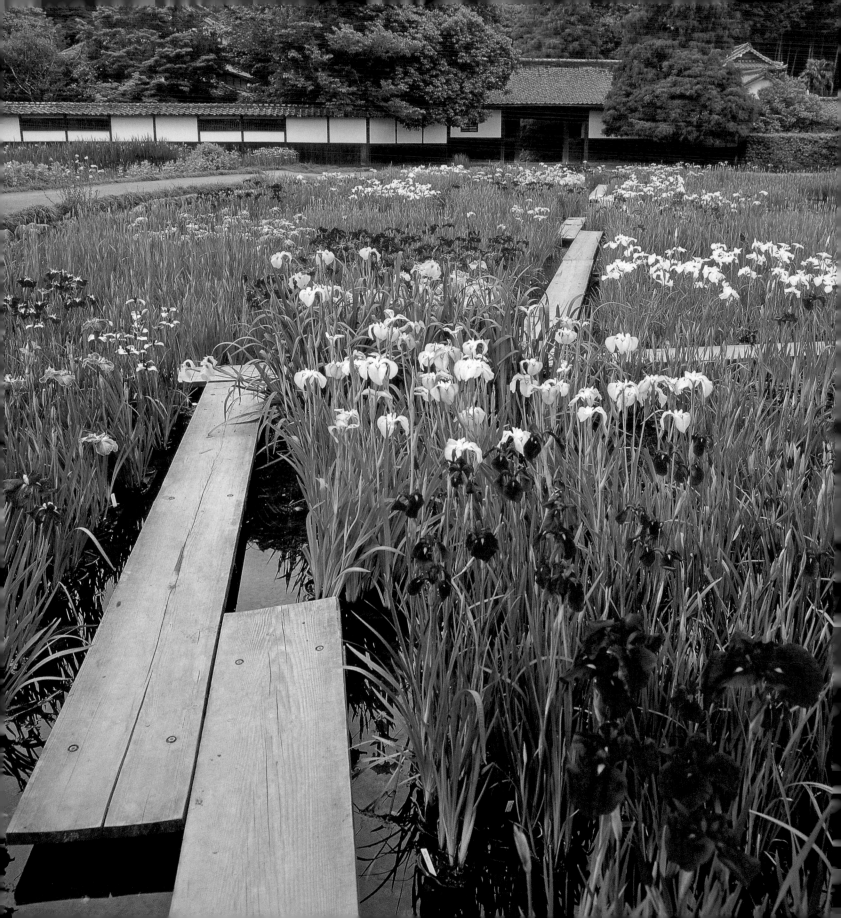

Kamo Hanashobu Garden

Kakegawa

This is not a garden in the traditional sense of the word, but rather an exuberant celebration of the beauty of *hanashobu*— Japanese iris (*Iris ensata*) flowers—in a perfect setting. This garden originally belonged to the Kamo landlord family of a village headman that traces its roots to the Momoyama period in the sixteenth century. The large house where the family lived and the *nagaya-mon* main gate with a storehouse/guardroom date back to the Edo period. Other parts of the house such as the exterior wall and warehouses were built during the Meiji period. After World War II, changes in the social, legal and tax systems in Japan resulted in the Kamo family losing their arable land. It was then that they started using their property as an inn, and later as an iris garden open to the public.

The Kamo family first started to plant iris just outside the main gate of their home toward the end of the Edo period. The climate and the environment turned out to be perfect for them. The number of plants gradually increased and Kamo soon became a popular spot for visitors. In 1958 the family closed their inn

LEFT The *nagaya-mon* or main gate of the Kamo estate, together with the storehouses, creates a beautiful backdrop for the field of iris flowers.

NEXT PAGES Images of *hanashobu*, iris flowers, growing out of water and next to a plank bridge have captivated the imaginations of Japanese gardeners and artists since the Heian period. This combination can be seen at Kamo Hanashobu Garden, and in many screen paintings, kimono patterns and other decorative arts.

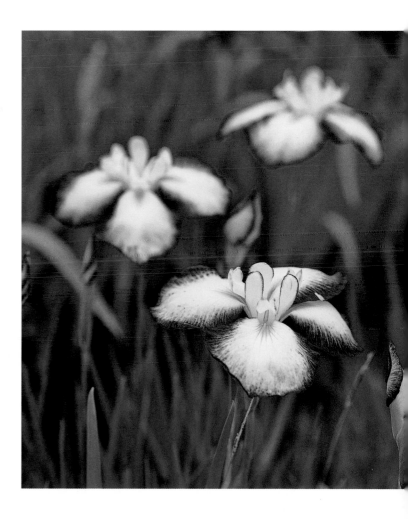

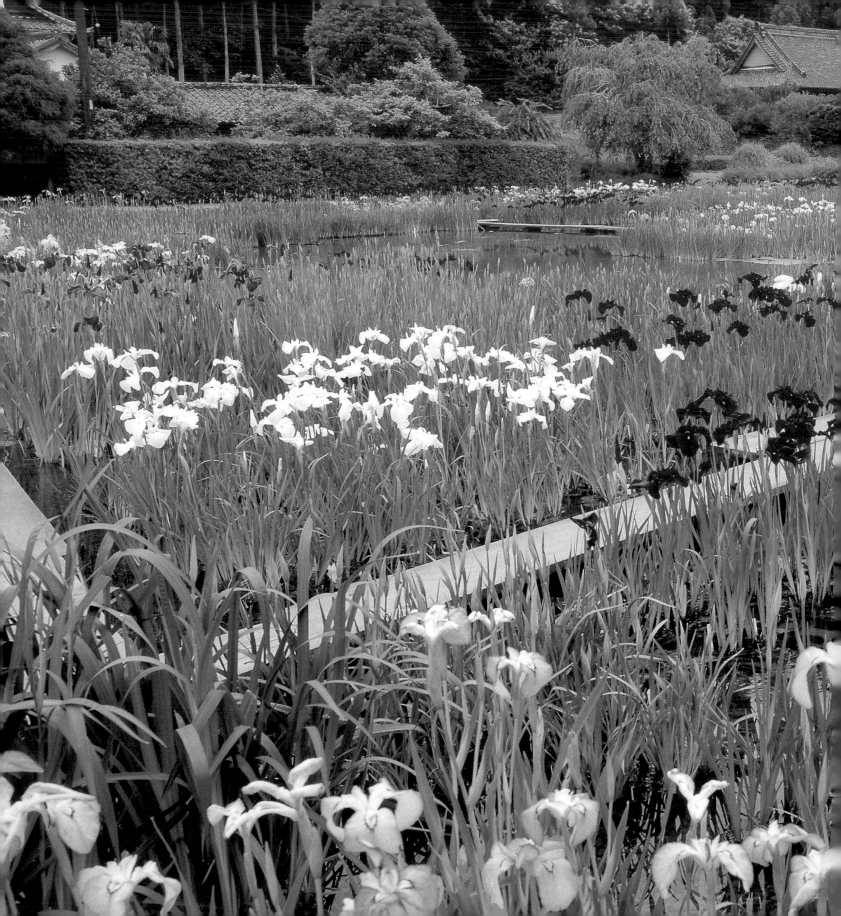

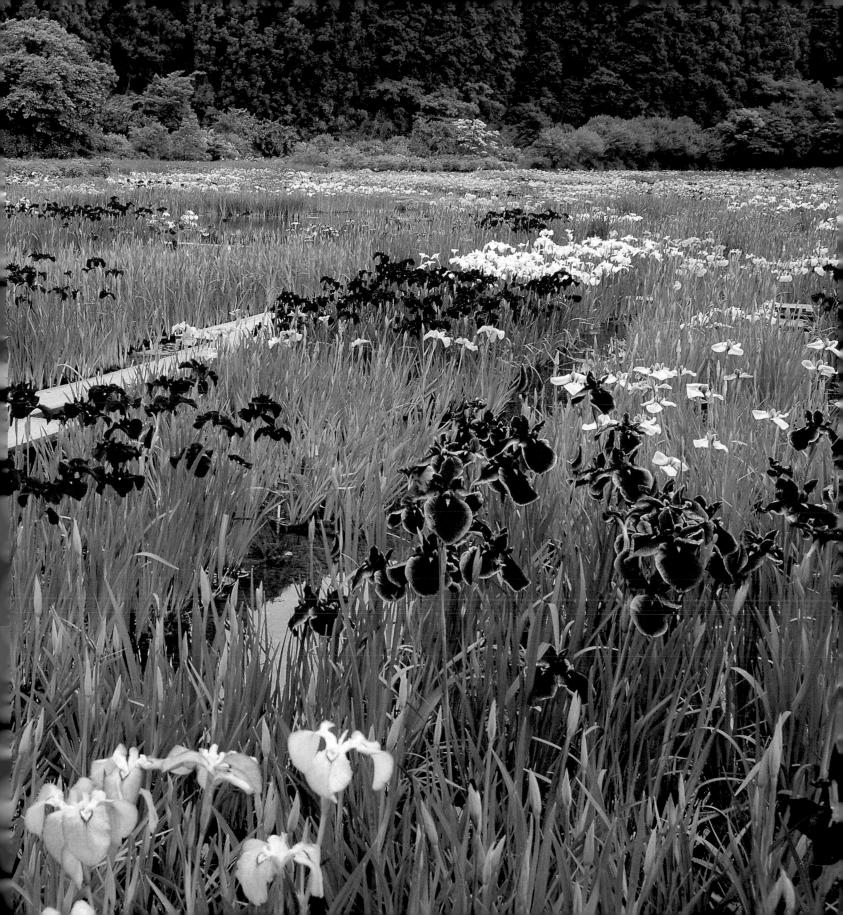

business to focus entirely on the garden, which is now open to the public from April till the end of June every year when iris flowers are at their best. The garden now features over 1,500 varieties of plants and over one million iris bulbs, all on about a hectare (2.47 acres) of land. The Kamo family has also developed expertise in growing iris flowers, and today ships them to all parts of Japan. About two thirds of these plants are grown directly in the soil that is submerged in about 20 to 40 centimeters of water during the flowering season. The remaining flowers are grown in small containers and forced in a hothouse for rotating and replacing in order to ensure a longer viewing season. During the iris season, visitors are also served box lunches in the old Japanese tradition of flower-viewing luncheons.

The Kamo *hanashobu* garden consists of three parts. The irises in a field of shallow water are the foreground; the buildings and trees around it make up the mid-ground; and the mountains covered with cedar and bamboo trees form the background. The mountains are not part of the Kamo estate, but are used in the layout as borrowed scenery, a well-understood concept called *shakkei* in Japanese garden parlance.

Iris flowers have an important place in Japanese arts and culture. In the past, *shobu* (*Angustatus arales*) flowers were considered

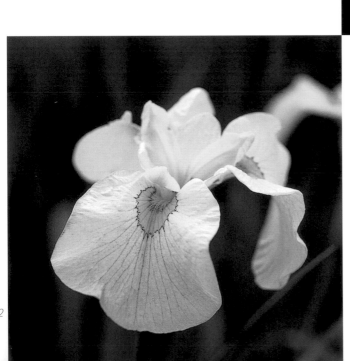

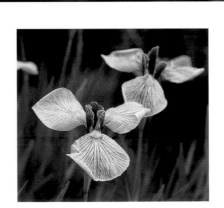

Besides the original purple variety of wild iris called *nohanashobu* that used to grow wild in grassland and marshes, there are numerous new varieties of iris flowers in Japan today with different sizes and colors. *Hanashobu* of white, yellow, pink and purple colors can be seen at the Kamo garden.

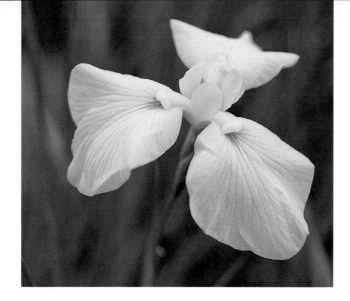

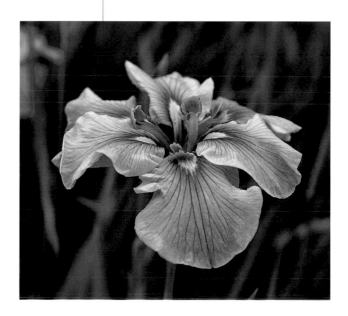

Iris is a bulbous or rhizomatous plant with distinctive flowers that consist of three large petals that fall on the outside around inner petals or "standards." The beautiful flowers are set off by the tall pointed leaves that make a field of them an unforgettable sight.

helpful in driving away evil due to the strong smell of their rhizome. The shape of their sharp sword-like leaves associated them with military arts of the samurai class. Leaves of *hanashobu* are similar to those of *shobu*, and both of these are associated with power. Shoguns during the Edo period were also fond of *hanashobu* flowers, and various varieties of *hanashobu* were gathered from Japan and abroad for the shoguns' enjoyment. Cultivation and appreciation of iris had become quite popular by the end of Edo period. The Boy's Day celebration observed in Japan on the fifth of May every year used to be a samurai festival, but is celebrated by all Japanese now. *Shobu* leaves are made into wreaths on this day and placed on the heads of young boys. It is also customary to put the leaves in bathwater for the boys on this day. The importance of iris flowers in Japan is also clearly seen through the importance of the Iris Garden at Meiji Shrine in Tokyo. Some of the flowers there are remarkable in that they have been cultivated since the end of Meiji period in the early twentieth century. Since the average life of an iris plant is about ten years, their longevity is a tribute to the careful tending and bulb division that has been carried out over many years.

Iris flowers at Kamo, growing in the water-submerged earth, are interspersed among plank bridges. This combination has become almost an artistic cliché and can be seen in screen paintings, kimono patterns and other decorative arts. This is somewhat curious because the Japanese iris does not actually need much water. On the other hand, another similar local flower called *kakitsubata* that grows wild in marshlands does, but since the leaves of the two are quite similar, the water association has carried on to *hanashobu*. The main characteristic that distinguishes

kakitsubata is its white center, while the center of *hanashobu* is yellow. It was during the Heian period that the combination of iris flowers, water and plank bridges first caught the fancy of artists, and that fondness has lasted to this day. Perhaps this image of long-leaved plants growing in water evokes the primal image of rice fields that is so dear to the Japanese heart. The association of the plank bridge may have also been perpetuated because the planks allow gardeners to go in and out of the water area and tend to the plants, as they do in the Kamo garden today. Leaving aside the historic logic of its individual parts, Kamo garden is deeply satisfying to the eyes as well as the soul.

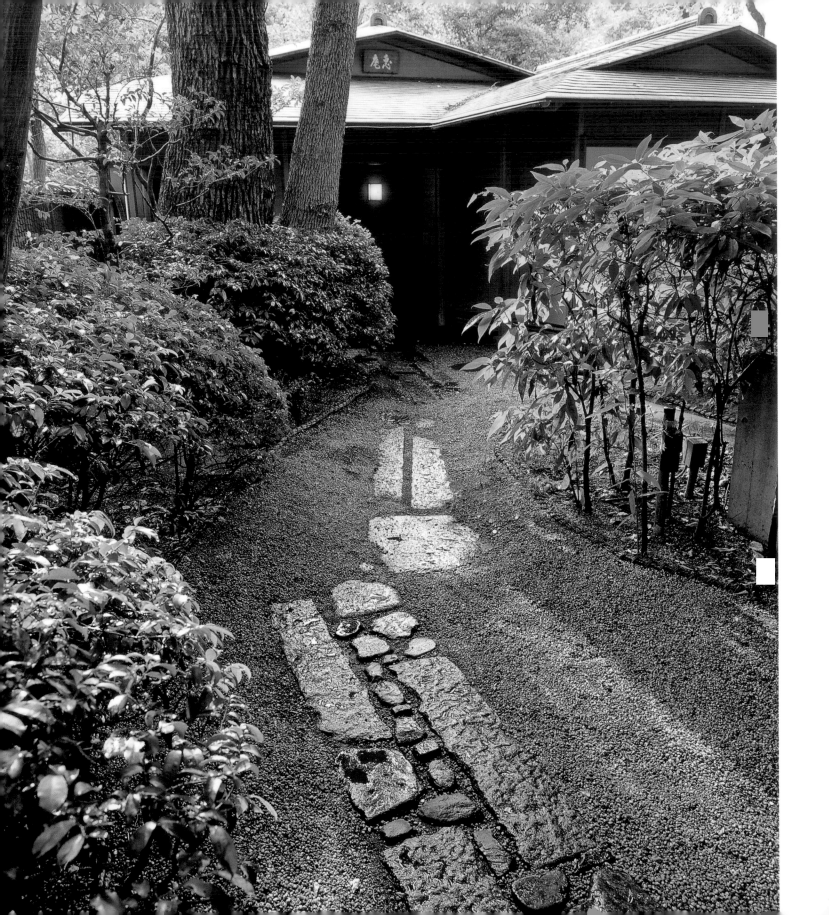

Ean Tea House
Tokyo

The Ean Tea Garden at the Grand Prince Hotel New Takanawa in Tokyo is an example of the intimate tea gardens that are integral to the setting for tea ceremonies. Famous Japanese architect Togo Murano (1891–1984) designed this hotel in 1982, and the Ean tea house and garden were completed three years later in 1985, just after his death. Murano's work is known for the beauty of its sensitive detailing based upon traditional Japanese architecture, and is quite different from the work of his contemporaries.

Although located in the center of Tokyo, Ean is surrounded by ten acres of a luxurious garden that was formerly the location of the Kitashirakawa royal family's home. The Ean complex consists of one large and a few small *sukiya* style rooms and an informal rustic tea hut tucked into the tree grove near a small winding stream. The choice of tea room for a particular ceremony is made based upon the number of guests and the mood of the event planned. The tea garden that wraps around the tea huts reinforces their ambiance of *wabi sabi* rusticity. The concept of *wabi sabi* is central to Japanese aesthetics, and relies upon the beauty of simplicity, rusticity and understatement to convey a feeling of harmony with nature.

The Ean complex can be entered from two directions. The formal entrance is up a long winding slope that leads to the hipped-

RIGHT The main gate of the Ean teahouse complex is of the *amigasa-mon* type. This name comes from the word *amigasa*, meaning an old hat made from straw or grass.

LEFT A special pattern of stones has been used for the *roji* pathway that leads from the main gate to the entrance.

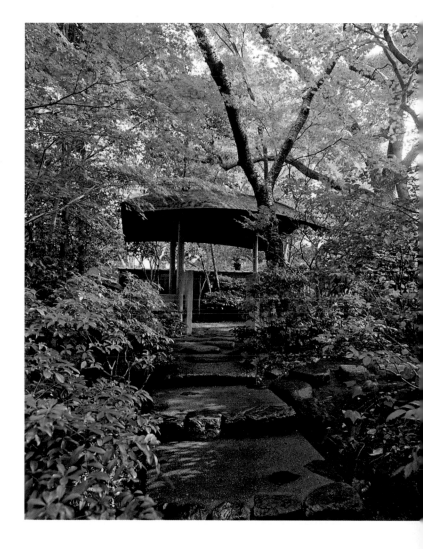

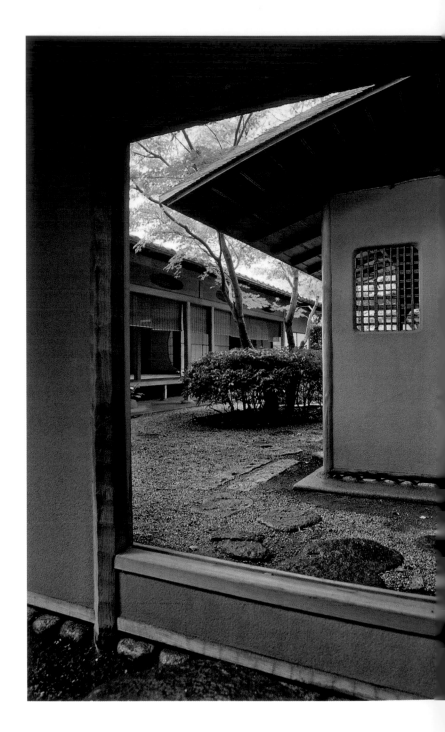

roofed entrance gate. The stepping stone path from here leads past a small tea room toward the inner garden. A framed glimpse of the inner garden can be seen from a large opening in the earthen wall separating the outer and the inner gardens, before one walks around the wall to enter the inner garden. The inner garden leads to the formal tea rooms and then past the rustic tea hut toward the other entrance to this complex, which is marked by a thatched-roof timber gate. The small stream that runs outside this gate is bordered by an abundance of shrubs, grasses and trees, giving it an appearance of untended nature in contrast to the manicured tea garden inside.

One of the important structures in the inner garden is the *machiai* waiting area. Covered with the *kokerabuki* style wooden roof, this structure is enclosed on three sides and open toward the garden, and has a simple bench for people to sit and calm their minds in preparation, before entering one of the several tea rooms. Stepping stones near this waiting arbor are in the informal *so* style, and are a part of the *roji*, the stone path that meanders through the garden from one entrance to the other. Such paths are designed according to the *shin, gyo, so* principles, which can be roughly translated into formal, semi formal, and informal. These paths are indicative of the level of formality intended in a particular part of the garden. *Roji* stones as well as the plants in the garden are usually watered in preparation for guests as a sign of welcome.

The Ean tea garden is screened off from the larger garden outside by a long narrow plastered wall with a tiled roof. Such walls separate the mundane world outside, no matter how beautiful, from the "world of tea."

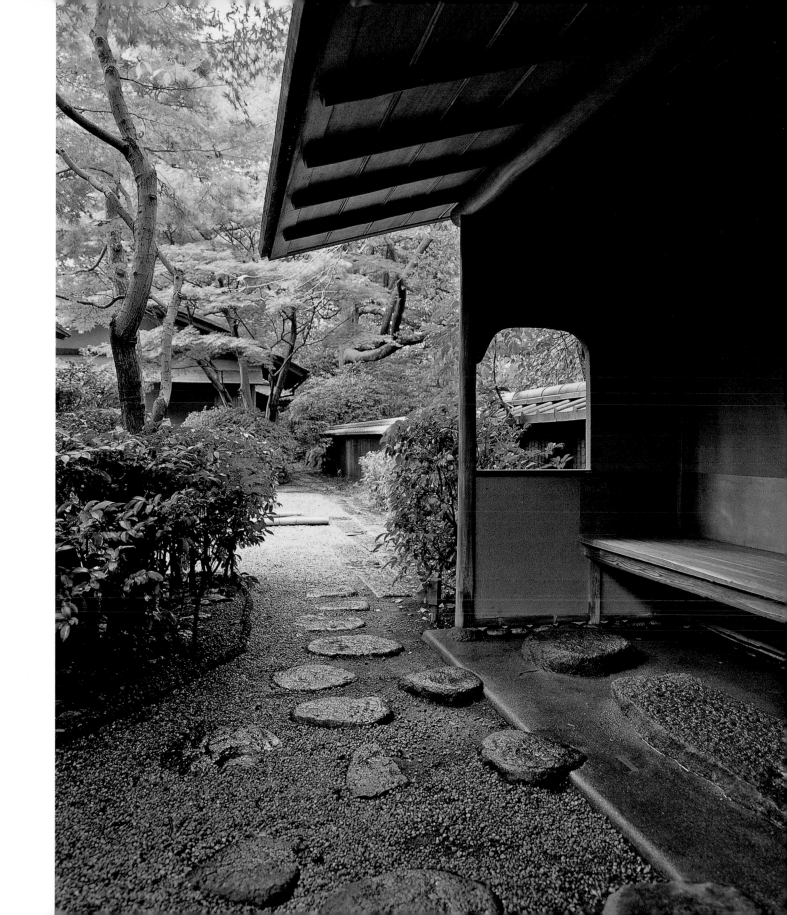

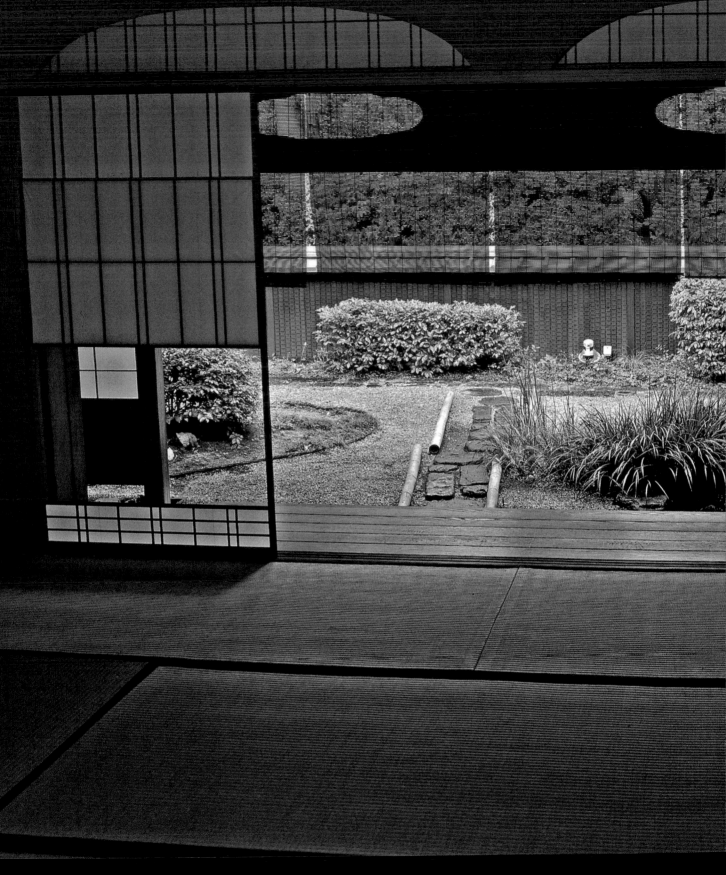

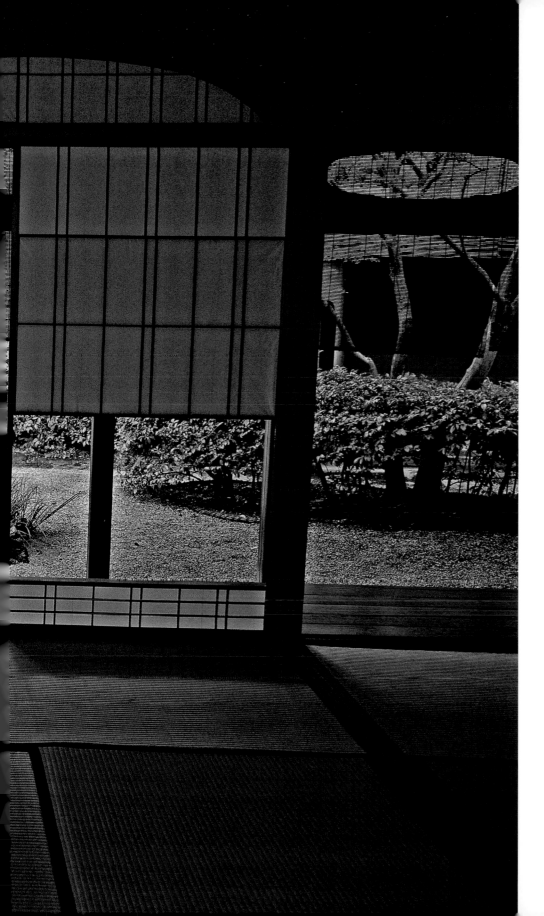

Plants, sand and the *tsukubai* washbasin have been used according to traditional principles in this garden in front of the main room of Akebono, but the overall result has a relatively modern feel to it. The view from inside the tea room is always carefully taken into consideration in designing a tea garden.

Ean Tea House, Tokyo *149*

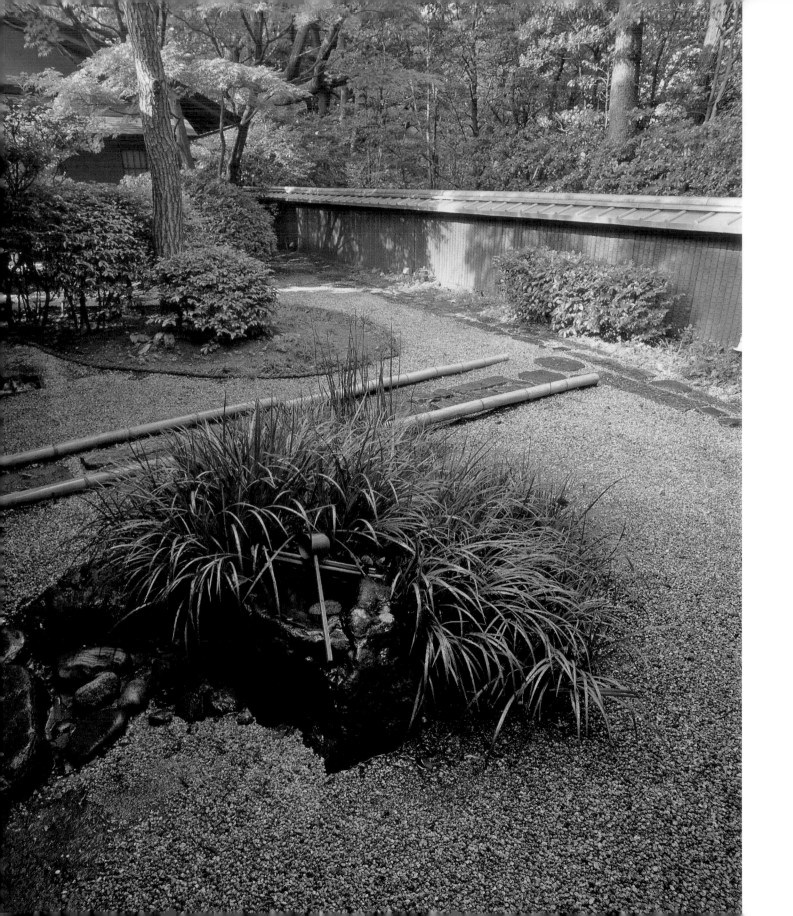

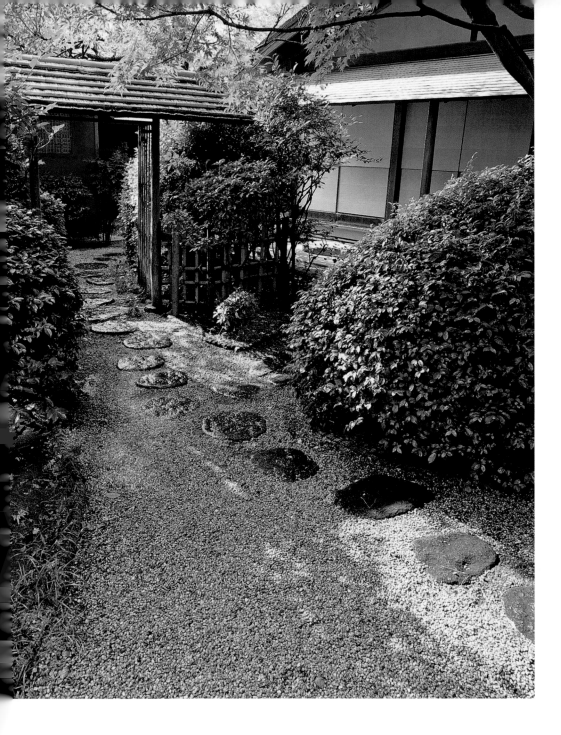

LEFT The semi-formal path that leads out from the main tearoom. Small pebbles called *jari* surround the stones.

BELOW The floor of the *engawa* porch of the tea hut is made from bamboo and wood. The square shape of the *tsukubai* water basin farther out gives it a rather modern feel.

OPPOSITE A *tsukubai* water basin is surrounded by *ryu-no-hige* (dragon's whiskers) grass. The *naguri* curved edge pattern on the wooden walls is reminiscent of the pattern achieved by using the traditional cutting instrument called a *chona*, which was used to cut very hard woods like chestnut.

Ishikawa International Salon

Kanazawa

RIGHT From the *engawa* of the main drawing room, one can step down onto the large *kutsunugi-ishi* (shoe changing stone), change into *geta* or *zori* shoes, and walk along the stepping stones into the garden.

BELOW Rocks, ornaments and shrubs have been carefully placed to complement each tree.

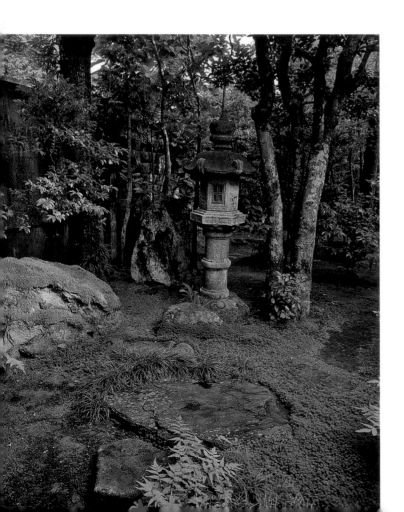

This 85-year-old traditional Japanese house and garden was originally built at the end of the Taisho period as the second home of an eminent citizen of Kanazawa. The property was acquired by the Ishikawa Prefecture government recently and opened to the public for cultural activities such as art exhibitions, performances and social events. Located near the popular Kenroku-en Garden and the newly built Museum of Contemporary Art in the heart of Kanazawa, this complex adds to the resources available to the people of this city who have long been known for their unique cultural traditions and patronage of the arts.

The Ishikawa International Salon garden is meant to be enjoyed by walking around in the tradition of Kenroku-en and other stroll gardens, and also as a visual delight to be seen from inside the house. Inviting stone paths emanate from various rooms and meander into the garden, creating a mood of relaxation. These have been designed so that the views change as you walk along the stepping stones, until the deepest place in this small garden almost feels like a secluded grove in the woods.

The foreground of the garden, seen from the various rooms, consists of groups of shrubs, stones, stone lanterns, water basins and a well, all surrounded by lush green moss and stepping stone paths. The stone lanterns in this garden are particularly valuable

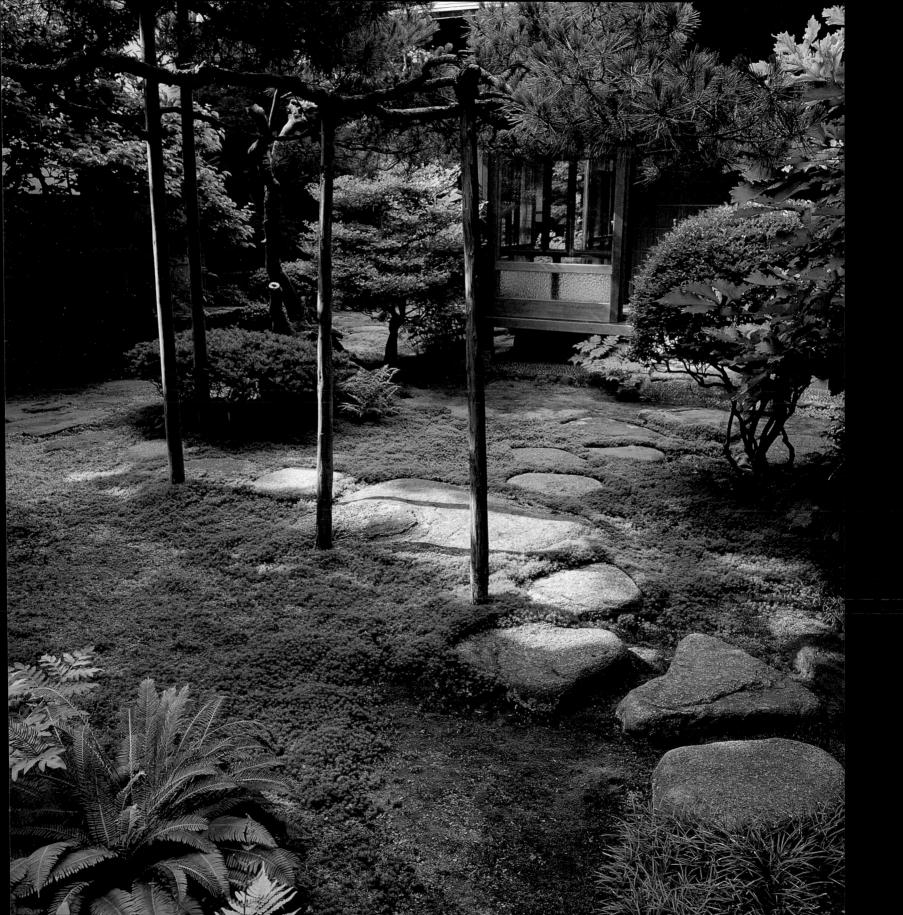

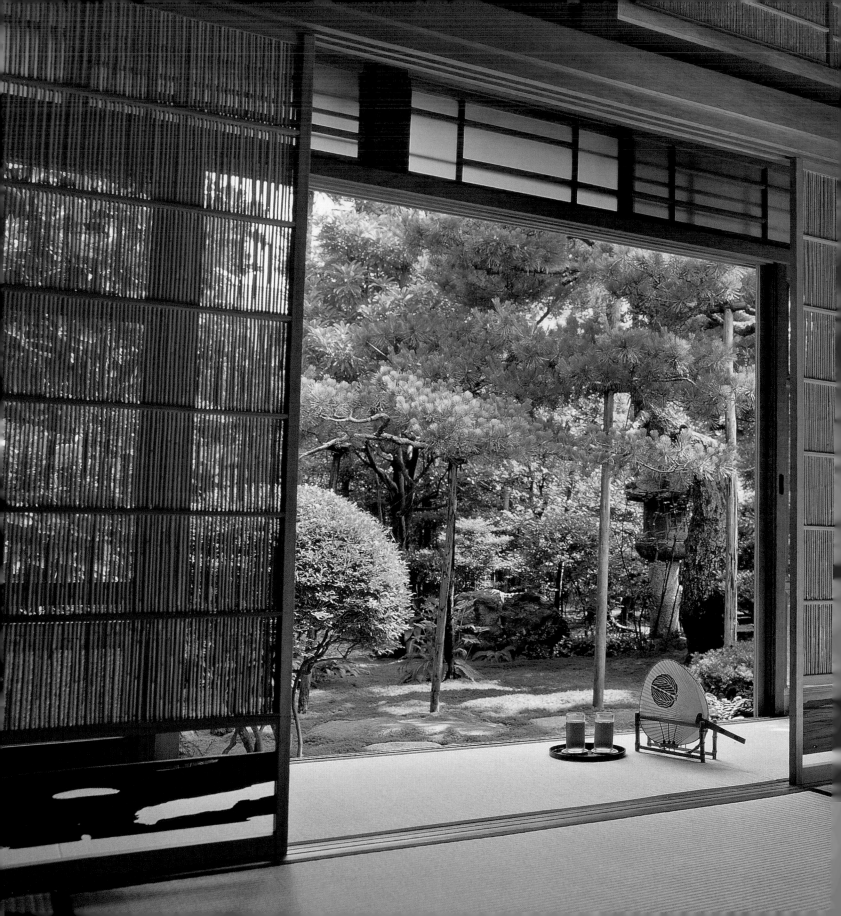

LEFT The *engawa* patio provides a perfect place to enjoy the garden. The usual *shoji* paper screens on two sides of this formal room have been replaced by *sudo* bamboo screens for the summer to allow breezes into the house. The bottom panels of the *sudo* screens have an elegant cutout design of clouds.

BELOW The *usuberi* floor covering in the *engawa* patio is a luxurious touch compared to the usual wood flooring in such areas.

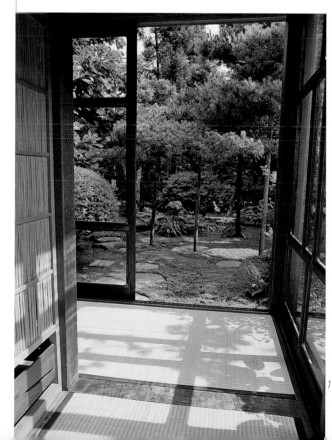

due to their age and quality. These features are seen against the background of many tall trees and larger shrubs that grow toward the rear of the garden, including a 300-year-old Japanese oak. Other trees in the rear include momi maple trees, cedars and pines. The tall *kura* storeroom wall on the right, and the traditional boundary walls to the left and the rear, define the garden's edges.

The main drawing room juts out into the garden, and can be opened on two sides. On each side, there is an *engawa* porch outside the walls made of posts and sliding screens. These screens can be completely removed, thus integrating the interior spaces with the garden. During summer, the movable *shoji* paper screen partitions are replaced with *sudo* blinds made of yoshi grass, making the garden visible from every part of the house through the moiré-like pattern of the blinds. The open screens also let in breezes to keep the house cool. Although this tradition of changing the wall panels involves great expense and effort, it was widely practiced in Kyoto and Kanazawa. This is a wonderful example of the Japanese sensitivity to changing seasons and love of nature, and is carried out at this property every year. Sliding *amado* shutters located outside the *shoji* or *sudo* screens are closed at night and during storms.

As in Kyoto, the moist climate of Kanazawa is conducive to growing moss. There are nearly 200 varieties of moss in Japan and about 100 of them can be found in this garden, where they give the ground a shimmering rich color that is made up of several shades of green. Moss is a unique plant that is sturdy like a weed in some ways, but also delicate because it can die due to too much or too little shade and moisture. As it draws water from its leaves and its roots, a balance between the supply of moisture from the

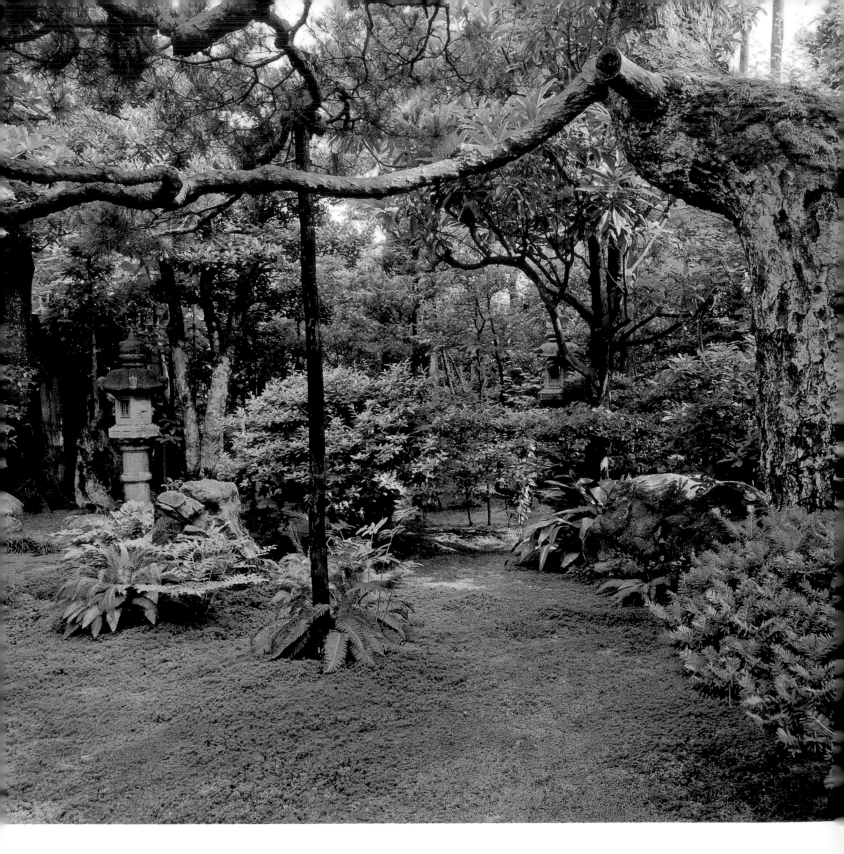

BELOW This lantern is a Nishinoya *toro*. Such lanterns are made up of rectangular stones. As in most lanterns, each stone of it is crafted with a knob that fits into the hole of the next stone.

OPPOSITE The star of this garden is a huge red pine tree of dramatic form. Charred cedar posts support the stooping branches, and also add to the ambiance of the tree. In Japanese gardens, great emphasis is placed on recognizing and celebrating the character of each tree and stone, and grand trees such as this one influence the entire design of a garden.

air and ground is necessary to keep the plants healthy. Tending a moss garden is a labor of love, as one needs to completely remove even the tiniest weeds so that the blanket-like appearance of the moss can be preserved. Well-tended moss gardens are therefore a testimony to the time and care put into their upkeep. The most spectacular of moss types that grow here is called sugi-goke, or cedar moss. Each individual spore of sugi-goke looks like a miniature cedar tree that is brownish in color, but is crowned by a bright green starburst form on top.

The large variety of stones used in gardens in Kanazawa is often attributed to the fact that the powerful feudal lord Maeda who ruled Kanazawa also supported the shogun during the Edo period by sending artisans and supplies for the several building and garden projects in Kyoto and Edo. These artisans would then come back having learned the latest trends and techniques, and would use them in Kanazawa. Since Kanazawa was also a center of commerce during the Edo period, goods were shipped from here to all over Japan, and the ships then came back loaded with a ballast of beautiful stones for use in gardens. However, the architecture and gardens of Kanazawa also have elements that are different than those found in Kyoto. For example, strong colors such as reds are boldly used in the interior walls, and wooden elements are often painted with red *urushi* lacquer. Stones of remarkable shapes or strong colors were also used more frequently in the gardens here. While the aesthetics of Kyoto are known for their restraint, those of Kanazawa are more celebratory and exuberant.

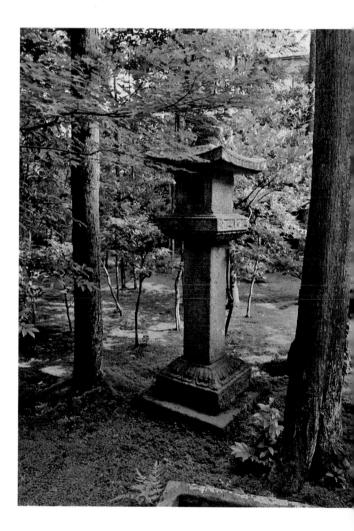

Nomura
House
Kanazawa

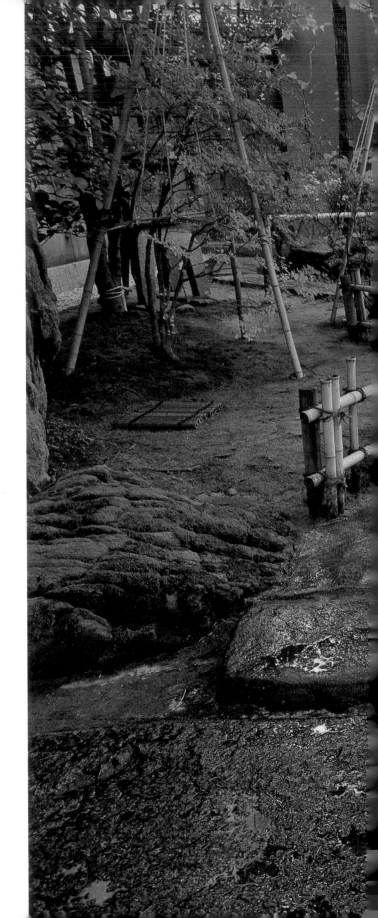

Located at the foot of the Kanazawa Castle, Nagamachi district is known for its many cobblestone streets and samurai houses with mud daub walls. One of the large estates here formerly belonged to Denbei Nomura, a family of high-ranking officials in service of the powerful feudal lord Maeda during the Edo period. The Nomura family had lived here for twelve generations before the feudal system was disbanded after the Meiji Revolution; stipends of the samurai were taken away and their properties were confiscated. The Nomura family also lost their house, and converted part of their land to vegetable and fruit farms. What remained of the original estate was about 1,000 square meters of the garden with old trees, a pond, an entrance gate and the surrounding walls. After the property changed hands several times, the new owner of the property in 1941 decided to restore the garden and brought part of a luxurious house built in 1841 by

Large stepping stones make up the imposing entrance to this house. These are watered in anticipation of the arrival of guests as a sign of welcome. A Chinese maple tree brightens up this garden with its intense red color in the autumn.

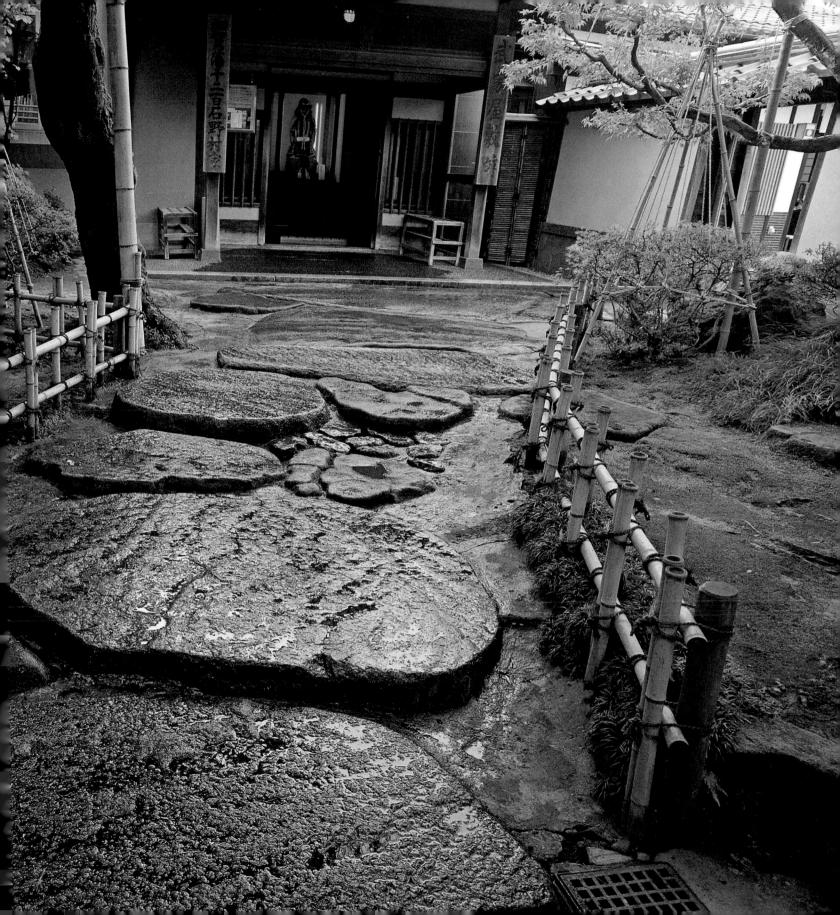

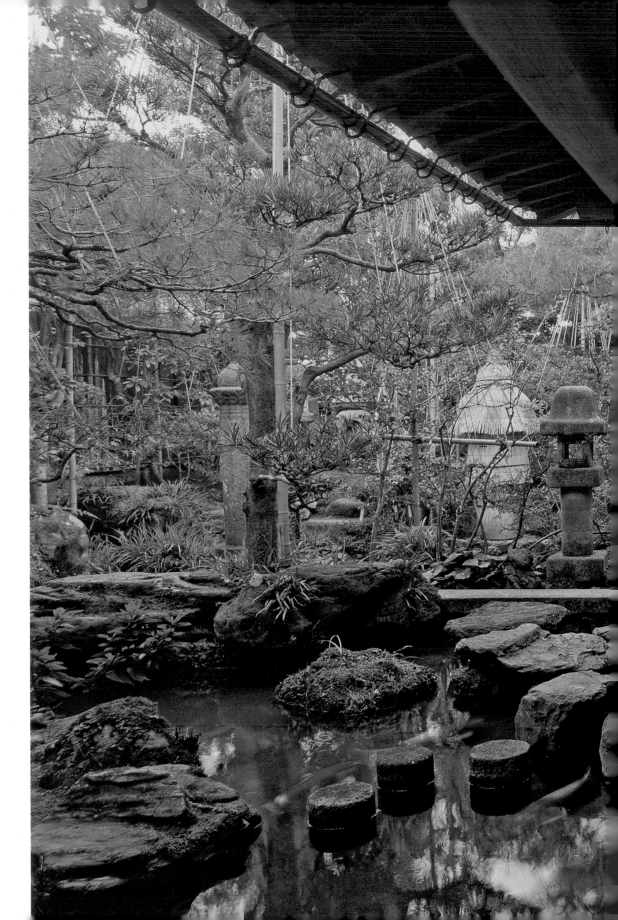

The deep *engawa* porch of the Jodan-no-ma drawing room overhangs the pond and rocks, blurring the distinction between inside and outside when the *shoji* screen doors have been slid aside. While the stream runs at a rapid pace near the waterfall, it becomes placid as it nears this drawing room, where carp fish swim in between the stones.

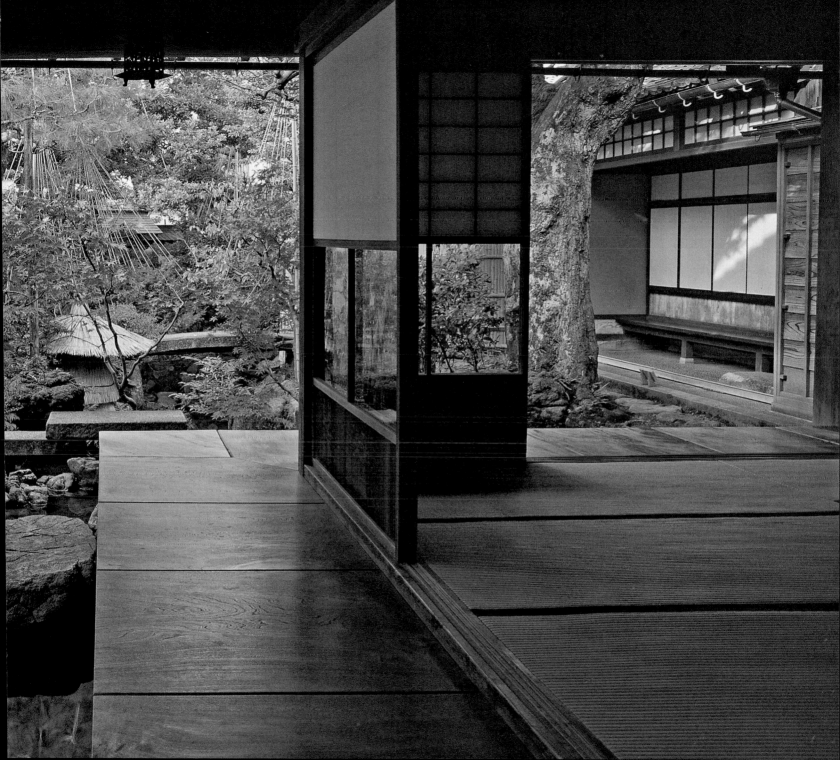

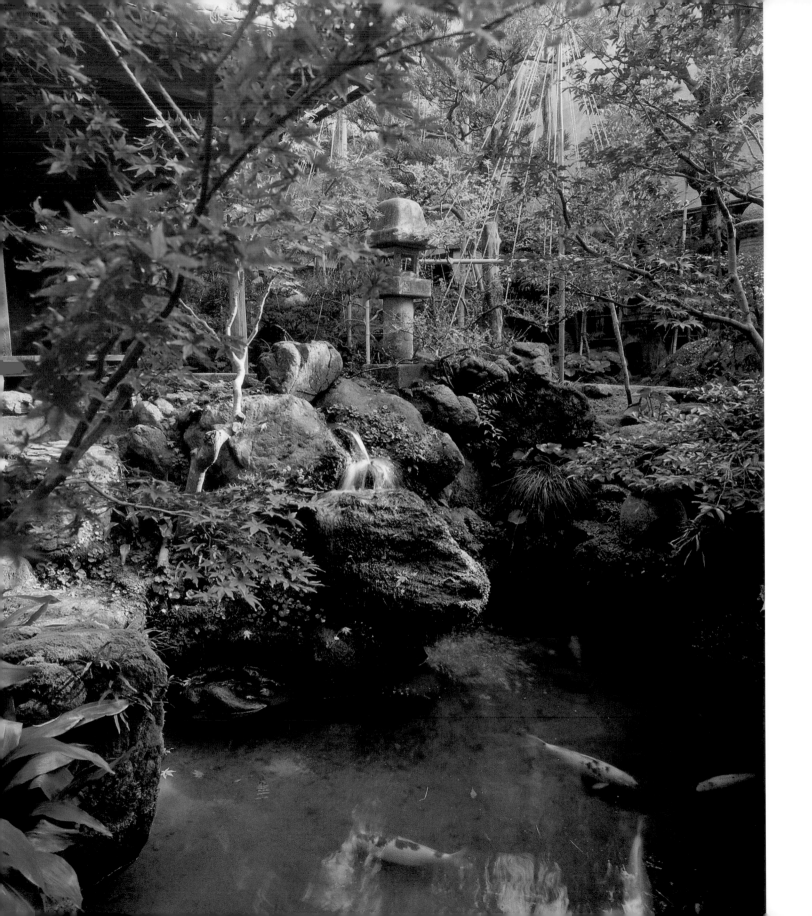

LEFT The Buddhist stone monument called a *tahoto* forms an unusual but important feature of this garden.

BELOW *Yukimi doro* lanterns are placed near water so that their reflections can be viewed in water. The word *yukimi* is thought to be a corrupted version of the word *ukimi*, which means to view something afloat.

OPPOSITE Many large rocks have been used in this garden. In the classic Japanese book on garden design, *Sakuteiki*, one is advised to take plenty of time while placing rocks "till the rock speaks to you about where it wants to be placed." The space in between rocks is as important as the rocks themselves, because it is infused with the energy of the rocks around it.

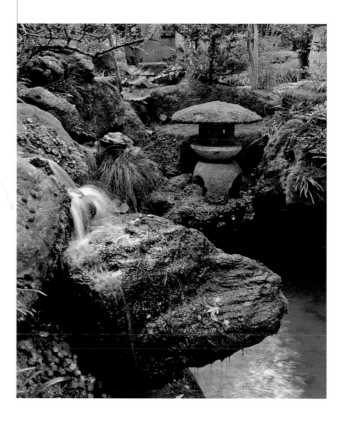

a wealthy merchant and ship owner Hikobei Kubo from Hashidate village to this estate. A tea house was also added to the property at that time.

Nomura estate is approached by passing through a small samurai-style gate and by following the stepping-stone path to the entrance. The garden has been designed in the style of Enshu Kobori, the renowned tea master and garden designer who was known for adding grace and luxury to the stoic simplicity of Zen garden design principles popular in the Muromachi period. The rules of garden design laid down by Enshu emphasize harmony between the plantings, stones, rivulets and ponds.

The sloping site of Nomura Garden has been skillfully used in locating the house, the tea room, and the various areas of the garden designed on two levels. The garden takes up the northwest half of the site and is designed to be seen from the five important

rooms of the house that was brought over from Hashidate. The *engawa* corridor of these rooms dramatically overhangs the water pools. The first glimpse of the garden can be seen from the viewing platform built outside the room named Oku-no-ma. The dramatic cherry granite bridge is also visible from here. This part of the garden is lively as it is closest to the waterfall and the rushing stream that passes under several stone bridges. The sound

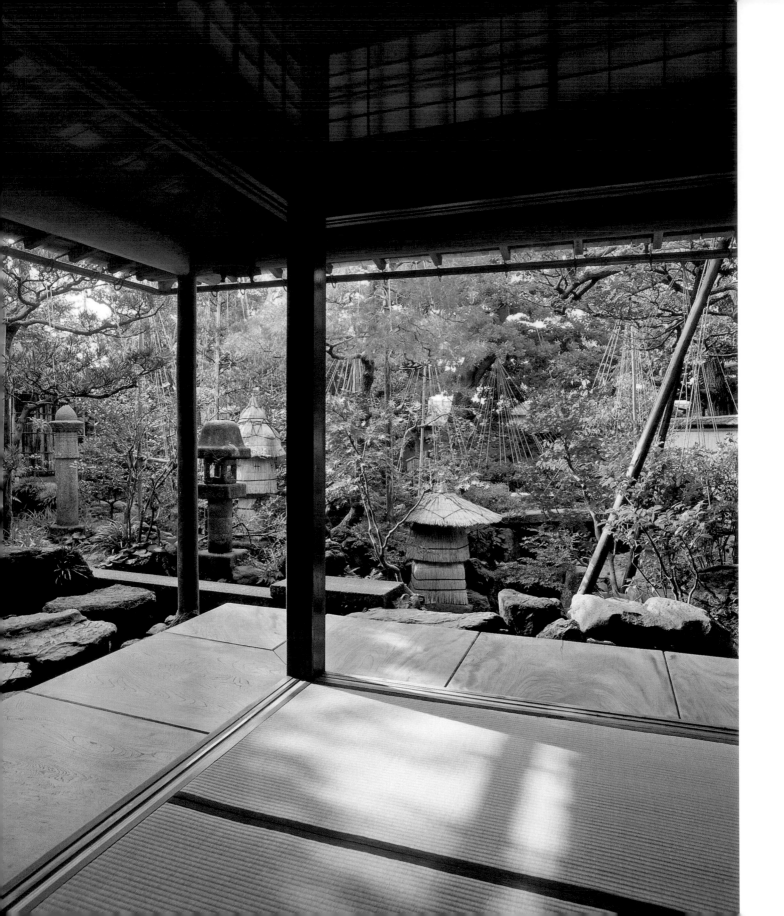

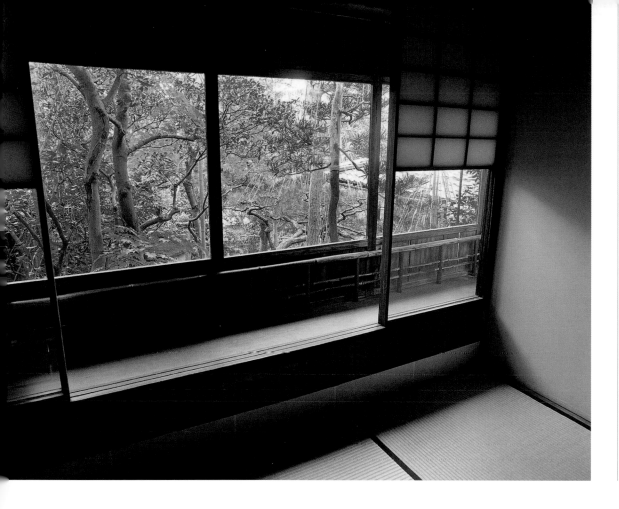

LEFT The tea room on the second floor has a bird's eye view of the garden. This small waiting room leading to the tea room underscores the aesthetics of Kanazawa, where flourishes of individual creativity offset the understated natural materials.

OPPOSITE Stone lanterns are wrapped in straw to protect them from the freezing weather in Kanazawa. This is done so skillfully that these wrapped lanterns have become symbolic of Kanazawa gardens.

of running water forms an integral part of the experience of this garden. This stream comes from a waterway called Onigawa that was used for moving supplies from the harbor to the Kanazawa castle during the Edo period. Part of the main drawing room that jets out into the garden is also visible from this viewing platform. The pond near the main drawing rooms is at a higher level. This level difference allows for the water features to be designed as a lively stream in one part of the garden, and a calm pond elsewhere. The garden slopes upwards from the main drawing room area toward the tea room.

The main drawing rooms called Jodan-no-ma and Ekken-no-ma that were reconstructed at the Nomura estate are particularly luxurious. They were built by their former owner Kubo to welcome the local feudal lord to his house, an extraordinary honor at that time. Of these two rooms, the Jodan-no-ma room has been oriented toward the garden and can be completely opened on two sides. From here, one can see the largest stone lantern of the garden,

surrounded by lush green shrubs and trees around it. Water from the rushing stream becomes a still pond in this part of the garden, with colorful carp fish swimming in it, and can be enjoyed sitting on the *engawa* porch with a deep roof overhang above it. One of the many objects on display in this room is a *koukei*, a box in which a nightingale bird was kept enclosed so that its resonating song would entertain the people sitting on the *engawa*.

A completely different view of the garden can be seen from the tea room, reached by leaving the main house and climbing a flight of stairs from a small inner garden. A comfortable windowsill has been provided in the tea room for enjoying the garden below. Besides the pine, Chinese maple and cherry trees, the view from here includes a myrica tree said to be over 400 years old. It is rare for myrica trees to survive this long in the cold climate of Kanazawa. It is said to have been planted by Denbei Nomura with nostalgia for his warmer hometown, Owari, and is now a treasured feature of this garden that recalls the history of Kanazawa.

Happo-en
Tokyo

Happo-en is known for the many beautiful varieties of cherry blossoms, such as kawadu-zakura, yoshino-zakura, shidare-zakura and yae-zakura, that all bloom here in spring one after another while other trees are still bare from the winter. It is only after the cherry blossoms shed their petals that soft green leaves emerge on trees, so in spring the spacious garden of Happo-en appears covered with heavenly pink clouds. Colorful azaleas and rhododendrons liven up the garden in summer, while the deep red Chinese maple trees bring the colors of autumn to this garden whose name means "beautiful from any angle."

Happo-en's site was originally the home of Hikozaemon Okubo, an Edo period samurai known for his bravery during the battle of Osaka in the early seventeenth century. He is said to have spent his retirement years in a home on this site. The garden and house as they appear today were constructed by Fusanosuke Kuhara (1869–1965), a powerful industrialist and politician. Besides his luxurious mansion at Kobe and three villas at Kyoto, he wanted a house in the center of Tokyo to entertain his honored guests. This prompted his purchase of the land as well as the surrounding

RIGHT Water basins are situated not just for washing hands, but also for the cool feeling one gets watching the water's surface.

LEFT The entrance gate to Happo-en reflects elements of the Edo period's samurai gates, so-called because only people of the samurai class were allowed to construct such gates on their estates.

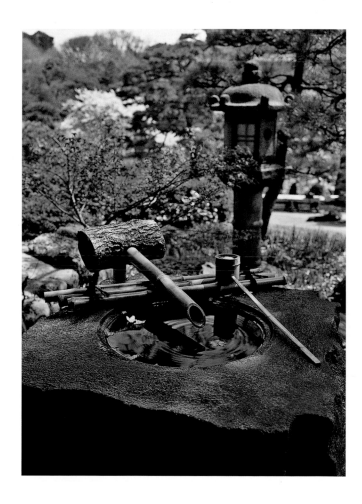

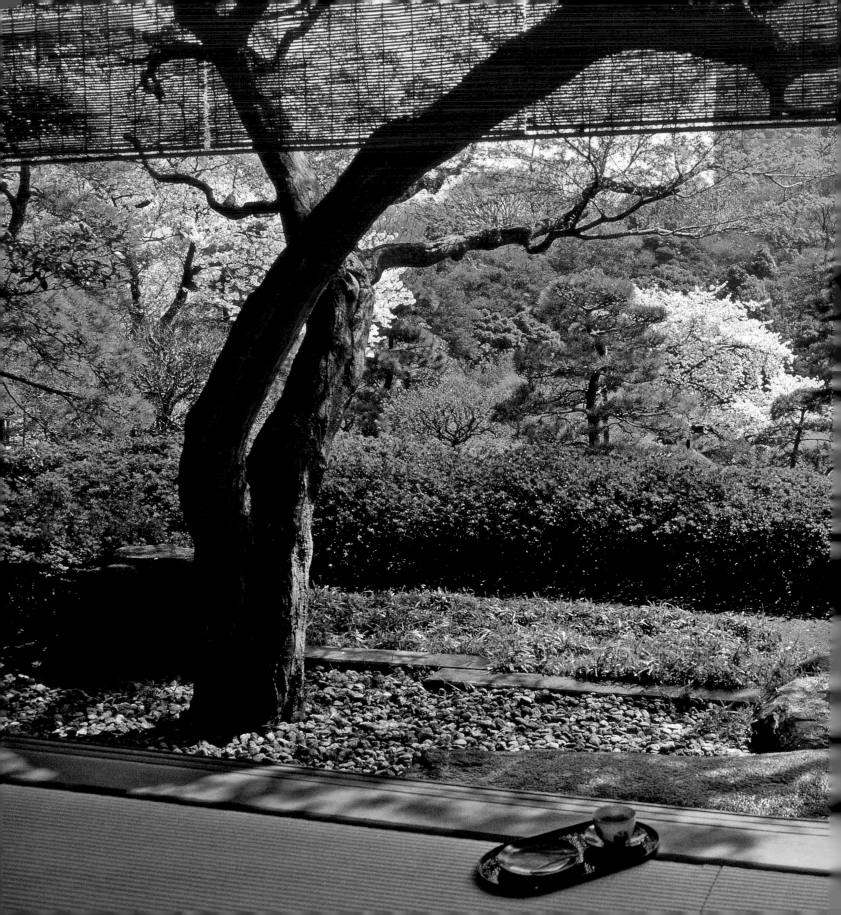

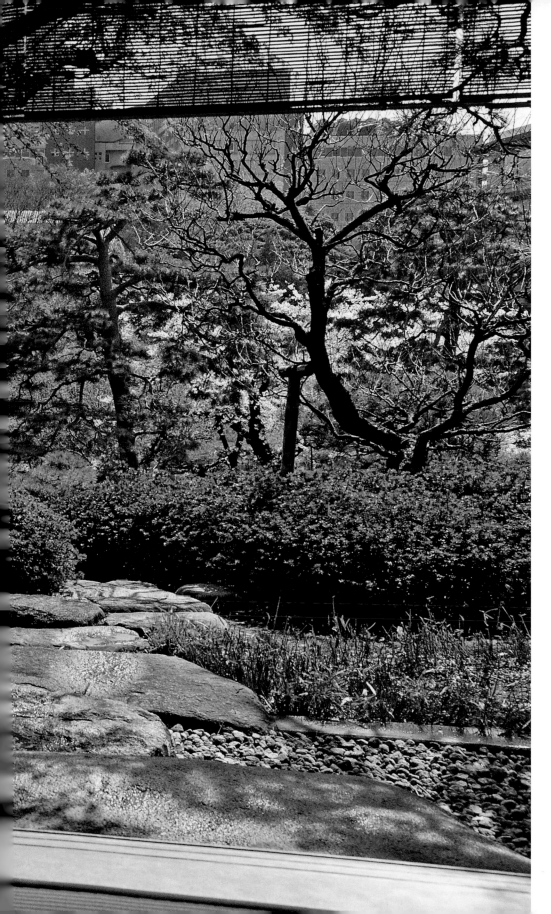

The entire wall of the drawing room's *engawa* porch can be opened so that the room and the garden become one. *Sudare* bamboo shades provide a feeling of coolness to the interior during the hot summer months.

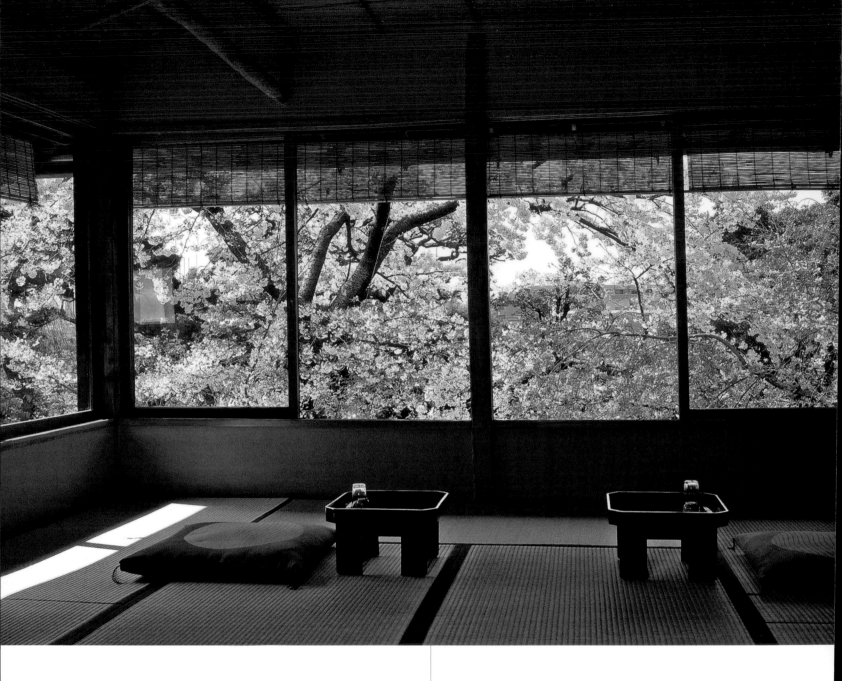

ABOVE The borders of the *tatami* mats and the window frames line up perfectly to frame the beautiful view of cherry trees outside.

TOP RIGHT Due to the hilly terrain in Tokyo, slopes of large properties are skillfully used for planting gardens while the building usually occupies the flat areas at the top. The pond at Happo-en is located at the bottom of the slope.

BOTTOM RIGHT A bough of willow cherry is reflected in the window of the main house.

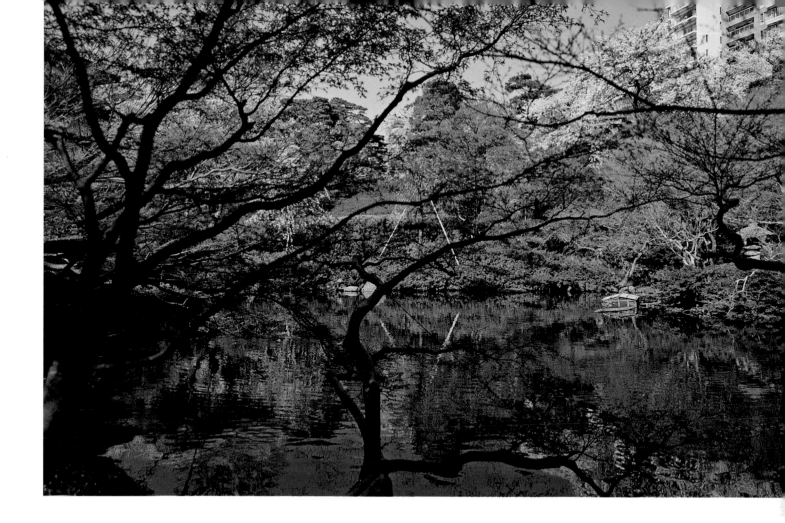

properties, to assemble a total of approximately 40,000 square meters. On this land he built a house and garden that were completed around 1910. The well-known garden designer of that time, Jihei Ogawa (1860–1933), also called Ueji, helped with the garden design. Jihei Ogawa's work set the standard for use of traditional garden techniques in gardens of this period of modernization in Japan. He is particularly known for the delicate use of meandering paths that run alongside flowing streams connected to each other, so that one can stroll endlessly along these paths viewing different scenes. Just as in typical daimyo gardens of the Edo period, the contours of gentle hills and valleys at Happo-en are skillfully used, making it impossible to view the entire garden from any one point, thus enhancing the feeling of spaciousness. Ueji's skills were matched by the enthusiasm of Kuhara himself, who gathered old trees, stones, stone lanterns, and historical stone monuments from all over the country for use in his garden. Kuhara wanted natural harmony and not

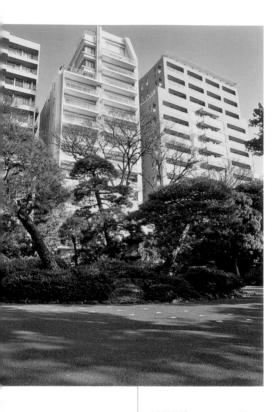

ABOVE Happo-en provides
a rare retreat in the middle
of the bustling city of Tokyo.

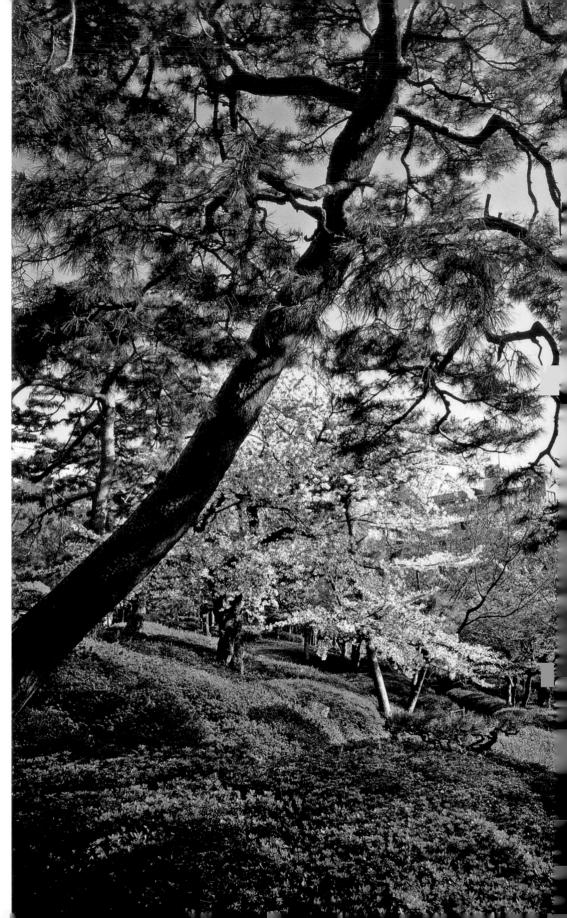

man-made features to dominate the spirit of this garden. Careful consideration for spatial relationships between the building, the garden, and the stone ornaments have helped achieve this goal.

The garden at the time of Kuhara included a large pond, the main building, a tea house, and other subsidiary buildings, most of which are still there. Kochu-an, the private house of Kuhara, was opened to the public in 1951. Some rooms of the old house are still in use and are considered some of the best places in Tokyo from which to view cherry blossoms. Consequently, the reservations for these rooms fill up a year ahead of the cherry blossom season. Restaurants, wedding halls, and banquet rooms have been added to Happo-en since then, making the garden a popular destination in Tokyo today.

LEFT Happo-en is particularly popular during the cherry blossom season due to the many varieties of cherry trees here that bloom one after another, offering a prolonged viewing season.

BELOW The winding path is laid out to present the walker with a different focal point and view at each turn. Prized bonsai trees line this part of the path, providing an opportunity to see how well bonsai trees mimic large trees in their shape as well as in spirit.

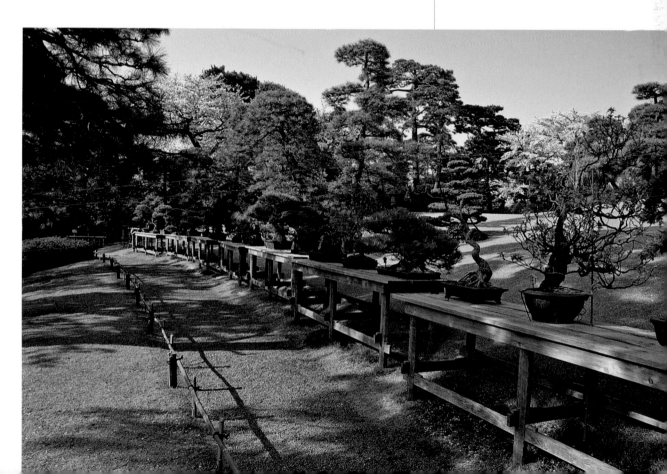

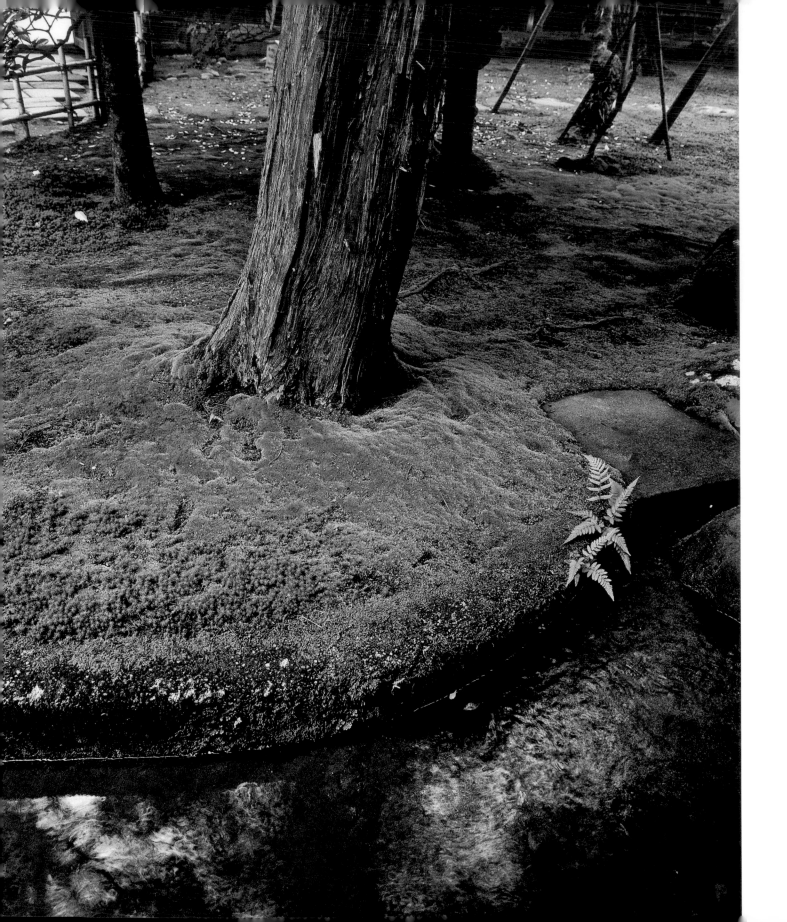

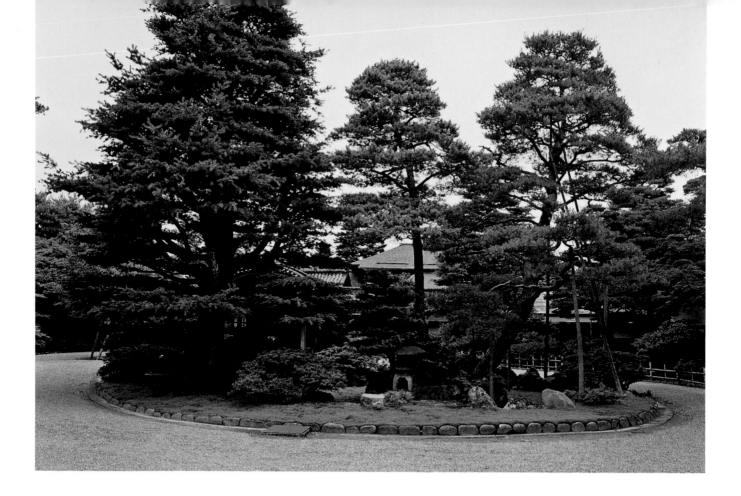

Seison-kaku

Kanazawa

The Meiji Revolution of 1868 caused an upheaval of all political and socioeconomic systems in Japan. As the feudal system came to an end, so did an entire genre of feudal architecture and garden design. The Seison-kaku house and garden was one of the last such properties to be built at that time of transition, and is on the register of Important National Cultural Properties. This estate is located close to Kenroku-en, formerly the garden of the Kaga feudal lord, at the center of Kanazawa city.

ABOVE This entrance garden announces the dignity and refined aesthetics of this remarkable residence.

OPPOSITE This garden has been designed in the typical *hira niwa* style of an open garden, where the ground is flat and no artificial hill has been created. It is covered with thick moss, with a stream flowing along a curvaceous path.

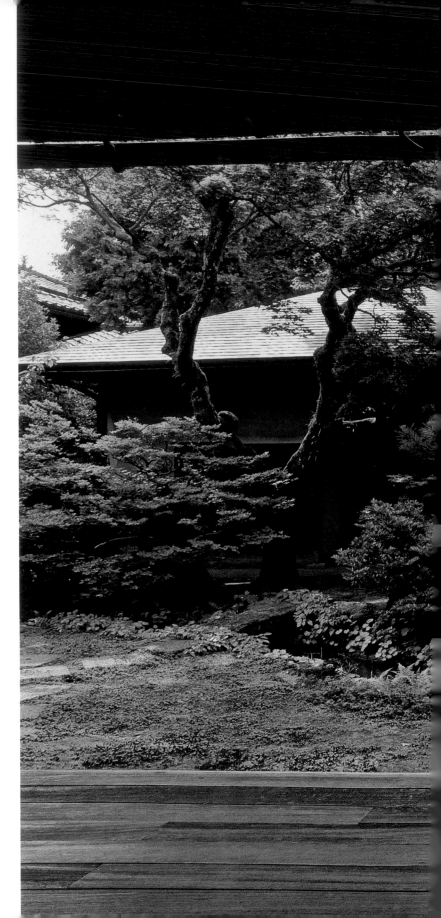

The large kuromatsu (black pine) tree, 200 years old, is the centerpiece of the Tsukusi-no-en garden. Its well-groomed branches are a testimony to the good care this tree has had throughout its life. The twenty-meter-long *engawa* patio outside the rooms adjoining it was designed with a cantilevered roof so that no posts would interfere with the view of this beautiful garden from inside the house.

Seison-kaku was built for Lady Shinryuin, wife of Narinaga Maeda, the twelfth feudal lord of Kage. Her son Nariyasu Maeda, the thirteenth lord of Kaga, built this property in 1863 as a retirement home for his widowed mother, who died at the age of eighty-four in 1870. The property changed hands after her death, parts of the garden were destroyed, and the building was used for a school and museum of Ishikawa prefecture before returning to the hands of the Maedas in 1908. It was finally given to the government and opened to the public in 1950.

The house and the garden were originally designed in the formal graceful style considered suitable for an old noble lady. This intent is exemplified by the fact that the doors to the Lady Shinryuin's chambers do not have door-pulls on the inside since attendants were always on duty outside her doors, and would open them upon hearing the shuffle of her feet on the tatami mats behind the door.

Seison-kaku has three consecutive gardens, each with its own distinct character. A tiny stream from the neighboring property of Kenroku-en flows through each of these three gardens and links them together.

The first garden is called Tsukushi-no-en, and has been designed as a flat open garden called *hira niwa* in Japan. It was designed to be enjoyed from Cho-no-ma, the living room with a butterfly theme, and Matsu-no-ma, a private relaxation room with a pine tree theme. The garden is visible from these rooms across a tatami mat–covered corridor and *engawa* patio. The twenty-meter-long *engawa* roof here has no supporting posts, so that the whole garden can be viewed from indoors without visual obstructions. A special hidden cantilevered timber truss supports the deep eaves overhanging the *engawa*. This structure is all the more impressive

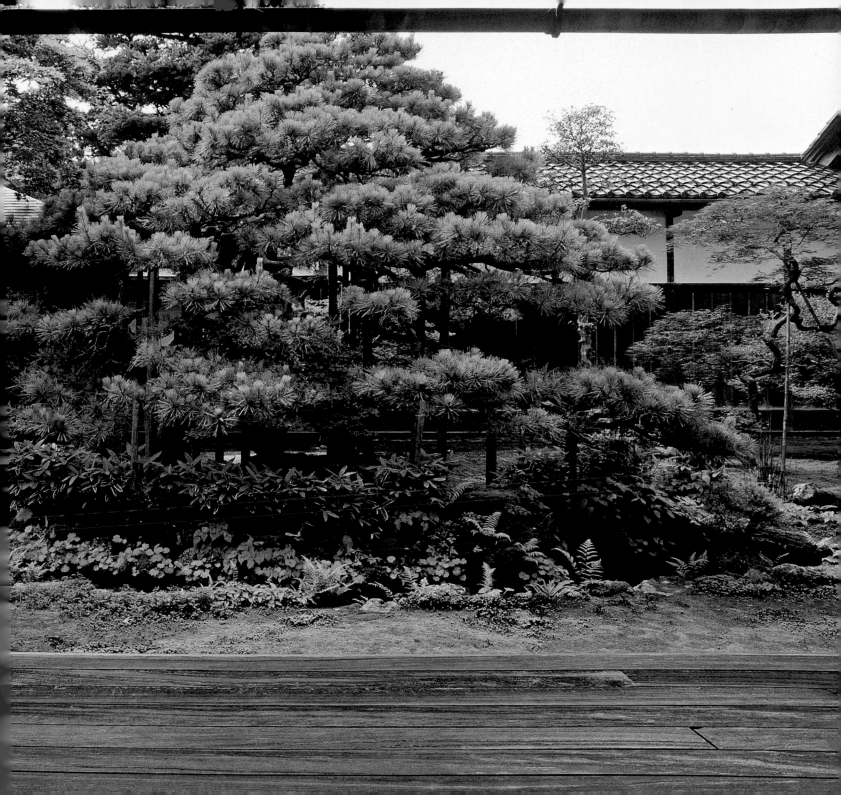

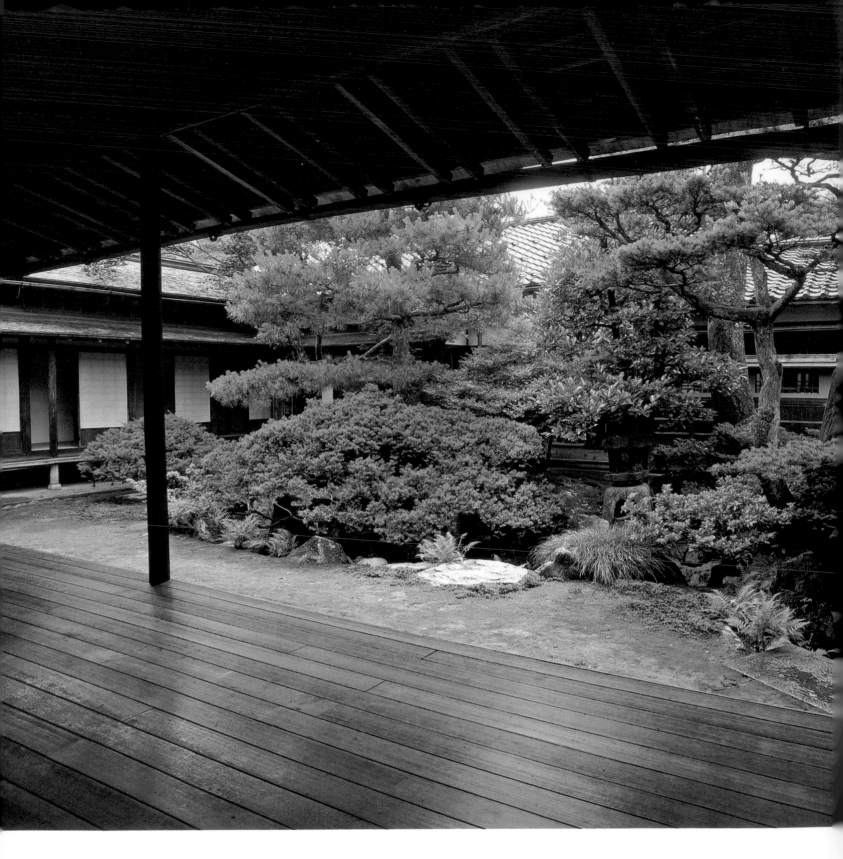

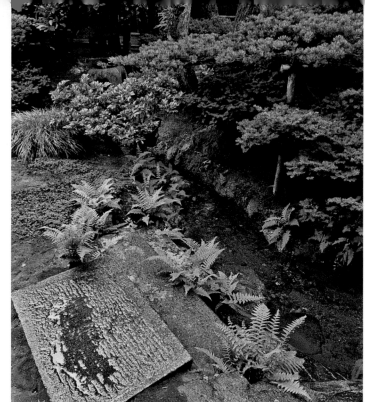

LEFT The rock arrangement around the stream mimics a wharf.

BELOW The base of this old red pine is an expression of the long life of the tree.

OPPOSITE Kyaraboku (yew) trees are symbolic of turtles, which in turn symbolize a long and happy life in Japan and China. They expressed the wishes of the thirteenth Lord of Kaga toward his mother when he commissioned this project as a retirement home for her.

as it is designed to withstand heavy snow loads; Kanazawa gets over six feet of snow each winter. The central feature of this garden is a large 200-year-old kuromatsu (black pine) tree. Other trees in this garden include ume (plum), goyomatsu (five-needled pine), tsutsuji (azalea), mokkoku (theaceae) and kaede (maple). These large trees form the background, while the smaller shrubs and low grasses planted along the stream define the foreground in the composition of this garden.

The next garden is called Omote-no-en and is located next to Kame-no-ma or the Turtle Room, which was designed as a bedroom for Lady Shinryuin. Here also, the tatami-matted corridor and *engawa* patio separate this room from the garden. *Kame* means turtle and is symbolic of a long and fulfilled life, an appropriate symbol that was selected to wish a long life for the house's original resident. Turtles are also featured in the paintings on the wooden wainscot of the *shoji* screen doors in this room.

While the stream flows gently through the Tsukusi-no-en garden, it has been designed with an undulating curve here in Omote-no-en, resulting in a murmuring sound of water suggestive of a valley in a deep mountain. It was so designed because Lady Shinryuin was known to sleep better listening to nature sounds.

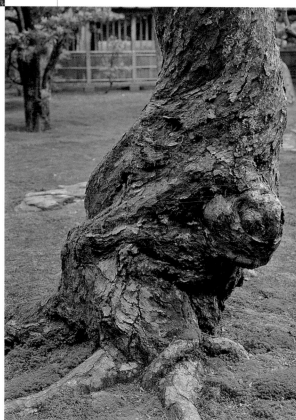

The third garden in this sequence is Hikaku Garden, located next to the tea rooms Seiko-ken and Seiko-shoin. Part of it goes right up to and under the tea rooms, and is called a *do-en*. This part of the garden has a lime plaster floor inlaid with colored stepping stones typical of Kanazawa. Each stone has a different shape and color and has been selected with great sensitivity. This design is as refreshingly surprising now as it must have been when it was made. A tiny part of the garden stream also curves away from the main flow directly into the *do-en*. The *do-en* garden continues across this stream to the main Hikaku garden which is covered with moss and beautiful old trees. The eaves have been made particularly deep in this area to allow tea ceremonies to be held during snowy days, using the *do-en* as the *roji*—the part of a garden that precedes the entrance into the tea room and helps the guests prepare their minds for entering the world of tea.

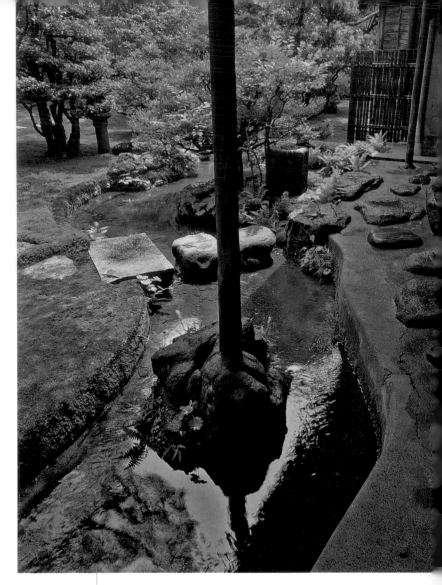

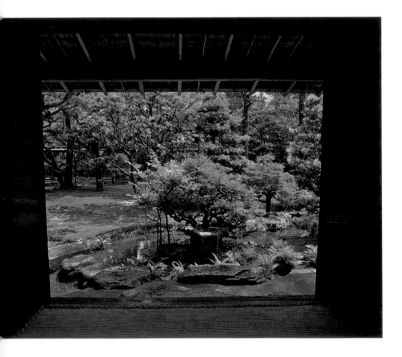

ABOVE The lime-plastered *do-en* garden is seen at the doorstep of the Seiko tea room. The main Hikaku moss garden continues on the other side of the stream.

LEFT A view from the Seiko tea room includes this hexagonal washbasin, which has images of Jizo, the guardian deity of children, carved at each side.

RIGHT The small stream that enters under the eaves of the *do-en* brings the garden indoors. The *shoji* sliding door is a *kinin-guchi* entrance meant for a person of high rank to enter without having to bend down, as opposed to the smaller crawl entrances called *nijiri-guchi* that are usual in tea rooms. The "way of tea" seeks to treat everyone as an equal, and variations such as *kinin-guchi* are rare.

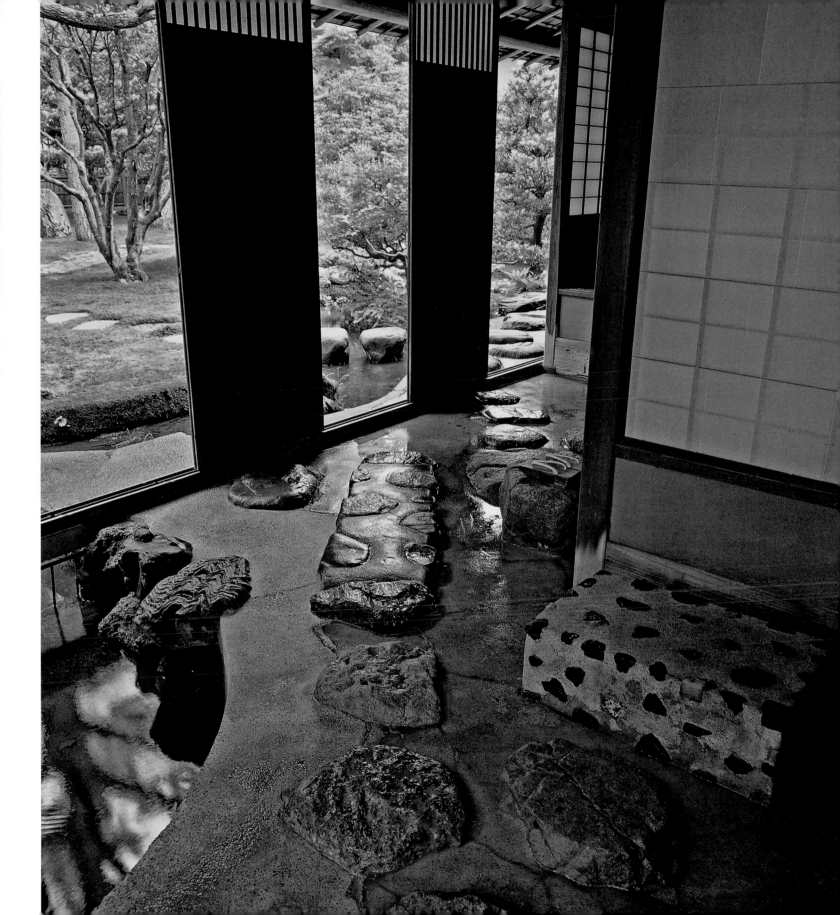

LEFT The small entrance and front yard leading up to the main building belie the existence of the lovely garden and waterfall behind them, adding to the delight of visiting the garden hidden behind.

BELOW AND RIGHT The garden path steps down the steep hill to various buildings. Lanterns light up the steps covered with white gravel and edged with granite stones, which are kept watered during the day.

Kincharyo

Kanazawa

This renowned garden inn is an example of the skillful use of steep sloping sites located in urban areas. Since Japan is a hilly country and urban land is a scarce commodity, planning gardens on slopes and difficult sites is a well-developed art.

Kincharyo is part of the property that originally belonged to Baron Yokoyama who was an important liege of Lord Maeda of the Kaga clan during the Edo period, and who later became a successful mining industrialist. The historic Ochin tea arbor dates back to his ownership in the late Edo period. However, the essential parts of the 1,000-*tsubo* (3,300-square-meter) Kincharyo garden were laid out in the early Meiji period according to planning principals prevalent at that time, whereby buildings are placed on the upper part of the hill, and the gardens slope downward. In 1934, this estate passed to Harujiro Takeuchi, a Kyoto cuisine and tea ceremony enthusiast, who started an exclusive Japanese restaurant here to bring Kyoto style refinements to local Kaga cooking. This marks the beginning of Kincharyo as we know it today. The complex now consists of the main buildings and five smaller detached buildings. While the architecture of the these buildings responded to the trend of combining Japanese and Western style rooms during the early Showa period, the quintessentially Japanese style garden has remained largely intact.

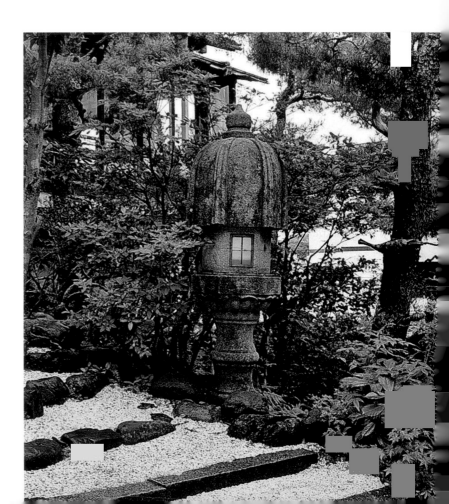

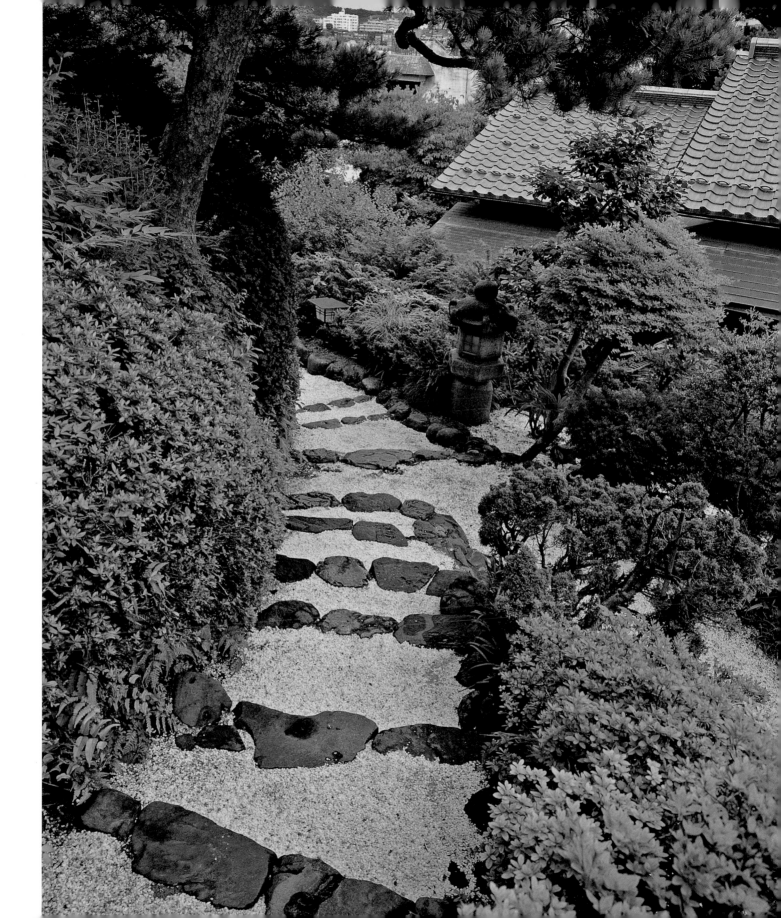

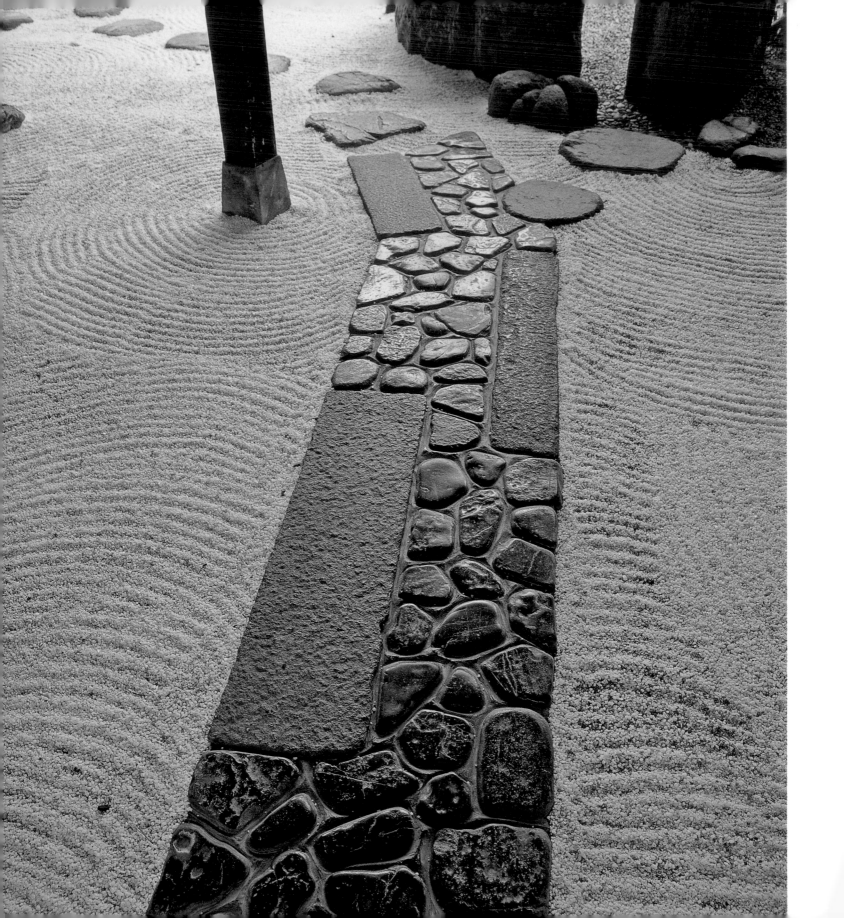

RIGHT The white gravel called *kansuiseki* on the paths is changed every year after the snow season to keep its pristine appearance.

LEFT The sparkling white pebbles are also meant to evoke snow.

NEXT PAGES The waterfall's design makes the most of the land slope in this garden. In Japanese gardens variations of waterfall cascades, flowing over a series of stones or falling clear directly onto the stones below, are well understood and recreated.

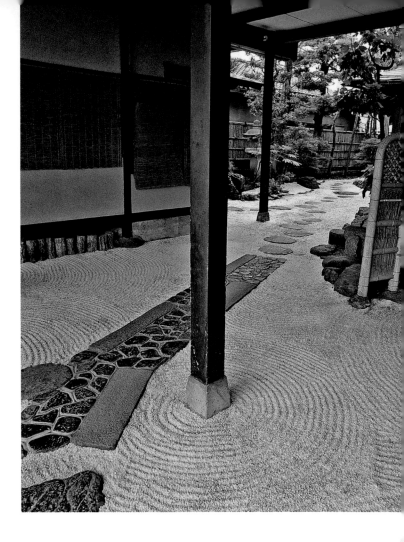

Kincharyo is entered from the street through a Western style stone gate typical of the early Showa period. The gate leads to a small driveway around clipped azalea bushes and a sculptured pine tree. The tile-roofed Japanese style building visible from the entrance includes the Western style drawing room and the administration office. Large flagstones are skillfully arranged into a sparkling raked white gravel path to set the mood for the experience ahead. After enjoying a view from here of the garden below, the center of Kanazawa city beyond, and the mountains far away, the visitors are led from here down a system of winding stone paths and stairs through the garden. The first building along this route is the Edo period tea arbor named Ochin. The view of treetops from its windows gives it the feeling of a tree house. The wood inside has a patina of age, while the motifs of the carvings and door-pulls reflect the sensibilities of the late Edo period, when Western influences were starting to be considered fashionable in Japan.

From Ochin, the path continues down toward the sound of the waterfall, until one reaches the entrance of the Fukinoma tea room. The waterfall created on the sloping sites is the centerpiece of the garden at this level. Design elements have been studied and categorized minutely in Japan, and waterfalls are no exception. Various ancient texts such as *Sakuteiki* have articulated rules for waterfalls to make them appear as natural as possible. The one at Kincharyo has parts that trickle along the surface of rocks and those that jump clear of the rocks in several steps. Rocks have also been arranged to interrupt the flow of water at various levels to provide a cooling spray for the summer breeze. The placement of rocks around the waterfall is also carefully thought out to blend with the surrounding parts of the garden. The water from this fall runs into the Saigawa River, forty feet below the top of the garden.

The seventy-tatami-mat sized Honkan, the main tea room, is located above the Fukinoma room and offers a panoramic view of the entire garden and waterfall. This view is particularly spectacular at night, when special trees, stone lanterns and water basins are illuminated.

Regular maintenance is a critical part of nurturing Japanese gardens, and Kincharyo has a dedicated staff to groom and water the plants, gravel paths and steps. The owners believe that if the maintenance is not done in the spirit of the garden, it can soon lose the power of its original design.

Kincharyo inn and garden has played host to many members of Japan's imperial family, influential politicians, business leaders and international dignitaries such as Henry Kissinger.

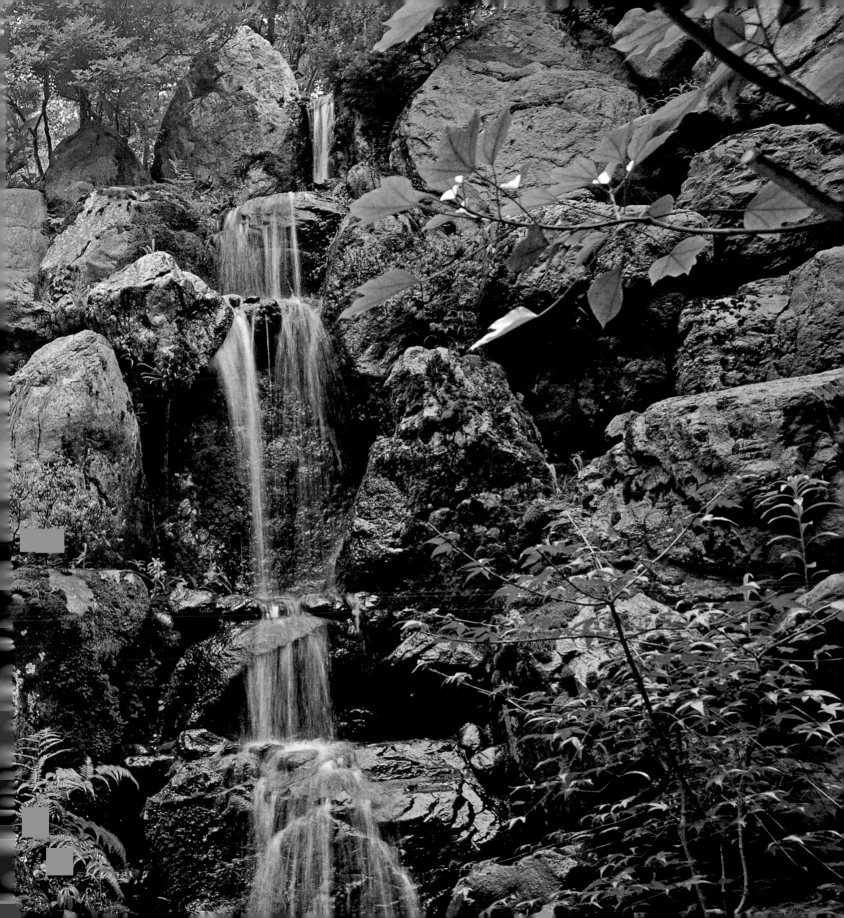

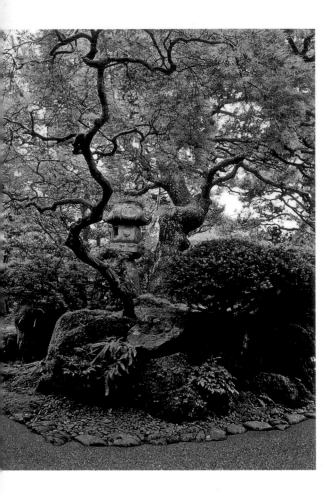

LEFT An island of greenery and a stone lantern announce the luscious garden beyond.

BELOW The Ochin tea room is the oldest building in this complex and dates from the later Edo period. It is open on two sides to the view of treetops, giving the visitor a feeling of being in a tree house.

OPPOSITE Several *toro* (lanterns) have been placed around the garden as ornaments and to provide soft lighting for the pathways. This one lights up the *tsukubai* washbasin in front of the Fukinoma room.

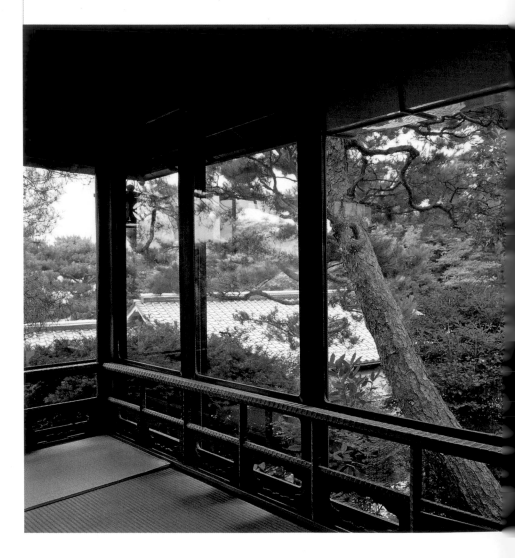

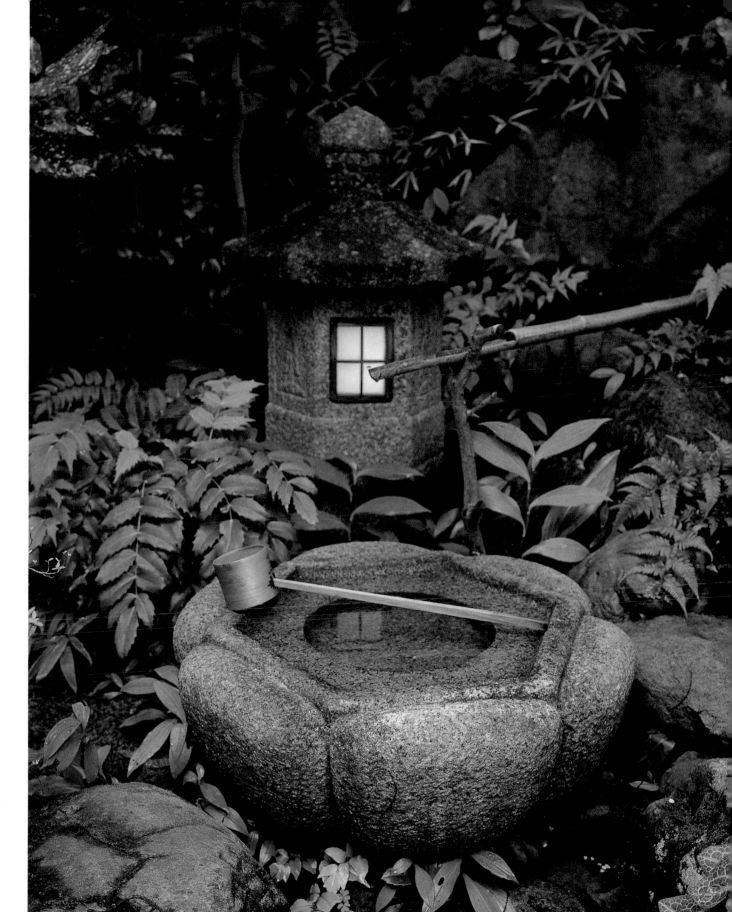

Shunka-en
Tokyo

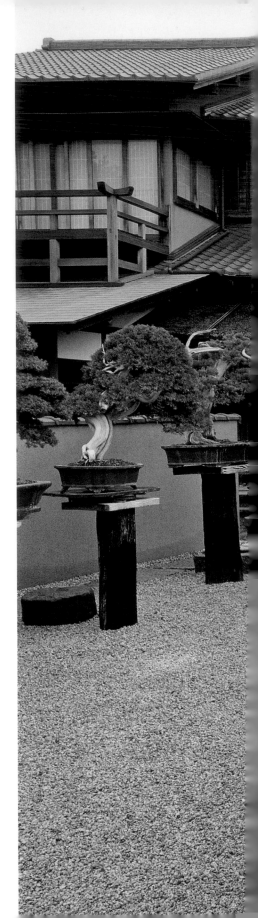

Bonsai is one of the quintessential arts of Japan that seeks to evoke the grandeur of nature in miniaturized forms and spaces. The miniaturization, the training, and the display of bonsai are all part of this art form. Miniaturization of trees first started in India for medicinal plants that were used in Ayurveda. The tradition was developed for aesthetic purposes in China, where it was called *p'en tsai* which means "potted plants." This art came to Japan in the Muromachi period in the fourteenth century and the name *bonsai* came about. Creating a bonsai is radically different than the art of *engei* or flower arrangement. While arranging flowers is about emphasizing the beauty of flowers themselves, bonsai seeks to emphasize the "bones" and soul of a tree.

Located in the Edogawa ward of Tokyo, Shunka-en bonsai garden is the life work of Kunio Kobayashi. Kobayashi considers the art of bonsai akin to painting, and likens the strong lines of a monochromatic ink painting or *yohaku* to the strong trunks of the bonsai trees. However, the strong lines of a bonsai may take ten, twenty, or even hundreds of years to create. During this period, time, nature and man work together as inessential parts of a tree are eliminated and its inherent nature is expressed. Kobayashi feels that his work and philosophy are closer to that of his grandfather, who was a priest, rather than his father, who was a florist. He refers to the Buddhist idea of the temporariness of life in his work, where intertwined dead and living bonsai trunks are symbolic of the perfect harmony between life and death. *Sabakan* are trees where the trunks are broken and appear bonelike, or damaged due to accidents. *Ishi-tsuki* bonsai have roots overgrowing rocks, and are another example of this life-death harmony symbolism.

This 700-year-old kuromatsu (black pine) bonsai is displayed in the center of a large watered pottery basin made by the Meiji period potter Keibun Tanaka.

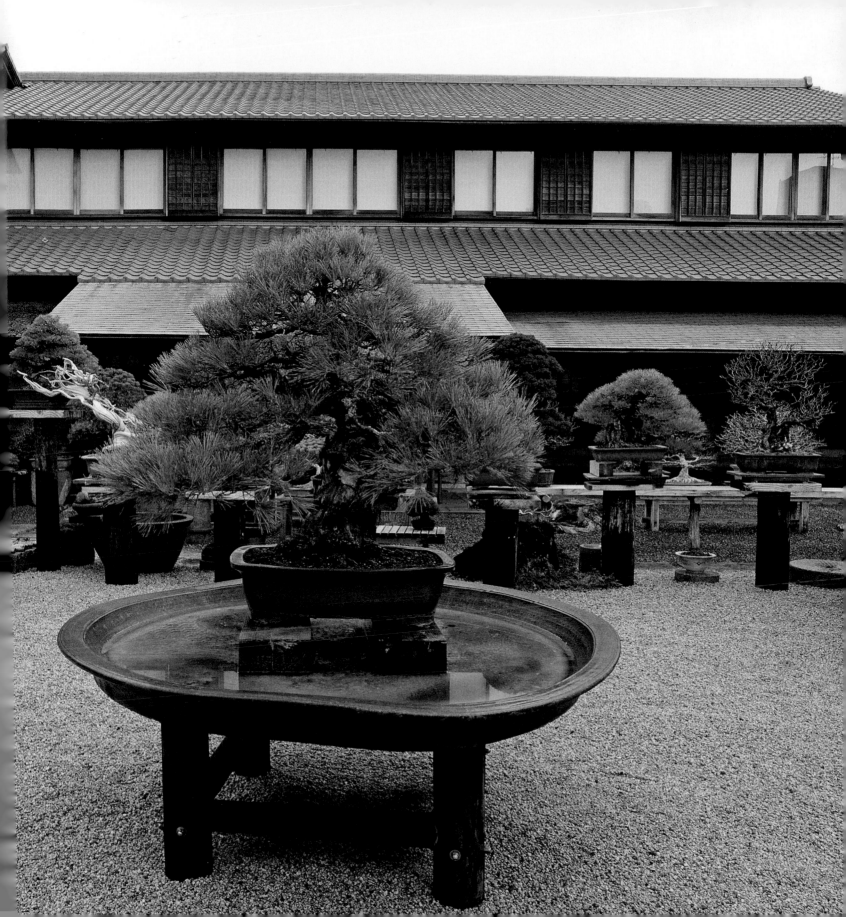

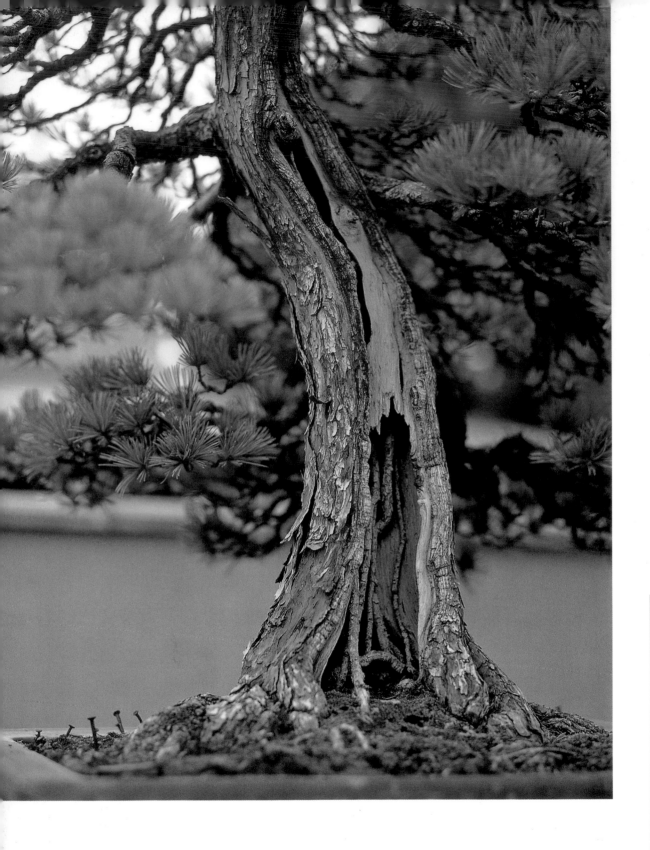

LEFT This sabakan goyomatsu bonsai is a five-needled pine tree of dramatic form. Parts of the trunk are broken and hollow, and present a contrast with the vitality of intensely green leaves.

RIGHT Shimpaku, or junipers, which can be fantastically shaped as bonsai, take hundreds of years to develop, and are the result of man, nature and time working in harmony. The left part of the tree trunk shown here is alive, while the part on the right is deadwood.

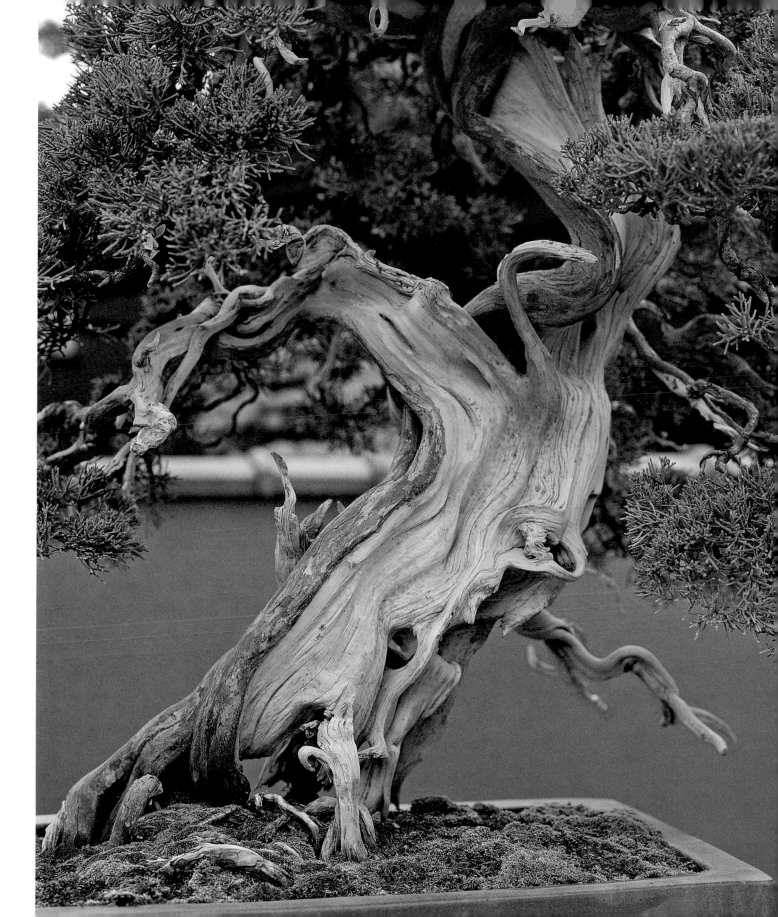

BELOW This 1,500-year-old shimpaku (*Juniperus chinesis*) tree is the star of this bonsai garden. Its complex trunk includes the living trunk as well as deadwood, a combination that is prized in bonsai as symbolic of the harmony of the present and the past.

RIGHT Bonsai are displayed on tall stands to enhance enjoyment of the trees at eye level, and for the ease of caring for them. The rocks and gravel in Shunka-en are watered before the arrival of visitors.

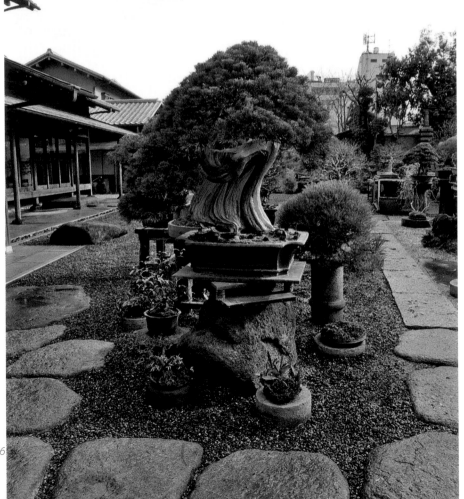

People in power have long been important patrons of the art of bonsai in Japan, and old bonsai trees have their own unique history. The oldest tree in Shunka-en is about 1,500 years old and has seen Japan's development from medieval times to its present position as a global power. Another tree in this garden, from the collection of Japan's imperial family, was originally owned by Shogun Iemitsu Tokugawa. This shogun's love of bonsai is exemplified by the legend of Hikozaemon Okubo, a feudatory, who is said to have thrown down Iemitsu's most cherished bonsai to remonstrate him for his extraordinary devotion to bonsai. In more recent history, important statesmen of the Meiji period such as Miyoji Itō and the recent prime minister Shigeru Yoshida have been bonsai aficionados.

The process of creating a bonsai begins with selecting or acquiring the right plant. Trees that grow in inhospitable locations such as crags and steep windswept hillsides of mountains are preferred, as they have naturally miniaturized for survival. There are specialists who find such trees and supply them to people such as Kobayashi. Since many suitable trees in Japan have already been harvested, trees are now brought in from East Asia or as far away as Spain. Many bonsai also come from China, the place from which the bonsai-making tradition first arrived in Japan.

Next comes the job of understanding the nature of the tree and its potential. Kobayashi says that it is critical to understand the soul of the tree in order to develop a good bonsai. After a concept has been created comes the discipline of working with time and nature to allow the tree to develop its own special beauty. During this process, inessential branches of the tree are removed one by one. However, this is not a fast process; the removal of even one single branch might need to be done over the course of several years, so as not to shock and kill the tree. Therefore small cuts are made in the branch over time before it is finally removed. Other branches of the tree are bent or trained to imitate grand old trees in nature. Symbols of the vitality of old trees, such as upright tips on the heavy drooping branches of a pine tree, are also incorporated. A tree's joints may be partially cut over time to help bend branches to certain angles.

Like most Japanese objects of art, bonsai can be placed in three categories of formality: *shin*, *gyo* and *so*. *Shin* trees appear formal

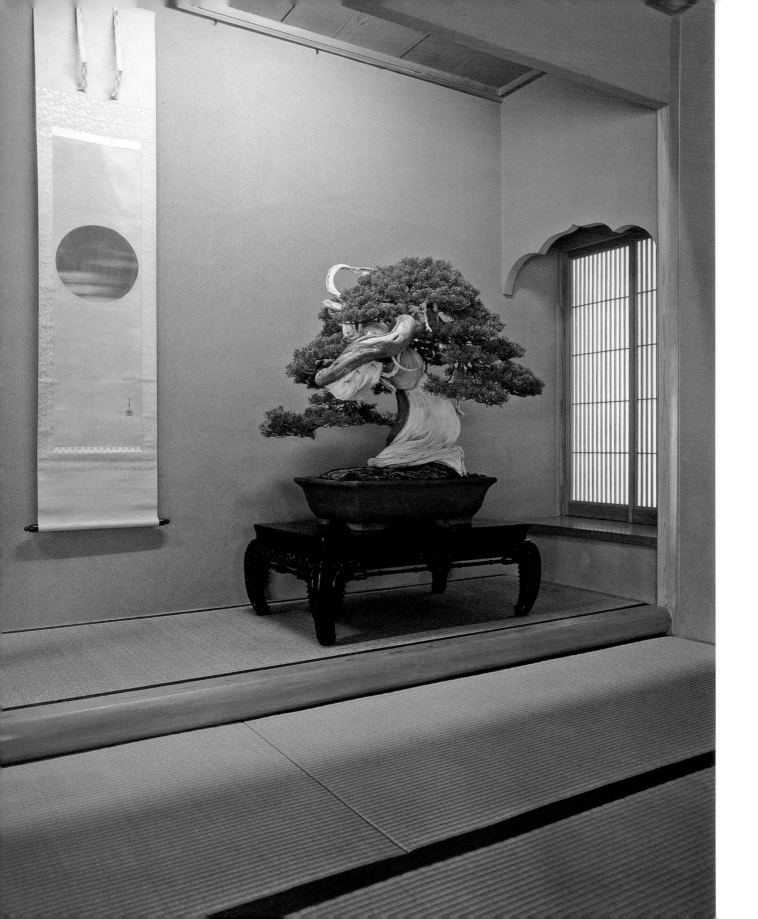

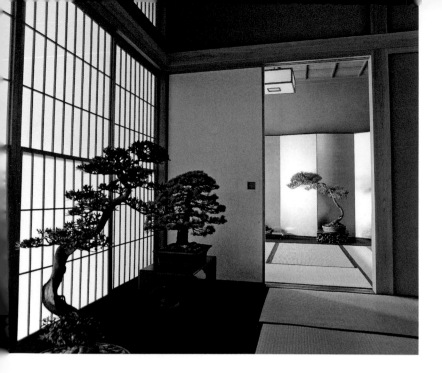

and grow straight, tall and symmetrical. The *gyo* category trees are usually in a *moyogi* curvilinear flowing shape, and usually asymmetrical. Less formal plants, bamboos, and grass bonsai fall in the *so* category. The balance between the container and tree is also of great importance, and appropriate containers are selected to suit each category. Containers for *shin* trees are usually square or rectangular, while containers for *gyo* plants are usually elliptical, and those for the *so* category are usually circular. The selection of a container also depends upon the structure and growth of the roots of the tree; and the stretch of empty space around the bonsai also is important and carefully considered. Such traditions and rules for bonsai were first compiled and documented by Shinkichi Koide, a scholar in the early Showa period.

With over 2,000 bonsai trees, Shunka-en is one of the ten most important bonsai gardens in Japan. Many of the bonsai trees in Shunka-en have been brought here by their owners for care and safekeeping. These trees are only taken back by the owners briefly for special ceremonial events and then are returned here. An important part of nurturing bonsai is the care with which the trees are watered. The quantity and frequency of watering determines how fast or slowly the trees will grow, and how miniaturized the leaves and branches will become. Controlling the development and miniaturization of leaves to complement the scale of the trunk is also carefully managed at Shunka-en.

Shunka-en is not only a garden but also a place for teaching the art of bonsai. Kobayashi is especially interested in providing training to foreign students who come to Japan to apprentice with him, as he considers it a privilege to pass on Japanese culture to these young people around the world. This is important since the popularity of bonsai in Japan has been declining in recent years.

Kobayashi has recently built a beautiful Japanese-style building designed by his teacher Sasaki, a painter, to house and display his collection of bonsai. In order to maximize the opportunities of display, the house has several *tokonoma* alcoves. In the main room, there are three *tokonoma* alcoves, each with a different level of formality, so that all three styles of bonsai may be viewed at the same time. Winner of numerous awards, Kobayashi's bonsai are now also sent abroad, especially to Europe.

ABOVE LEFT The curved lines of bonsai make a dynamic contrast to the straight lines of the framework and *shoji* screens of the structure.

ABOVE RIGHT Kunio Kobayashi considers the shed where he creates and tends to bonsai akin to the studio of a painter.

OPPOSITE The tea room Mukyu-an has been arranged for a celebratory new year welcome, with a 1,000-year-old shimpaku bonsai and a scroll depicting the first sun of the new year.

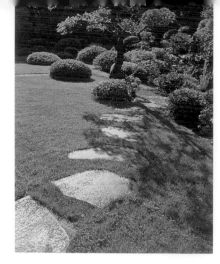

International House of Japan

Tokyo

This exquisite garden in the heart of Tokyo is easily accessible and open to pubic, a befitting contribution to community by an institution committed to promoting international and intellectual exchange. The history of the garden as well as the main building of the International House of Japan is interwoven with the history of Japan. The site formerly belonged to the Kyogoku clan during the Edo period. After the Meiji revolution it was taken over by the government and given to foreign minister Kaoru Inoue, and later to Prince Kuninomiya. It was then acquired by the Akahoshi family and then the Iwasaki family, the founder of Mitsubishi Companies. It was briefly owned by the government after World War II before it finally passed on to the International House of Japan upon that organization's founding.

The present garden was designed by Jihei Ogawa (1860–1933) for Koyata Iwasaki's mansion in 1930, which was built for entertaining guests from abroad. A well-known designer from Kyoto, Ogawa worked in the tradition of Ueji gardeners, and received the seventh

ABOVE Traditional garden manuals suggest that the distance between stepping stones should be equal to one *geta*, or a garden slipper, so that they are comfortable to walk on.

RIGHT This modernist landmark building integrates into its beautiful surroundings with its rooftop garden, and also by overhanging the pond. The patio that surrounds the upper floors is akin to the *engawa* patios in traditional Japanese architecture.

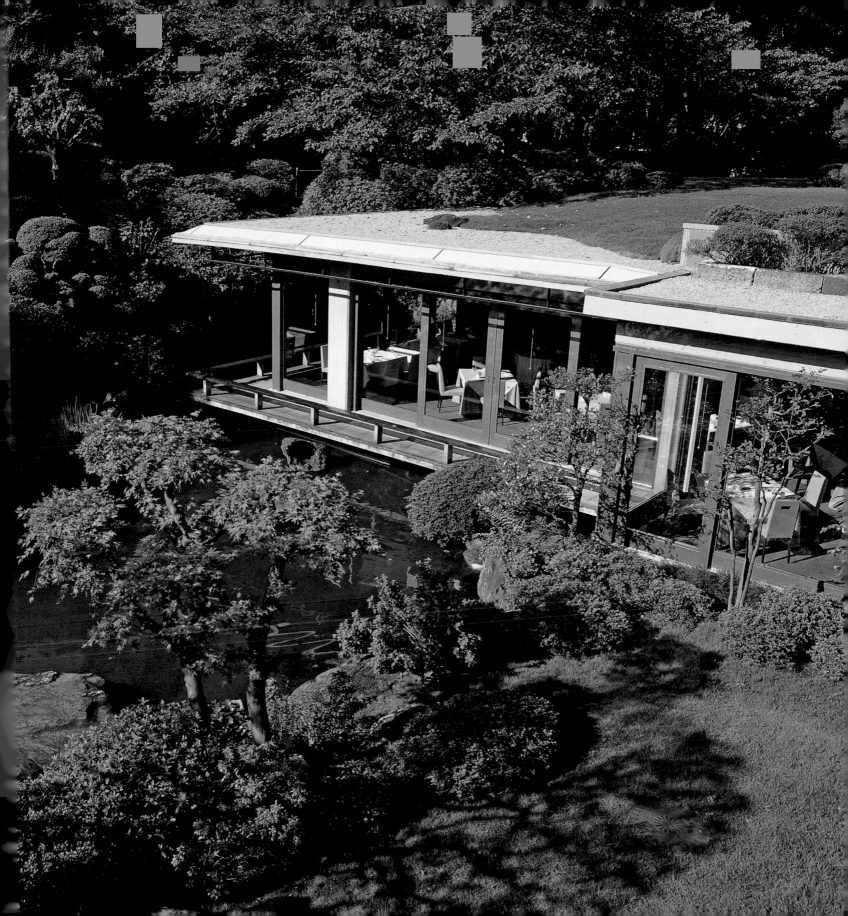

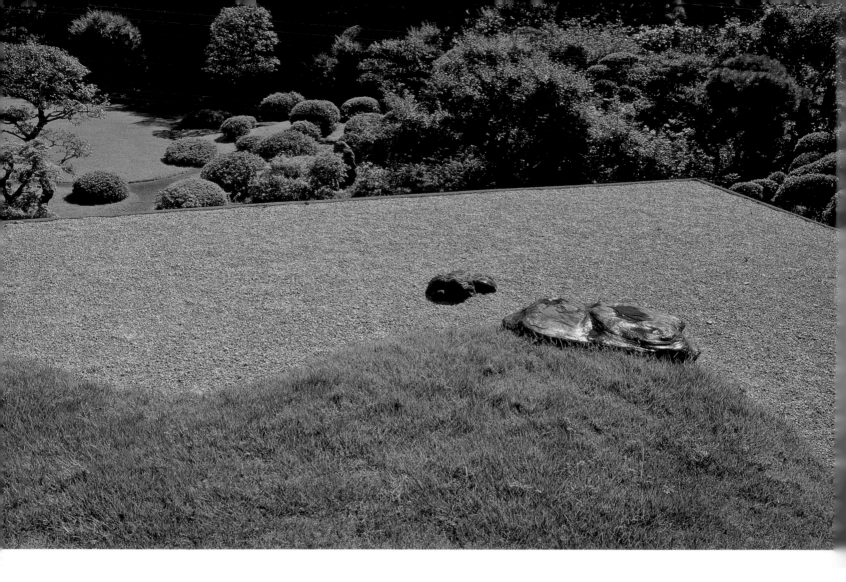

title of Jihei Ogawa in 1879. He is known as one of the most prolific and creative gardeners in Japanese history. Like Enshu Kobori, he modernized many elements of traditional Japanese garden design during the early modern period of Japan. Ogawa is especially known for his innovative use of the traditional concept of *shakkei* or borrowed scenery, and the use of streams that flow through gardens. Many systems of canals were constructed during the Edo and Meiji periods to provide water for transportation, water supply, irrigation and firefighting. Ogawa first started to use canals that originated from Lake Biwa near Kyoto, the biggest lake in Japan, to provide water for the gardens of the aristocrats. Water would meander through one garden and enter the one in the next property, finally returning to the river or the canal. Ogawa's innovative use of these streams was so influential that it came to

be known as Ogawa style. Other gardens and parks designed by him in Kyoto include those for the Heian Shrine, Maruyama Park, Kyoto National Museum and Murin-an Retreat.

The present building of the International House of Japan was designed in 1955 by three prominent Japanese architects: Kunio Maekawa, Junzo Sakakura and Junzo Yoshimura. The building was expanded in 1976 using Maekawa's design. It is noteworthy that while these architects were the pioneers of the modern architecture in Japan and greatly influenced by Le Corbusier and other modernists, they brought a Japanese sensibility in relating the building to this beautiful garden. In particular, the projection of the building above the pond was modeled after a motif that can be seen in scroll paintings of the Heian period (794–1185).

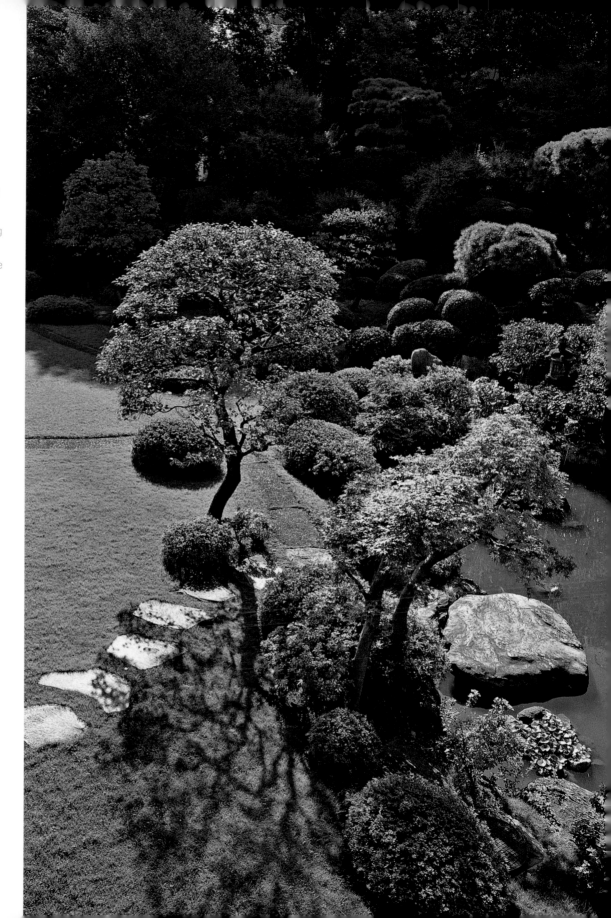

LEFT The garden continues uninterrupted onto the roof of the building. The need for a railing has been avoided by using *jari* (gravel stones) to prevent people from going close to the edges.

RIGHT Japanese gardens are usually designed keeping their three parts in mind. The foreground of this garden consists of a lawn, the mid-ground is made up of the clipped azaleas and other bushes, while the background is of tall trees on a hill.

Much has changed in the garden since it was designed by Ogawa. Most channels that were designed to carry water are now dry beds and the tea house has long gone, but the ambience of the Momoyama/Edo period gardens can still be seen, especially around the pond area. Since this property sits on prime real estate, the building and garden of the International House of Japan were once slated for demolition by a developer at the turn of the century, but The Architectural Institute of Japan and members of the International House of Japan successfully campaigned to save the property and renovate the Modernist landmark building. This garden was designated a place of scenic beauty by the Minato Ward of Tokyo in October 2005.

RIGHT Besides the pond at the bottom, this garden also has meandering dry bed streams of pebbles designed to evoke the idea of water running downhill to feed the pond.

BELOW Artificial hills are often formed beside the ponds by using earth excavated in the digging process. These hills provide a picturesque backdrop to the ponds.

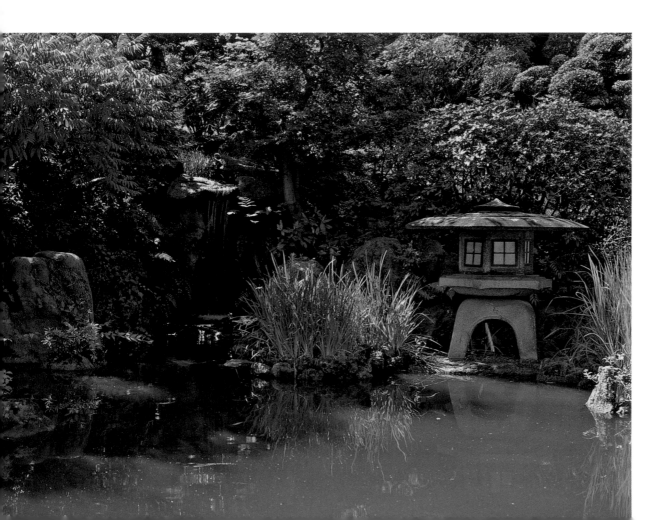

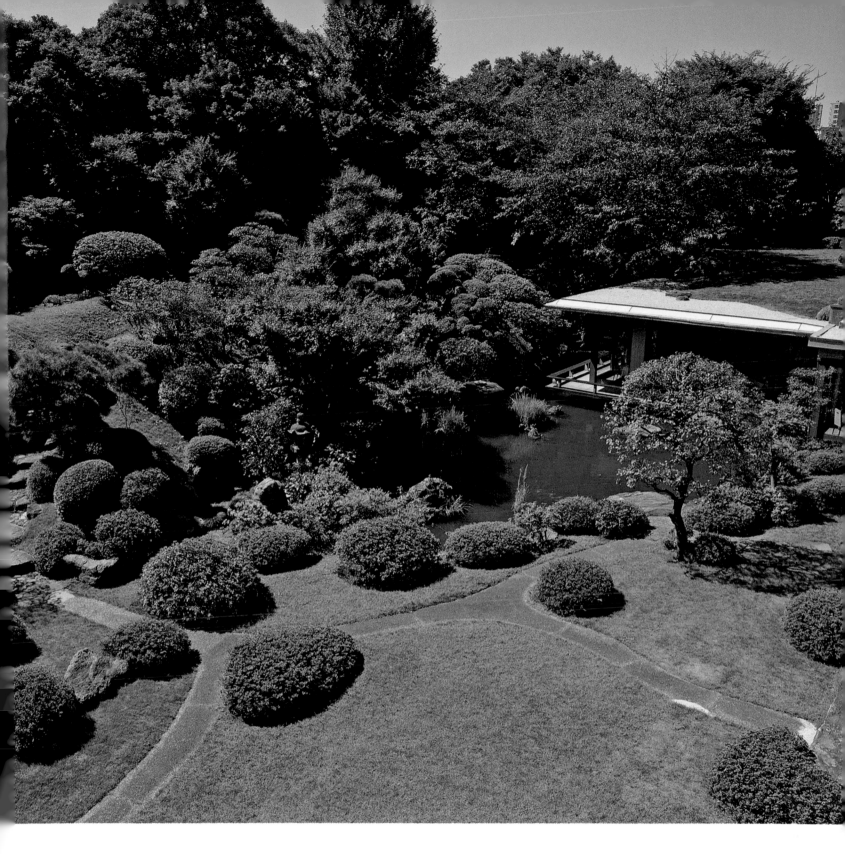

Glossary of Garden Terms

amado: shutters located outside the shoji or sudo screens

araiso: Literally "rocky shore." Usually refers to a group of rocks in a garden set at water's edge and designed to evoke a rugged seashore.

bengara: a red pigment originally imported from Bengal in India

byakusadan: white sand mound in a garden

chisen: pond, also called *ike* in a garden

doma: packed earth entrance area in traditional houses in Japan

engawa: porch, usually on the garden side of houses

feng shui: Chinese tradition of geomancy used in architecture and garden design

fumi-ishi: a flat-topped stepping stone

goyomatsu: Japanese five-needled pine tree

hanashobu: Japanese iris (*Iris ensata*)

hira niwa: flat open garden

hojo: residence of the abbot in a temple

ike: pond

ishi: rock or stone

ishidoro: stone lantern

ishigumi: the arrangement of stones

ishihama: pebble beach

ishi niwa: stone garden

ishi-tate-so (also called **ishidateso**): Zen priests in medieval Japan who often made gardens for the elite warrior class in return for financial support for their temples

ishi-tsuki bonsai: bonsai trees with roots overgrowing rocks

iwahama: pebble beach

iwajima: stone island in a garden pond, also called *gantou*

iwakura: sacred stones thought of as abodes of kami, the spirits of Shintoism

Jodo: literally "Pure Land." Jodo gardens are meant to evoke the Pure Land or paradise of Amida Buddhism.

kakitsubata: iris with white center that distinguishes it from *hanashobu* iris

kanji: Chinese characters

kansuiseki: white gravel used around stepping stones on garden paths

kare nagare: dry stream. May also refer to a stone arrangement meant to evoke water's flow.

karesansui: "dry-mountain-water" gardens, where water is evoked by designed rocks and sand

karikomi: clipped shrubs

Kasuga doro (or **toro**): stone lantern usually with voluted capstone on a stylized lotus flower base

keyaki: zelkova tree

Enshu Kobori: a well-known garden designer of the early seventeenth century

kuri: priests' living quarters in a temple

kuromatsu: black pine tree

kutsunugi-ishi: shoe-changing stone at the entrance to tea huts or *shoin* rooms

kyokusui: meandering streams popular in garden designs of the early Nara period

ma: a pause, often referred to in the names of rooms meant for relaxation

machiai: waiting area

mitate: literally "seeing with fresh eyes." Usually refers to the surprise of seeing something ordinary from a fresh new perspective.

mokkoku: theaceae

momi: fir tree

momiji: Japanese maple tree

Mount Horai: Central mountain of the Daoism universe. Often represented in Japanese gardens with vertical faced rocks.

Mount Shumisen: Central mountain of the Buddhist universe. Often represented in Japanese gardens with vertical faced rocks. Also called Sumeru in Sanskrit.

Soseki Muso: a well-known priest who designed many gardens using sand, gravel and stones during the first half of the fourteenth century

nagaya-mon: main gate

naka niwa: interior garden

namakokabe: a type of wall used in storehouses, usually featuring black tiles set in raised white lime plaster

Nishinoya doro (or **toro**): a type of stone lantern made up of rectangular stones

niwa: originally a pure place in Shintoism; now refers to any garden

niwa-shi: garden maker

nohanashobu: wild iris

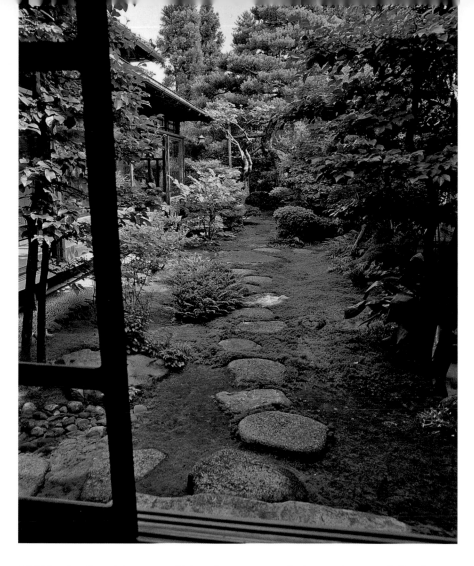

nokishinobu: a type of epiphyte that is coveted in Japan for its taste

onmyodo: animistic beliefs about the power of stones and other superstitions from pre-Buddhist Japan

Oribe doro (or **toro**)**:** a type of lantern that does not have a base and is planted in the ground

roji: stepping-stone path in gardens, especially tea gardens

sabakan: bonsai of dramatic form with barkless trunk often distorted by harsh weather or natural disasters

sabi: an aesthetic concept that relies upon the beauty of imperfection due to rusticity and age. Often used along with *wabi*.

Sakuteiki: the oldest Japanese garden design book, by Toshitsuna Tachibana and published during the late Heian period

satsuki: Japanese azalea (*Rhododendron lateritium*)

Sen no Rikyu: one of the foremost tea masters from the Momoyama period

shakkei: borrowed scenery, such as neighboring trees and distant mountains, that is considered in the design of gardens

shikkui: lime plaster with seaweed paste and hemp fiber used for interior or exterior walling

shime-nawa: straw rope tied around trees, stones or other objects to mark their sacredness

shinden: literally "sleeping room," but refers to the main room in aristocratic buildings of the Heian period

soribashi: arched bridge

Shirakawa: white sand from the Shirakawa river, favored in rock gardens

shishiodoshi: literally "boar scaring away device," a garden decoration designed to make a sharp sound caused by two pieces of bamboo

shoin: a low study desk that gives the study room its name

shoin: formal-style Japanese room

shoji: sliding screen doors made of wood lattice and Japanese paper

sorihashi: arched bridge

suhama: stones laid around a garden pond to evoke a pebble beach

Sukiya style: a tea ceremony, arbor or house with refined wabi-sabi aesthetics

tataki: flooring of gravel stones rammed into earth

tatami: a woven rush floor mat with compressed straw base, usually measuring 90 by 180 cm

teien: a garden, usually larger than a niwa

toro: lantern

tsubo niwa: small interior garden to provide light and ventilation to rooms in the back of narrow urban lots

tsukiyama: man-made hill

tsukubai: water basin, washbasin

tsuru ishi: a stone representing a crane

tsurujima: an island in a garden pond which represents a crane, a symbol of longevity

tsutsuji: azalea, a popular plant in Japanese gardens. Satsuki is also one type of tsutsuji.

ume: plum

wabi: an aesthetic concept that relies upon the beauty of simplicity, rusticity and understatement to convey a feeling of harmony with nature; often used along with *sabi*

yama: mountain

yarimizu: a water channel that flows through the garden and usually runs into the pond

yukimi-doro (or **-toro**)**:** literally, a snow-viewing lantern, usually situated near ponds

yuki zuri: rope umbrellas made over trees to prevent snow damage to the boughs

Acknowledgments

Whom should one thank for making possible a book on gardens besides time, sunshine, earth, water and breeze? The humble work of the authors in bringing the beauty of the gardens in this book to the readers was greatly aided by the help and goodwill of many people and we thank them all from the bottom of our hearts. We especially wish to acknowledge photographic assistant Tomoko Osada, as well as architect Sytse de Maat for his insights, and Arjun Mehta who helped with our research. We would also like to thank Tatsumi Azuma, Kinya Sawada and Chieko Kanamori for introducing us to some lovely gardens in Hiroshima and Kanazawa. A very special thanks to Kaoru Murata, who acted as project coordinator for this book.

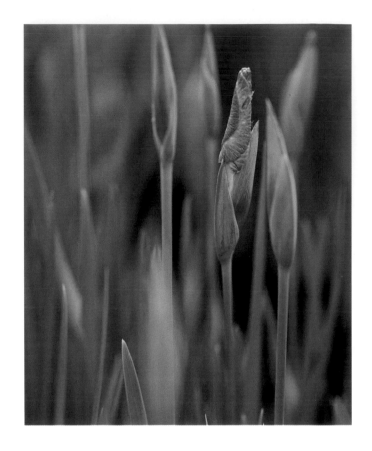

ABOUT TUTTLE: "Books to Span the East and West"

Our core mission at Tuttle Publishing is to create books which bring people together one page at a time. Tuttle was founded in 1832 in the small New England town of Rutland, Vermont (USA). Our fundamental values remain as strong today as they were then—to publish best-in-class books informing the English-speaking world about the countries and peoples of Asia. The world has become a smaller place today and Asia's economic, cultural and political influence has expanded, yet the need for meaningful dialogue and information about this diverse region has never been greater. Since 1948, Tuttle has been a leader in publishing books on the cultures, arts, cuisines, languages and literatures of Asia. Our authors and photographers have won numerous awards and Tuttle has published thousands of books on subjects ranging from martial arts to paper crafts. We welcome you to explore the wealth of information available on Asia at **www.tuttlepublishing.com**.